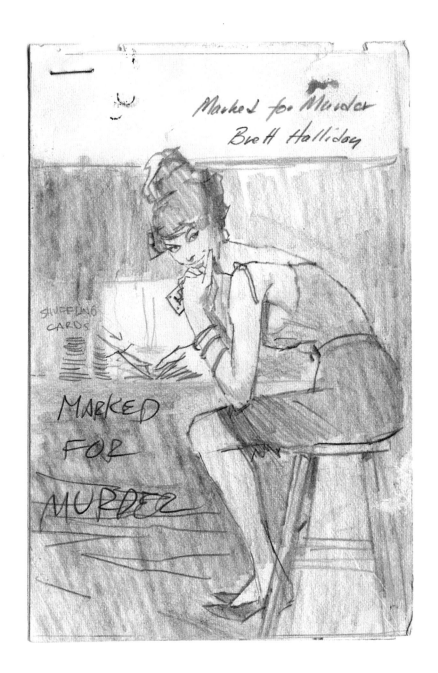

LOUIS L'AMOUR

HONDO

The Paperback Covers of **Robert McGinnis**

A complete listing
of the 1,068 titles and 1,432 editions
of the paperback
cover illustrations of Robert McGinnis
compiled by Art Scott
and Dr. Wallace Maynard

A Paul Langmuir Book

POND PRESS

Acknowledgements

On the Cover:
Brett Halliday, **Marked for Murder,**
Dell D291

Page 3:
Pencil Sketch, 1959 (Brett Halliday,
Marked for Murder, Dell D291)

Page 4:
Louis L'Amour, **Hondo,** Bantam 24757

The authors owe a special debt to Al Fick,
who brought us together, and whose tireless
efforts on behalf of a McGinnis book had
much to do with the genesis of this project.

Many dedicated paperback collectors have
helped over the years in providing informa-
tion and tracking down elusive books:
Lance Casebeer, Bill Denholm, Jean and
Walter Shine, Bill Lyles, Dave Killian, Bob
Briney, Tom Lesser, Ellen Nehr, Frank Eck,
Marv Lachman, George Kelley, Steve
Schultheis, Lynn Munroe, Ron Tatar, Bruce
Taylor, Rose Idlet, Ray Torrence, Bob Speray,
Jim Goodrich, Dale Goble, Paul Willis.

We also wish to thank the following folks
for their help and encouragement in the
preparation of this book: Walter Albert,
Graeme Flanagan, Gary Lovisi, Bud Plant,
Dianne Day, Jane Langmuir, Henry
Horenstein, and Cynthia Charron.

Second Edition, March 2002

Design and Art Direction by Paul Langmuir
Providence, Rhode Island
langmuir@cox.com

Typography and Production by Cynthia Charron

Printed in Great Britain by Butler & Tanner Ltd.,
Frome and London
Printing Number 1 2 3 4 5 6 7 8 9 10
ISBN: 0-9666776-4-1 paperback
ISBN 0-9666776-5-X hardcover

A Pond Press Book
1140 Washington Street, Boston MA 02118
www.pondpress.com

Distributed by Consortium Book Sales and Distribution
1045 Westgate Drive, St. Paul, MN 55114
1-800-283-3572
www.cbsd.com

Information about purchasing prints of
Robert McGinnis's art can be found at his
official website: www.mcginnispaintings.com

McGinnis collectors are encouraged to visit
the McGinnis fan website:
www.geocities.com/SoHo/Courtyard/9088/index.html

Contents

FAWCETT
GOLD MEDAL

T2665 • 75¢

SHELL SCOTT

MIXES

UP

THE SCRAMBLED YEGGS

Former title: PATTERN FOR MURDER

RICHARD S. PRATHER

Foreword **Richard S. Prather** A Salute – and Long-delayed Thank You – to Bob McGinnis

I'll never forget the first time I saw a painting by Robert E. McGinnis on the cover of one of *my* books.

It wasn't the first McGinnis cover I'd seen. I had by then seen a lot of them (alas, on books by a lot of other authors), and admired them *all*, lusted for them *all*, wanted them *all* (or at least one of those wonders for at least one of my own books).

I had also by then seen and (mostly) enjoyed a myriad different covers for my own titles, not only many U.S. editions but several hundred foreign editions as well, and some of that artwork was very good indeed – I think particularly of Baryé Phillips, who painted the definitive "Shell Scott" and created the Shell logo seen on millions of my paperbacks.

But: Then I got *my* first McGinnis, and knew immediately that I was looking at the best and most eye-catching cover I had ever seen on one of my books. Wonder of wonders, seventeen more, each equally and uniquely pleasuring, followed.

I regret that now, nearly four decades later, I don't recall which McGinnis painting that first one was, or even what mystery of mine it magically improved. But I do remember well my surprise approaching shock and my uninhibited delight that finally "a McGinnis" was mine. So in the end it doesn't really matter which painting that first one was because the description "best and most eye-catching" would have been true no matter which of the eighteen I first saw.

Curiously, the above-mentioned "surprise approaching shock" was due to the fact that, when it happened, I didn't have a clue that it was going to happen. Nobody – not even my friends at Fawcett Gold Medal, the best publisher I ever had – bothered to tell me. You would think that any author would be informed by his publisher, before and during and after the fact plus at every other opportunity, that future editions of his books would have their sales wondrously accelerated by the presence upon them of cover art by the incomparable Robert E. McGinnis himself, if only to enjoy hearing the author's fervent, "Thank you, thank you!" or even, "You're pulling my leg, aren't you?" Nope. Didn't happen. Go figure.

At any rate, I was not only surprised and shocked but *happy*, very happy. Especially as Fawcett Gold Medal continued releasing more editions of my books with McGinnis artwork setting them apart from the ordinary, each new cover seeming even better than the last one. Yes, I was a most fortunate fellow, very happy during those very early years of the sixties.

But: Into each life some floods must fall. Thus into all this bliss crept what might conservatively be described as more than a modicum of auctorial pain. For during the same period of time when my books with that splendid McGinnis artwork were being widely distributed throughout the USA by Fawcett, I was – for reasons not here germane – completing my transition from Fawcett Publications/Gold Medal Books to Simon & Schuster, Inc., parent of Pocket Books, my new publisher.

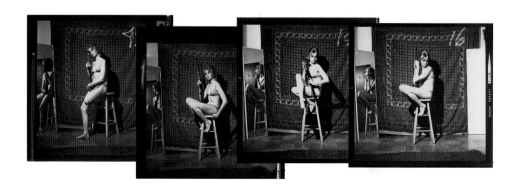

During the last half of 1962 I completed my final two novels for Fawcett (**Joker In the Deck** – which is graced by what's surely one of the best McGinnis inspirations of all eighteen inspirations – and **The Cockeyed Corpse**); and at the beginning of 1963 I began writing the first of the thirteen books I did for PB. Moreover, Pocket Books began preparing, it seemed enthusiastically, to smartly package and expertly promote their dynamite continuation of my Shell Scott series. All of which sounded pretty snappy to me.

But: For some strange reason, which still entirely escapes my comprehension, the Pocket Books people opted to create, for my new titles, covers that were not painted but photographed – this resulting in drab depictions of women who resembled thin men and a Shell Scott who looked like a dork.

I'm not giving away any secrets here. Anyone familiar with my work, and even remotely familiar with those early Pocket Books/Prather covers, must recall this guy with a pound and a half of white flour or powdered sugar in his hair and a vacant expression, understandably, in his eyeballs. I remember one photo in which he's holding onto a little gun like a manic chef about to stir cookies with his Colt .38 spatula. Even if you don't recall those dismaying covers, I do; I'll never forget them; they give me excruciating pain to this very day. Pain bearable only because of the unalloyed pleasure those eighteen McGinnis masterpieces gave me then, and still give me now.

You see where I'm going with this, don't you?

If there's any published writer on the planet with uniquely pleasurable/painful reason to *really* appreciate the beauty and brilliance and wonderfully provocative pulchritudinousness of a Robert E. McGinnis cover painting it's got to be yours truly. For I had, in the space of a mere year or two – in retrospect it seems almost instantly – experienced first The Best (McGinnis) and immediately thereafter The Worst (Shell Dork).

So let me do at last what I should have done long ago, which is to say "Thank you, Bob McGinnis, for those eighteen wonderful covers, and the thousands of other splendid splashes of Beauty you've given to the world of publishing, and the world period."

I have of course been asked, by admirers of McGinnis who are also familiar with my work, what my *own* favorite McGinnis cover painting is. That's a difficult question to answer, and at different times I've given different replies, but I think now's the time to end the confusion and tell the whole truth.

Richard S. Prather
Slab Happy
Fawcett Gold Medal M 2880

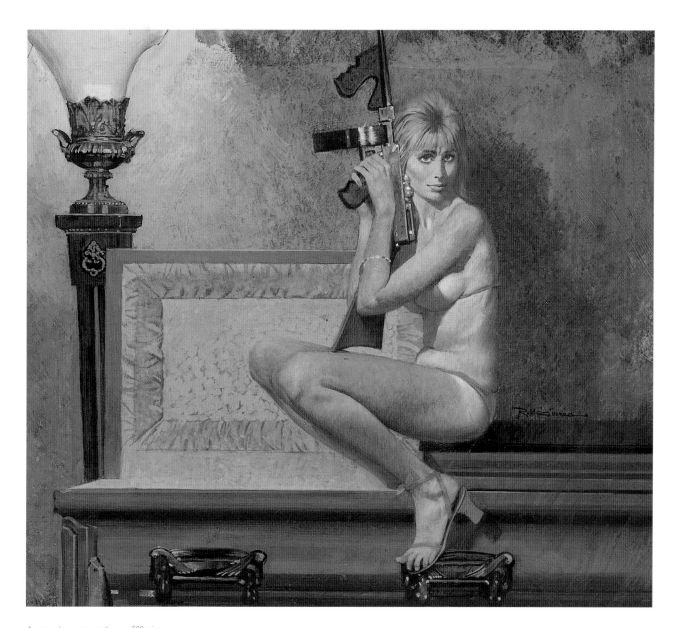

An unusual cover among the over 500 crime
novels that McGinnis did, in that the femme
fatale is holding a gun – a cliché frequently
found on crime paperbacks, but rarely used
by McGinnis.

Slab Happy 1972, gouache on board, 13½" × 11½"

For a while, for several years in fact, my #1 favorite was the exceedingly beautiful lady making **Strip For Murder** a best seller even among people who couldn't read: the shapely redhead standing coolly in the lake's hot water (don't tell *me* it wasn't hot) while disrobing as artfully as disrobing has been done since Eve accidentally lost her fig leaf for the nineteenth time.

But after a while I began thinking maybe, just maybe, the lady transforming **The Wailing Frail** into a hot collector's item should be #1; how could she not be, with her long flowing blonde hair and long flowing blonde body, her wise face and wiser form, her magnetic and charismatic and hoo-boy! impact upon a man's eyes and aorta and etc.?

Well, when I was through with her (temporarily), I convinced myself that the best McGinnis cover art was on **Find This Woman**, the Woman being sufficient all by herself to start three-alarm fires in Christian bookstores and motivate preachers to rewrite their sermons… but there was also that sweet and saucy lass with enough blonde hair for two irresistible sirens, midway through a memorable game of strip poker, relaxing audaciously and flirtily fingering the Joker of **Joker In the Deck**… and even after all of *those* beauties had been studiously considered there were *still* – forget it.

I think you can see my problem. So the honest and final answer to this question is, perhaps not entirely grammatically but I swear entirely truthfully: All eighteen is my favorite.

O.K. I have given you at least a hint above that, like many other published writers, I consider Robert E. McGinnis unique in the field of fine art, particularly cover art (which when he does it *is* fine art). But what is it, exactly, that sets him apart from most of his peers?

At least from this writer's point of view, some of it is, to paraphrase what I've said elsewhere, that he paints members of the opposite sex in a way that makes them *more* opposite; somehow he makes brush strokes in another dimension (one I hope to visit at least briefly when – far far away in the future – I kick the bucket); clearly, at his most creative, he is in contact with angels, some of whom pose for him.

Pursuing this mystical connection: I suspect that Mr. McGinnis and I share a belief seldom spoken of aloud by us men, for fear that we may be considered mentally unhinged. I have long believed that all women – tall or short, fat or thin, beautiful or less-beautiful – are Goddesses. Yes, I really do mean authentic honest-to-God capital-G Goddesses, bright sparks of burning spirit with their blinding light temporarily dimmed behind sweet flesh in order that we dorks, at least sometimes, may approach them with less fear and trembling than we otherwise would.

Extreme or wacky as this conviction of mine may sound to some, I think Robert E. McGinnis may be far-out enough to share it; that is, I think he also believes pretty much *the same thing*. If, however, he does not, I suggest that he take another long look, now that I've enlightened him, at those Goddesses blazing on my eighteen covers, and the thousands of other lovely and luminous ladies he has created, shaped, transformed and stripped of their earthly disguises.

Do any of them look to you like *mere* women?

Sincerely yours,

Richard S. Prather

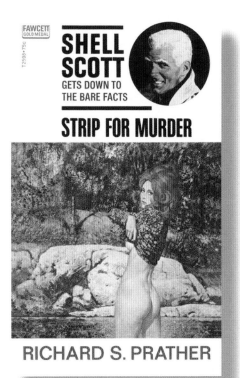

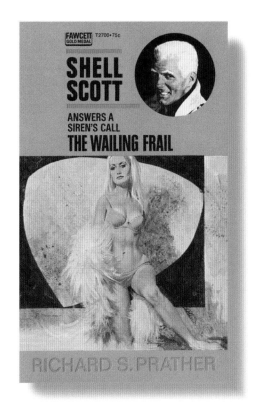

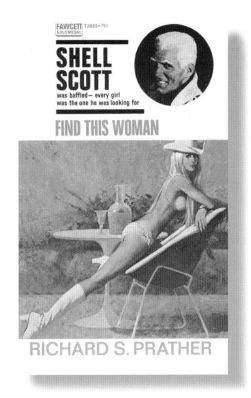

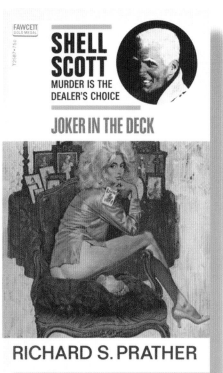

Richard S. Prather
Strip for Murder
Fawcett Gold Medal T 2598

The Wailing Frail
Fawcett Gold Medal T 2700

Find This Woman
Fawcett Gold Medal T 2683

Joker in the Deck
Fawcett Gold Medal T 2587

Working with Bob McGinnis **Frank Kozelek**

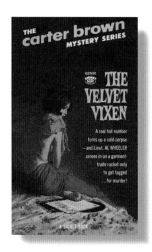

I started in the paperback publishing industry in 1965 at New American Library in New York. When I got my first assignment from the Art Director, Bill Gregory, it was a Carter Brown book titled **The Velvet Vixen.** Bill told me that a sketch for the cover was coming from an artist named Robert McGinnis. That didn't mean much to me at the time because before working at Signet Books I had not had much contact with magazine or book illustrators. As it turned out, because of that book I started out with the very best.

When I got the "sketch" for **The Velvet Vixen** it turned out to be ten or twelve beautifully drawn cover ideas, several of which were in full color. This was Bob's hallmark throughout my working relationship with him. He always wanted to give you his best effort to choose from. He was always concerned with your reaction to his work and always ready to do more on a project if you weren't totally happy with either a sketch or a finished painting. I don't think I have ever met an artist with less apparent ego — though his work could have supported a very healthy one.

The Carter Brown series for Signet Books was truly a McGinnis project. The manuscripts were always extremely late, so Bob started with nothing to work with other than the concept that a striking female would be featured on each book. Therefore, the poses, the clothing or lack thereof, and the backgrounds had to be extremely different from book to book to alert readers to a new title. Over their entire run these covers represented a male fantasy world. They were also very artful paintings. In one case, the Museum of Modern Art in New York wanted to sue Signet for copying, without permission, one of their paintings as a background on a book. I had to show the red-faced curators that Bob's painting, while evoking their art, actually looked nothing like it.

Working with Bob has always been a piece of cake. When you're done with your song and dance trying to describe the feeling you want for some book and probably partially failing, he not only gets the mechanics right, but more importantly, he gets the emotions right. In this new computer age when much illustration — even that which is technically beautiful — has a decidedly plastic look, Bob's work serves up emotion as well as technical skill. As idealized and exotic as his women may be they still seem to breathe real air; they're definitely not Barbie dolls.

Over the years I have always thought of Bob McGinnis as a true romantic. He seems ready to suspend a certain amount of reality in order to maintain an idealized vision. Bob occasionally lunched at a German-style restaurant just off Gramercy Park in New York. Although the profusion of decorations and flowers was not real, I could see by the bright smile on his face that he thought it was beautiful and that he was transported to Bavaria. When I think back about it now, he probably had the right idea.

Bob and I don't work together as much as we once did because romanticism and theatricality are no longer popular with many editors. However I will always remember the fun times when we were working on the Carter Brown girls; i.e., the Robert McGinnis Girls. — F. K.

Carter Brown
The Velvet Vixen
Signet G 2500

At right:
Carter Brown
Zelda
Signet S 2033

McGinnis usually did his own photography. The Carter Brown series – 100 covers over 12 years – was a truly remarkable long-term assignment, rivaling Norman Rockwell's relationship with the *Saturday Evening Post*.

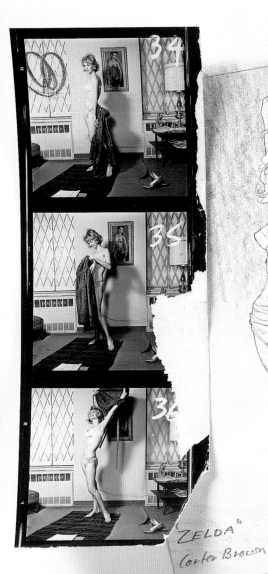

"ZELDA"
Carter Brown

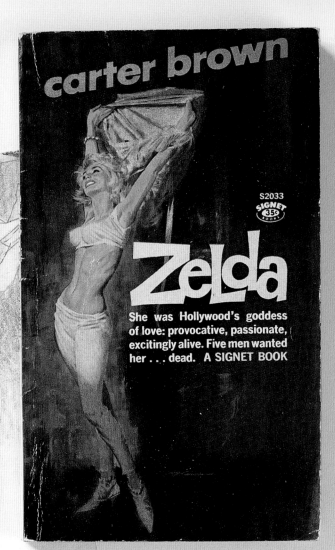

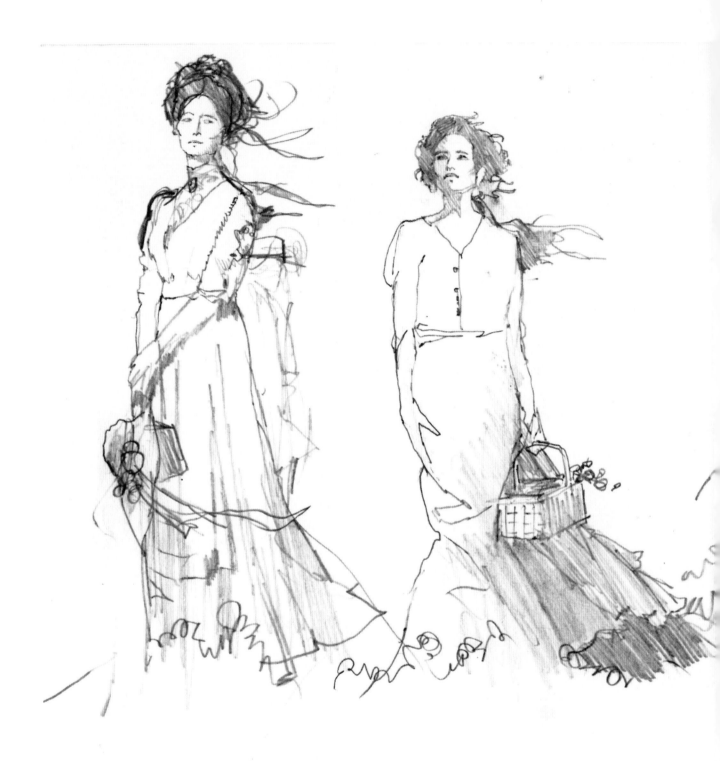

Variations on Wo

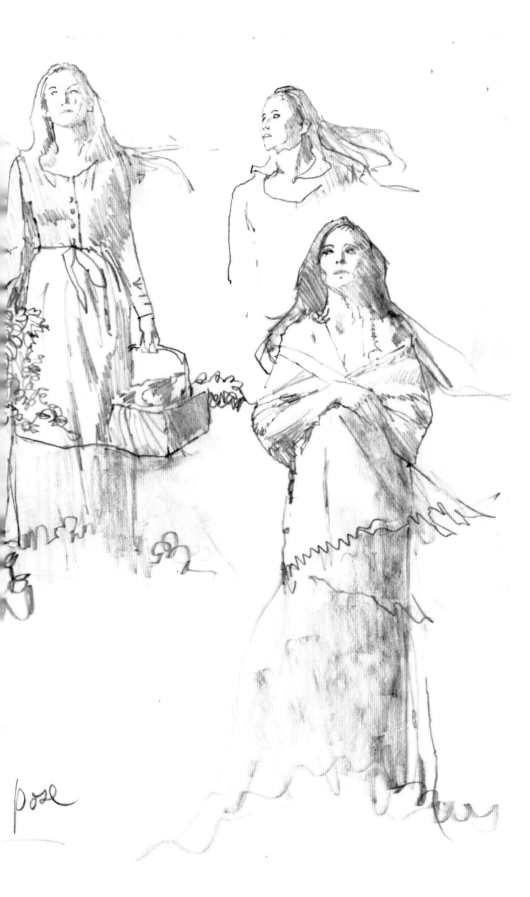

Sketches for the Conrad Richter trilogy, **The Trees, The Fields,** and **The Town.** A nostalgic softness and sweetness characterize these drawings, far different from the frank erotic appeal of the women on the private eye covers.

pose

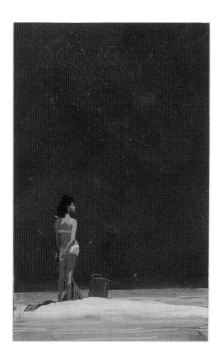

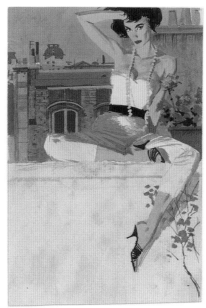

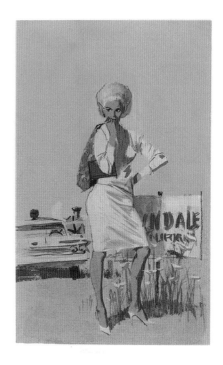

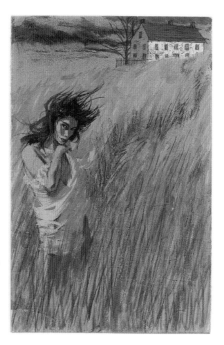

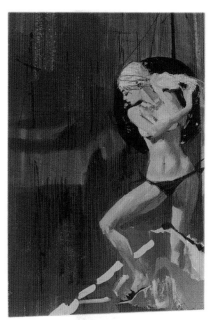

McGinnis does incredibly detailed color "comps"; they could pass muster as finished art. The comprehensives are painted same size as the books, 4" x 7". None of these were selected for covers; it's difficult to imagine an art director saying "no" to these striking images!

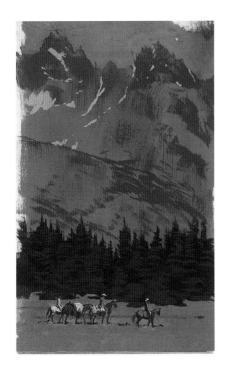
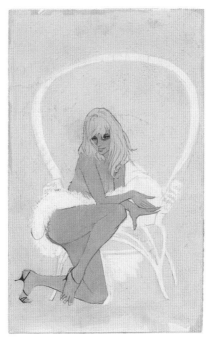
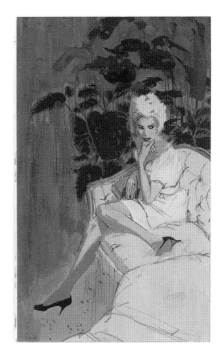
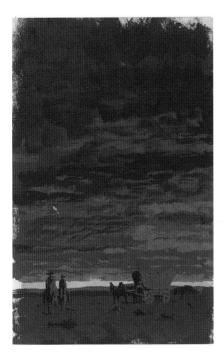
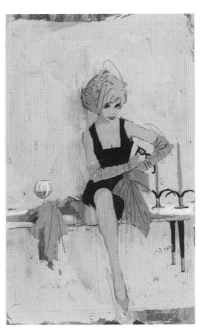
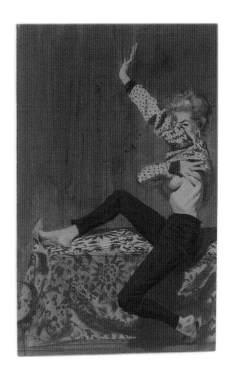

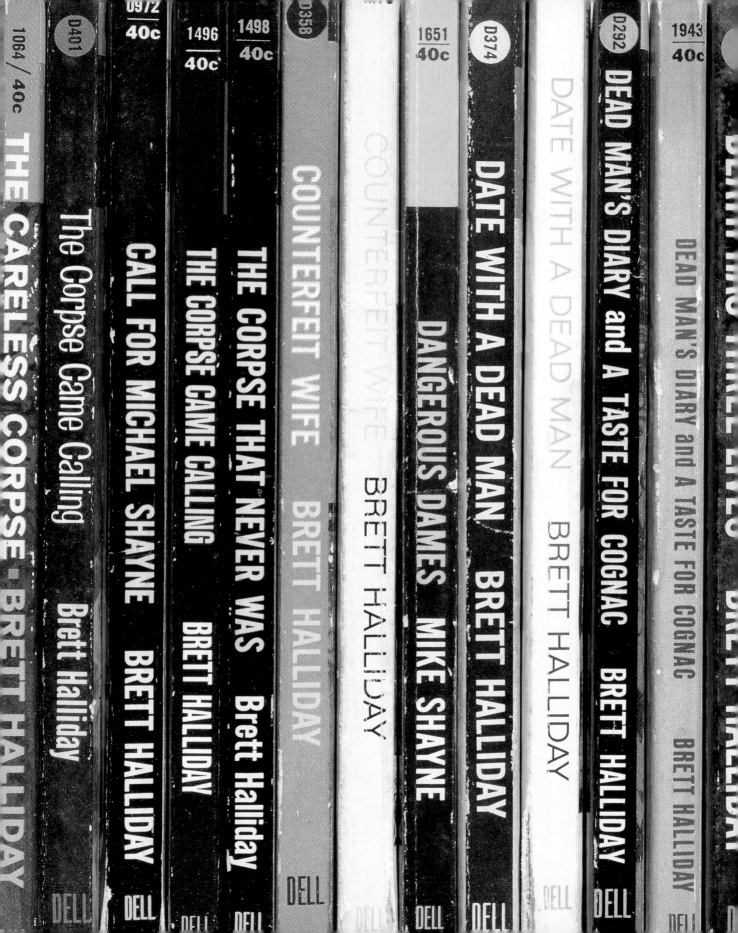

1064 / 40c

THE CARELESS CORPSE • BRETT HALLIDAY

D401

The Corpse Came Calling Brett Halliday

0972 40c

CALL FOR MICHAEL SHAYNE BRETT HALLIDAY

1496 40c

THE CORPSE CAME CALLING BRETT HALLIDAY

1498 40c

THE CORPSE THAT NEVER WAS Brett Halliday

1358

COUNTERFEIT WIFE BRETT HALLIDAY

COUNTERFEIT WIFE BRETT HALLIDAY

1651 40c

DANGEROUS DAMES MIKE SHAYNE

DATE WITH A DEAD MAN BRETT HALLIDAY

D374

DATE WITH A DEAD MAN BRETT HALLIDAY

D292

DEAD MAN'S DIARY and A TASTE FOR COGNAC BRETT HALLIDAY

1943 40c

DEAD MAN'S DIARY and A TASTE FOR COGNAC BRETT HALLIDAY

DELL
DELL
DELL
DELL
DELL
DELL
DELL
DELL
DELL
DELL

Collecting McGinnis **Art Scott**

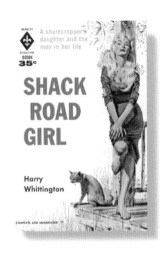

It all started with Shell Scott…and Mike Shayne, Perry Mason, Travis McGee and their brethren. I've always read a lot of crime fiction, and preferred paperback editions – they were cheap, and they had striking covers. Without setting out to do so, by the early 1970s I found myself with the nucleus of a McGinnis cover collection, simply because, in the 1960s, McGinnis was the most prominent and most prolific paperback cover artist specializing in private eye series and the like. I had known and sought out his work at least since the mid-'60s, when his incomparable *Cavalier* magazine nudes first jolted my youthful libido. So, being a compulsive collector, at some point I decided to specifically seek out all the crime and mystery paperbacks with McGinnis covers, even writers I didn't care for and wasn't likely to read.

About the same time, I became involved with a small but incredibly knowledgeable cabal of serious paperback collectors on the West coast. Two of them in particular, Bill Denholm and Lance Casebeer (The Godfather of vintage pb collecting), already serious McGinnis collectors, looked at a preliminary McGinnis checklist I had published in a fanzine. They took me aside and told me, in effect, "Collecting McGinnis's crime paperbacks is all very well, but you're only doing half the job – what about all his other stuff?" Well, I had seen his work on non-mysteries here and there, but until they gave me tours of their collections, I had no idea how much work McGinnis had done in mainstream fiction, westerns, and historical romances. I had some trepidation about having to chase books outside of my area of specialization, but I finally decided I might as well go for it – collect them all!

I knew at the outset it was going to be a large and difficult project, and I soon found out just how large and difficult. I not only had to find the books; I first had to identify which books had covers by McGinnis. Not so easy – some publishers were helpful in usually giving cover art credit, but most were not; signatures were often cropped off or obscured by typography. Worse, McGinnis worked in several styles, and by the mid-'70s had spawned several capable imitators. Ron Lesser was the most problematical, since his faux McGinnis covers were appearing in the same series as The Genuine Article – Prather, Aarons, Carter Brown, MacDonald. There was a lot of peering through magnifiers and much spirited discussion, trying to decide whether certain books were McGinnis or Lesser. And, of course, no McGinnis checklists had been published.

Nevertheless, armed with a wantlist put together by inspecting other collections, I sallied forth. In those pre-internet days, with only a handful of vintage paperback specialist dealers, there was really only one way to collect the books, and that was to make the rounds of the paperback exchanges (and thrift stores, and garage sales). Fortunately, there were a lot of them in the greater San Francisco bay area in those days, and they still stocked the older, less-than-a-dollar books on their shelves. I was out every weekend, inspecting the cover of every likely book in every store, buying books I knew were McGinnis and books I thought might be McGinnis.

When the easy books had been snared, I came to rely more and more on the network of dedicated paperback collectors, who knew how and where to find the scarcer early titles.

Harry Whittington
Shack Road Girl
Berkley D 2004

I became known as the "McGinnis nut", and other collectors would keep their eyes open for uncommon McGinnis items for me. I could generally count on somebody having a present or two for me at Tom Lesser's collectors' show in L.A. in March, or at Lance's Portland get-together in August. I still remember being floored when I first saw a copy of the gorgeous **Shack Road Girl** at Lance's. My lust for that book (never mind the girl…) became a standing joke; it was quite a while before somebody found a copy for me. Other McGinnis collectors I was corresponding with got the word about the barefoot blonde on the rickety porch and wanted one – thereafter I bought the book whenever I found it and passed copies down the line (I just bought another one a few months ago; I paid a lot more for it than I did twenty-five years ago!). As I recall, after **Shack Road Girl** had been run to ground, the next Most Wanted book was **The Love Lush**, then **Money, Marbles and Chalk**, and so on…

By the early 1980s, my collecting energies were running out of steam. I'd found nearly all of the tough books – that I knew about, at least – there were a couple of dozen "is it or isn't it?" titles that everybody had given up on ever identifying, and McGinnis had largely left crime fiction for steamy romances, as the big boom in "bodice-rippers" was well under way. While McGinnis's covers were clearly best of breed in the romance market, the books themselves had scant appeal to me, and scanning a bookstore romance cover display – all featuring bright colors, ornate gold-leaf typography, and the inevitable man and woman in a clinch – was fatiguing to the eye.

A continent away, much-needed reinforcements were entering the arena in the person of Dr. Wally Maynard, a long-time friend and neighbor of Robert McGinnis ("Bob" to Wally, and thereafter to me). In 1980 he and Bob were on vacation and visited a country store that had a lot of old paperbacks; Bob pointed out some of his covers, and Wally decided to make a project of collecting his work. When he retired in 1983, he plunged into the project with a will. It was Al Fick, a dedicated McGinnis fan, who brought us together via a letter to me in December, 1984 which said, in effect, "You've got a list, Wally's got a list (and access to McGinnis!), you should combine forces."

And so we did. The next several years saw a steady traffic of lists, letters, phone calls, cover

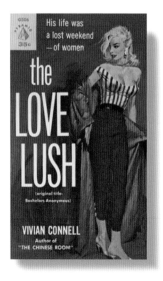

Vivian Connell
The Love Lush
Pyramid G 506

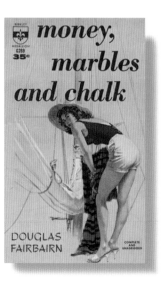

Douglas Fairbairn
Money, Marbles and Chalk
Berkley G 269

Xeroxes and paperback books (from our duplicate stacks) between Livermore, California and Greenwich, Connecticut. There was less overlap between our lists than might have been expected. Wally was meticulously going through Bob's invoices assembling a worklist (not just of paperback covers, but magazine art, movie posters, book illustration and so on), but prior to 1969 Bob's clients had been billed through an agent, whose records were unavailable. Since I had concentrated on Bob's early crime stuff, and had the connections to the collecting community, I was able to provide a long list of early titles that Wally didn't know about. On the other hand, Wally provided lists of recent and oddball covers that I had either mis-identified or never seen. Some I never would have spotted, despite my having developed a pretty good eye for McGinnis's style, because they had neither women nor men on the cover, like **This City Is Ours** or **Out of the Shadows**. Plus, of course, Wally had access to the Ultimate Authority in determining whether McGinnis had or had not painted those unsigned and uncredited covers that were in dispute. Bob was ever patient and helpful in resolving those questions.

I was re-energized, and armed with fresh lists provided by Wally, hit the bookshops again. In one letter to Wally from 1985 I bragged about having whittled a wantlist of thirty titles down to four in just two weekends of intensive booking (I shouldn't have been so puffed up; those last four probably took months – or years – to track down). Wally, meanwhile, was making the rounds of East coast bookshops with my list in hand. Having access to Bob's records did not necessarily make things dead easy; many of the working titles on his invoices were subsequently changed when the books went to press. Thus we had to track down items like "Laid Out, reclining hippie surrounded by 3 girls, Berkley"; that turned out to be **Wilbur's World of Women**.

We also came across all sorts of oddities and little mysteries: paintings that Bob had done but were (apparently) never used; or a painting that the publisher told Wally was not used but which did, eventually, turn up (**Till Morning Comes**). Then there was **Long Shot** by David Mark (Dell D300), credited on the back cover to McGinnis, but which Bob identified as by Mitchell Hooks (I suppose we should have been more skeptical of publishers' cover credits, having already seen more than a few books crediting "Maginnis" and "McGuiness").

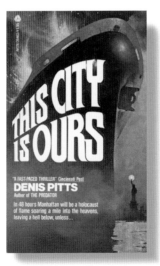

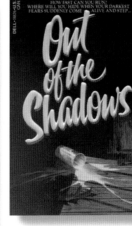

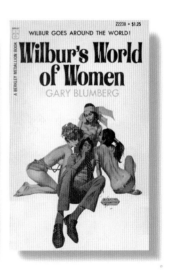

Denis Pitts
This City is Ours
Avon 36483

Duffy Stein
Out of the Shadows
Dell 16826

Gary Blumberg
Wilbur's World of Women
Berkley Z 2238

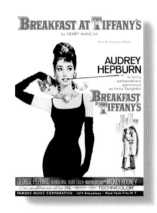

There was the Erle Stanley Gardner title (**The Case of the Ice-Cold Hands**) that neither Wally nor I spotted for the longest time because it had a gold spine, while all the rest of the thirty Perry Masons had silver spines. Sorting out the "multiple-use" covers from Popular Library (tabulated here in an appendix) was an interesting sub-project. I later discovered that, in addition to using many of Bob's paintings on two or three different book titles, the thrifty Ned Pines of Popular Publications used the illustration for **That Far Paradise** on his magazine *Ranch Romances!*

And let us not forget the "multiple-version" covers, like the four background color variants for **...And Ladies of the Club**, and the four different cover photos on **Princess Daisy** (I was sure there were only three, until I found a fourth in a thrift store just as we were preparing final copy for this book; could there be a fifth?). Another odd one was **Vice Avenged**, which Fawcett issued with two different covers – only one by Bob – as a market test. McGinnis's cover had a laughing rake with a struggling wench over his shoulder; the other was a more conventional romantic scene of the man tenderly carrying the girl. Then there was the great **Tender Is the Storm** scandal. Bob's "naked man" cover for that Johanna Lindsey title caused quite a stir in publishing circles, and apparently some distributors and retailers thought it too racy, despite a sprig of helpful foliage partially obscuring the gent's hindquarters. So copies began appearing with a butt-ugly (pardon me) gold sticker strategically slapped on the cover. I've found two different sticker variants; are there more? (Sticker or no, the book sold like crazy, started a new trend on romance covers, and got Bob named "Romance Artist of the Year" by *Romantic Times* magazine.)

There was an element of friendly rivalry and one-upsmanship as Wally and I chased down McGinnis esoterica. For instance, I laid claim to finding the first piece of sheet music with Bob's art (music from *Breakfast at Tiffany's*), and the first McGinnis fridge magnet (also *Breakfast at Tiffany's*). But Wally could always top me with a story about Bob: e.g., his coming by at Christmas and giving him a suitcase-full of old paperbacks that he'd found in the attic; or the raccoons in Bob's garage that dumped a forgotten box of color comps on the hood of his car. And so on...we had great fun. We also bought a lot of books. My collection as it stands is close to the 1,400+ total, with all the reprint

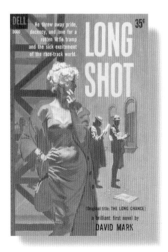

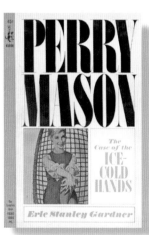

Erle Stanley Gardner
The Case of the Ice-Cold Hands
Pocket Books 45008

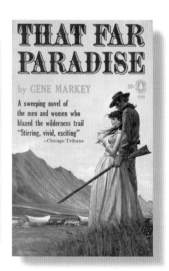

Gene Markey
That Far Paradise
Popular Library SP 96

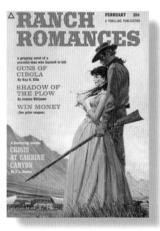

editions, but many titles were bought three or four times, as I upgraded condition. I'd guess that well over 3,000 McGinnis books have passed through my hands to date. In one respect, cover art collectors have it worse than other pb collectors; not only do we want to find the tight, white, square, uncreased and unmarked copy that everybody else wants, it must be in perfect registration as well (paperback books are, after all, a mass-produced, throw-away product).

While all this was going on, I was getting involved with the then-new personal computers; I was able to combine our lists and refine them in a database, which made the process of generating printouts and documenting new acquisitions much easier. In 1989 a preliminary version of the McGinnis List appeared in Gary Lovisi's excellent collectors' magazine, *Paperback Parade*. Unfortunately, it was marred by numerous typos and transcription errors. Wally moved from Greenwich to North Carolina, and our joint efforts went into hibernation until just recently, when, through the intercession of an enterprising and energetic McGinnis fan named Paul Langmuir, we had the opportunity to finally publish a definitive version of the McGinnis List in proper book form. Another scramble for books ensued. I hadn't been following Bob's work closely in the late '90s; so when I got Wally's list of recent books it was a replay of 1985. Well, not quite; now there's the internet. I had another list of 30-odd books to start with that I whittled down to a handful in a couple of weeks, but this time half of those books came to my mailbox via book dealers online.

Wally and I obviously expect that publication of the McGinnis cover bibliography will be a boon to those fans who have been collecting McGinnis willy-nilly, giving them a proper checklist to work from at last. We also hope that it will energize a new generation of illustration buffs and paperback collectors into embarking on The Quest. In one respect only, the internet, new McGinnis collectors will have it easier than Wally and I did. In all other respects, acquiring a substantial McGinnis collection will be a much bigger challenge. For one thing, paperback exchanges are much fewer in number than they were 15-25 years ago. For another, older paperbacks – cover price less than, say, $2 (some, remember, as much as forty years old) – have largely disappeared from the shelves of ordinary bookshops into the hands of specialty dealers (or worse, been moved to a special "Vintage" shelf, where even the

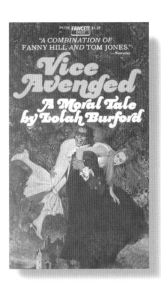
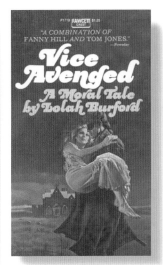
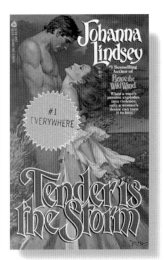
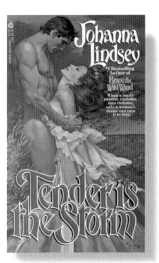

Lolah Burford
Vice Avenged
Fawcett Crest P 1719

Johanna Lindsey
Tender is the Storm
Avon 89693

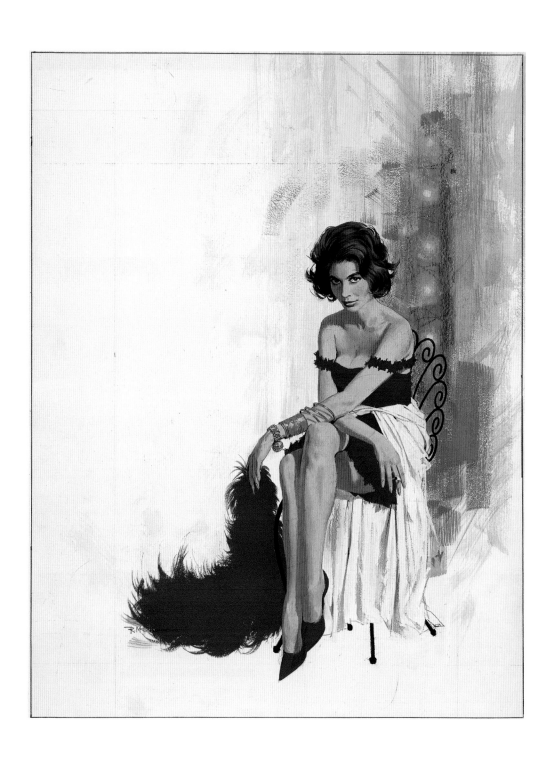

Killers From the Keys 1962, gouache on board, 11" x 15"

raggiest copy is priced as "Mint"). For yet another, strong collecting interest in "paperback originals" – true first editions – by certain writers has driven up the prices of some McGinnis titles into three figures (in good shape). The top three, in terms of price, are probably **Pop. 1280** by Jim Thompson, **Beebo Brinker** by Ann Bannon, and **The Big Bounce** by Elmore Leonard.

So, given all that, and the overarching fact that we're talking about nearly *eleven hundred* books, would you be crazy to begin building a complete McGinnis collection? Well, look at Bob's covers reproduced in this volume, just a sampling of his entire *oeuvre*: the stunning Western landscapes, the compelling images of contemporary life and love, the evocative historical tableaus; and, of course, the leggy, sophisticated, devastatingly smart and sexy McGinnis Women. You'd be crazy not to!

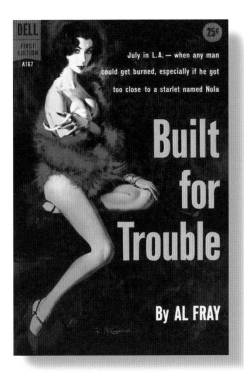

McGinnis's first two paperback covers, 1958.
He showed his work to the Dell art director,
Walter Brooks, at the urging of artist Mitchell
Hooks. Soon he was doing six books a month
for Dell: "Walter liked the way I painted
women and gave me complete freedom
of expression."

Al Fray
Built for Trouble
Dell First Edition A 167

John Creasey
So Young, So Cold, So Fair
Dell 985

Introduction

What follows is a bibliography of American paperback books with cover art by Robert McGinnis, spanning his career in the Twentieth Century, 1958 through 2000. It represents the joint work of two McGinnis fans with roughly fifty years of collecting experience between them. To our knowledge, such a comprehensive cover art bibliography has not been published in book form before (though checklists for many cover artists have appeared in the collectors' fan press). As such, we have had to invent a format, rules and nomenclature to organize the presentation of this information, some of which differ from traditional bibliographic practice. The purpose of this headnote is to explain the format of the List and point out various notations and peculiarities.

The List covers only paperback books. Though McGinnis has done some hardcover dust jacket art (and recently some publishers have adopted the practice of issuing books in simultaneous soft- and hardcover, with the same cover art on both), only paperback books are listed. Most of these books are in the standard "mass market" format, 4.25" by 7", though some early Dells and Pocket Books are in the old "short format", 4.25" x 6.375". We have included trade paperbacks and digest format paperback books as well; coding for these exceptions is explained below.

The List covers only paperback books published in the United States. McGinnis's art has been used on paperback books published all over the world, often on titles different from those in America; to compile a comprehensive listing of non-U.S. titles would be an impossible undertaking. We offer a small sampling of "International McGinnis" on pages 134-135.

The List differs from conventional bibliographies primarily in our interpretation of the concepts of edition and printing. Quite a few titles in this List – mainly by Carter Brown, Brett Halliday and John D. MacDonald – were published with more than one McGinnis cover. We consider a change in cover art to constitute a new edition; this may or may not correspond with what is stated in the printing history (if any) on the verso of the title page. Similarly, subsequent printings with the same cover art are considered to be reprints, even though some may be designated as new editions by the publishers. Also, a book may go through several printings, but if there is no change in code number or price this fact is not noted in the List.

Finally, a Disclaimer. We have made every effort to produce a complete and definitive List of Robert McGinnis's paperback work. Aided immeasurably by McGinnis's full cooperation and access to his work records, we believe we have identified every piece of paperback cover art that saw publication; but it is still possible that a book or two might have slipped through our net. Although we have identified and listed hundreds of reprint editions, it is certain that we have not found every reprint. This is particularly true in the '90s, where rapid price escalation has led to frequent reprinting to accommodate price rises. Thus if you see a book listed at an original price of $2.95, with reprints at $3.95 and $5.95, odds are there are copies out there at $4.50 or $4.95, but one has not yet found its way into our hands. We would like to think we have identified all the titles with 99% certainty, but can only claim to have identified perhaps 85 or 90 percent of the reprints.

Author

The List is organized alphabetically by author. The author's name is given exactly as his or her byline is presented on the book. A great many of the author names in this List are pseudonyms. We have not attempted to sort out pen names here; readers seeking such information are referred to standard references such as Pat Hawk's *Hawk's Authors' Pseudonyms,* or Allen J. Hubin's *Crime Fiction II, A Comprehensive Bibliography 1749-1990.* Where authors have published under multiple bylines – A.A. Fair / Erle Stanley Gardner; Ed McBain / Evan Hunter – the books are listed separately under the respective bylines.

We have had to wrestle with alphabetization of compound foreign names such as Le Comte and De Rivoyre. There seem to be no clearly codified rules here, at least not for English-speakers. In general, we followed the practice of an online library database, which, for example, places De Camp and Le Comte under "D" and "L"; but De Rivoyre and Di Lampedusa under "R" and "L". Collectors seeking books by authors with like names on bookstore shelves or online will typically find them listed under both letters in roughly equal proportion.

Title

For each author entry, titles are listed alphabetically, in boldface. There are a few exceptions to the strict alphabetization scheme, where a particular character series (Mike Shayne /Brett Halliday; Shell Scott / Richard S. Prather) is grouped separately from non-series titles. Also, the serially numbered M.E. Chaber books are presented as numbered, rather than alphabetically.

Where a particular title has been issued with two different covers by McGinnis, that title is listed twice, each cover/edition treated separately.

Immediately after the title, certain codes may appear in parentheses:

(M) - Artwork used on Multiple titles. Certain publishers, particularly Popular Library, extracted extra value from their cover art by using a particular painting on two and sometimes three different titles. For example, the same McGinnis painting was used on **Don't Crowd Me** by Hunter, **The Inn of Five Lovers** by Saint-Laurent and **The Laughing Matter** by Saroyan. These instances of multiple cover usage are cross-referenced in the table on pages 132-133.

(MTI) - Movie Tie-In. McGinnis's poster art for the film is used on the cover of the movie tie-in paperback. Only books that use poster art are marked thus. The presence of the familiar "Soon to be a Major Motion Picture!" blurb or the like is not by itself sufficient to qualify a book as a movie tie-in.

(IFC) - Inside Front Cover artwork. A few books were given deluxe treatment, where a typography-free painting was used inside the front cover, sometimes as a two page spread or foldout, often with a die cut on the outer cover providing a "peephole" to the IFC art.

(BCA) - Back Cover Art. This refers to those few books where a piece of McGinnis art-work appears on the back that is entirely different from and not contiguous with the front cover art (i.e., not a wraparound). A great many books use the front cover artwork in some fashion to add interest to the back cover – a portion of the cover art may appear on the back – cropped, blown up or shrunk, often in monochrome. Those instances are not noted; the "BCA" code is used only where new art appears on the back. In one case, Trevanian's **The Loo Sanction,** McGinnis's art appears only on the back cover.

(W) - Wraparound. Nearly 10% of the McGinnis covers are wraparounds. That is, the artwork extends in a panorama from front to back, usually across the spine as well.

Publisher

We have in general differentiated between multiple imprints of the same publishing house, where the imprints clearly maintained separate identities. Thus Dell and Dell First Edition (reprints and paperback originals), Fawcett Crest and Fawcett Gold Medal (ditto), are noted separately. The same holds for "young readers" imprints like Bantam Starfire and Dell Laurel Leaf. On the other hand, the various Popular Library designations – Popular Giant, Popular Special, Popular Eagle – are all lumped together as Popular Library.

Code & Cover Price

The code and price immediately following the publisher are those pertaining to the first edition of the title with a McGinnis cover.

There are few more tangled thickets than the number codes used by American paperback publishers. In the very beginning, most publishers used simple serial numbering: 1, 2, 3, . . . Later on, letter codes were added, sometimes as a price indicator, sometimes to designate a house imprint. In the early 1970s the International Standard Book Number (ISBN) system was introduced. Some publishers, Signet for example, continued to use their in-house numbering schemes in parallel with the ISBN, even though all books published now have an ISBN code (and a companion UPC bar code defacing the back cover!).

We have tried to reduce the code numbers to the minimum necessary to uniquely identify the particular edition/printing. Superfluous publisher codes, leading zeros and numeric price codes have been excised. Thus Popular Library 445-00131-125 is reduced to: Code 131, Price $1.25. Similarly, where the ISBN only is used by the publisher, only the third number group of the four-part ISBN is given (the first group is the country code, the second the publisher identifier, the third the title or edition identifier, the fourth the check digit).

In a small number of instances a format code is noted following the number:

(T) - Trade paperback format, typically 5.25" x 8.25".
(D) - Digest paperback format, 5.125" x 7.625".

A few books were issued only in trade format; others, mostly romances, were first issued in trade and later reprinted in standard mass market format. The digest format is unique to "Young Adult" imprints like Puffin and Bantam Skylark.

We would have liked to include Publication Date in this bibliography. While some publishers – Dell and Pocket Books, for example – were scrupulous in including such information, others, most notably Fawcett and Popular Library, were not. We lacked a publication date for nearly one-third of the books in the List. However, it is possible to fix publication date in an *approximate* fashion by reference to price. McGinnis began working in paperbacks in 1958 when the price of most paperbacks was still 25¢ – a price that had held for nearly twenty years! However, 35¢ books had started to appear at that time, and prices began the upward climb that continues to this day. The following chart provides a rough guide to publication date as a function of cover price (mass market format).

25¢	1958-1960	75¢	1970-1973	$1.95	1976-1978	$3.95 / 3.99	1983-1989
35¢	1959-1962	95¢	1972-1974	$2.25	1976-1980	$4.50	1987-1991
40 / 45¢	1962-1965	$1.25	1972-1975	$2.50	1979-1981	$4.95 / 4.99	1988-1992
50¢	1961-1968	$1.50	1973-1977	$2.75 / 2.95	1981-1987	$5.00 & up	1992-2000
60¢	1966-1970	$1.75	1975-1977	$3.50 / 3.75	1982-1988		

Reprints

Number and price codes listed in the reprint column are for subsequent printings of the same title with the same cover art, which differ in code number, price, or both. This is another thicket: some publishers carried the same code number through many editions/printings of the same book, even when the price was raised or new cover art used. On the other hand, publishers sometimes assigned a new code number to a later printing even if the cover art and price were unchanged.

The serious collector will want to own the first edition of a particular title, not only on account of primacy, but because reprint covers were very often cropped or shrunk, and crowded with additional blurb copy, "#1 Bestseller" stickers and the like. The most egregious example of this is surely **Lost Love Found** by Bertrice Small (Ballantine). The initial trade edition had an elaborate wraparound cover, the subsequent mass market edition shrunk the back cover art to a small vignette, and a later printing cropped the front cover artwork to a postage stamp-sized cameo of just the faces of the hero and heroine!

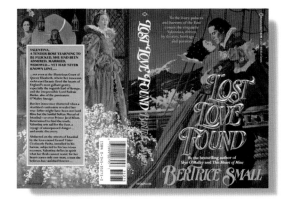
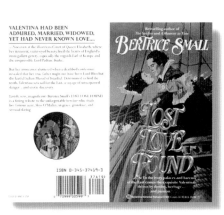

Notes on Reproduction

In reproducing the paperback covers displayed in this book we have opted for a somewhat smaller size than is usual in order to showcase as many as possible. Even so, they represent only about a quarter of McGinnis's output. If some of your favorites are missing, we apologize, but some of our favorites didn't make the cut either – there are just too many great covers and there is only so much space. Most copies we worked with were in very good condition, but where necessary we cleaned the images up digitally, removing creases, scuff marks and the like in order to display the artwork in the best possible light.

In reproducing the original art we have in some cases cropped the painting approximately as it appears on the book; in other instances, e.g., **The Private Practice of Michael Shayne,** we display the entire illustration board in order to provide a better look at the artist's method and technique.

Bertrice Small
Lost Love Found
Ballantine 35275 and 37419

The Paperback Covers

At left:
The cover art for a paperback book is submitted sans text, which is added later using overlays. The artist allows space for the typography, often according to a layout specified by the art director. This often creates illustrations that, when viewed alone, have bold and dramatic compositions.

For a detailed explanation of how this list has been constructed please refer to the "Introduction" section starting on page 28.

Author	Title	Publisher	Code	Cover Price	Reprint	
						A
Aarons, Edward S. (Assignment Series)	**Assignment – Amazon Queen**	Fawcett Gold Medal	M 2904	.95	3544	1.25
	Assignment – Bangkok	Fawcett Gold Medal	T 2559	.75		
	Assignment – Black Viking	Fawcett Gold Medal	3765	1.25	4017	1.75
	Assignment – Budapest	Fawcett Gold Medal	T 2479	.75	M 3163	.95
					3785	1.25
	Assignment – The Cairo Dancers	Fawcett Gold Medal	d 1583	.50	d 1983	.50
	Assignment – Carlotta Cortez	Fawcett Gold Medal	T 2654	.75		
	Assignment – Cong Hai Kill	Fawcett Gold Medal	d 1695	.50	R 2011	.60
					T 2408	.75
					M 2933	.95
	Assignment – The Girl in the Gondola	Fawcett Gold Medal	k 1398	.40	d 1661	.50
					R 2054	.60
					R 2506	.60
					3897	1.50
					3897	1.75
					4165	1.75
	Assignment – Karachi	Fawcett Gold Medal	M 2881	.95		
	Assignment – Lili Lamaris	Fawcett Gold Medal	T 2705	.75		
	Assignment – Lowlands	Fawcett Gold Medal	M 3207	.95		
	Assignment – Maltese Maiden	Fawcett Gold Medal	T 2635	.75	M 3198	.95
	Assignment – Mara Tirana	Fawcett Gold Medal	s 1036	.35	k 1307	.40
					k 1570	.40
					d 1920	.50
					T 2378	.75
	Assignment – Nuclear Nude	Fawcett Gold Medal	R 2000	.60	T 2293	.75
					M 2815	.95
	Assignment – Peking	Fawcett Gold Medal	R 2145	.60	T 2462	.75
	Assignment – School for Spies	Fawcett Gold Medal	d 1640	.50	R 1999	.60
					T 2353	.75
					M 3145	.95
	Assignment – Silver Scorpion	Fawcett Gold Medal	M 2735	.95	3615	1.50
					4294	1.95

Assignment – Sorrento Siren 1970, gouache on board, 11¼" x 17¼"

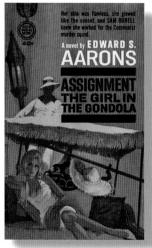
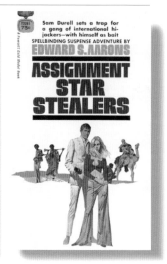

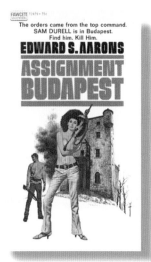
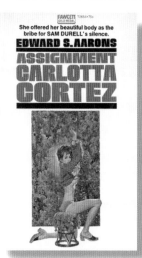
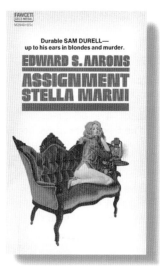
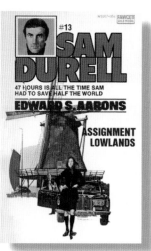

Aarons, Edward S. (continued)	Assignment – Sorrento Siren	Fawcett Gold Medal	s 1270	.35	s 1270	.40
					k 1556	.40
					d 1740	.50
					R 2254	.60
					M 2875	.95
	Assignment – Star Stealers	Fawcett Gold Medal	T 2281	.75	T 2620	.75
					T 2653	.75
	Assignment – Stella Marni	Fawcett Gold Medal	M 2949	.95		
	Assignment – Tokyo	Fawcett Gold Medal	T 2390	.75	T 2733	.75
	Assignment – Treason	Fawcett Gold Medal	d 1656	.50	d1958	.50
					T 2303	.75
					M 2917	.95
	Assignment – White Rajah	Fawcett Gold Medal	R 2202	.60	T 2391	.75
					M 2988	.95

Aarons, Edward S. (continued) (not "Assignment" Series)	**Passage to Terror**	Fawcett Gold Medal	d 1737	.50	R 2200	.60
					T 2727	.75
	State Department Murders	Fawcett Gold Medal	R 2260	.60		
	State Department Murders	Fawcett Gold Medal	T 2799	.75		
Albert, Marvin	**The Pink Panther** (MTI)	Bantam	J 2696	.40		
Aldrich, Bess Streeter	**Song of Years**	(Bison) University of Nebraska Press	5918 (T)	12.95		
Allen, Hervey	**Bedford Village**	Popular Library	361	.95		
	Toward the Morning	Popular Library	131	1.25		
Ames, Norma	**My Path Belated**	Avon	V 2367	.75		
	Whisper in the Forest	Avon	V 2409	.75		
Andersch, Alfred	**The Redhead** (M)	Popular Library	SP 169	.50		
Andrews, Felicia	**Seacliff** (W)	Charter	75640	3.50		
Ard, William	**Wanted: Danny Fontaine**	Dell	D 364	.35		
	When She Was Bad	Dell First Edition	B 145	.35		
Ashby, Kay	**Climb a Dark Cliff**	Dell	1247	.75		
Atlee, Phillip	**The Silken Baroness**	Fawcett Gold Medal	k 1489	.40		
	The Silken Baroness Contract (same art as The Silken Baroness, k 1489)	Fawcett Gold Medal	d 1702	.50	R 2108	.60
					T 2685	.75
Auchincloss, Louis	**The Embezzler**	Avon	17582	1.50		
	The Injustice Collectors	Avon	19182	1.25		
	Portrait in Brownstone	Avon	16741	1.50		
	The Rector of Justin	Avon	17483	1.25		
Auerbach, Arnold M.	**Is That Your Best Offer?**	Paperback Library	66937	1.25		

Bagby, George	**Dead Wrong**	Dell	D 392	.35	
Baird, Thomas	**Finding Out**	Avon	44248	1.95	
	Losing People	Avon	40956	1.75	
	The Old Masters	Avon	45088	2.25	
	People Who Pull You Down	Avon	39339	1.75	
	Poor Millie	Avon	46094	1.95	
	The Way to the Old Sailor's Home	Avon	39008	1.75	
Ballard, P .D.	**Age of the Junkman**	Fawcett Gold Medal	d 1352	.50	
Ballinger, Bill S.	**The Body Beautiful**	Signet	G 2428	.40	

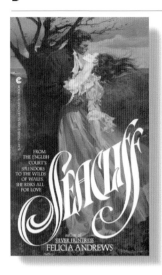
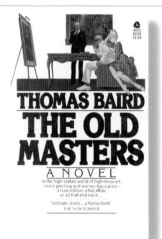
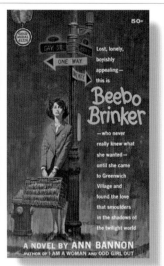
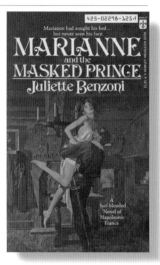

Banister, Margaret	**Burn Then, Little Lamp** (M)	Popular Library	8546	1.95		
Banko, Daniel	**Not Dead Yet**	Fawcett Gold Medal	T 2581	.75		
Banks, Raymond	**The Computer Kill**	Popular Library	EG 547	.35		
Bannon, Ann	**Beebo Brinker**	Fawcett Gold Medal	d 1224	.50		
Barnes, Margaret Campbell	**The Tudor Rose** (M)	Popular Library	1362	.75		
Basso, Hamilton	**A Touch of the Dragon** (M)	Popular Library	SP 365	.50		
	The View from Pompey's Head (M)	Popular Library	W 1149	.75	1246	.75
					321	.95
Becker, Stephen	**Shanghai Incident**	Fawcett Gold Medal	994	.25		
Bellamy, Jean	**The Prisoner of Ingecliff**	Dell	7138	.75		
Belle, Pamela	**Alethea**	Berkley	8397 (T)	6.95		
	The Chains of Fate	Berkley	7367 (T)	6.95	9218	3.95
	The Moon in the Water	Berkley	7200 (T)	6.95	8268	3.95
Bennett, Constance	**Blossom** (IFC, die-cut)	Diamond	628	4.99		
	Moonsong (IFC)	Diamond	809	4.99		
	Morning Sky	Diamond	471	4.50		
Benzoni, Juliette	**Marianne and the Masked Prince**	Berkley	2298	1.25		
Binchy, Maeve	**Firefly Summer**	Dell	2049	4.95	20419	6.99
Binder, Otto	**The Avengers Battle the Earth-Wrecker**	Bantam	F 3569	.50		

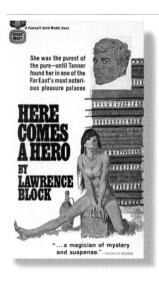 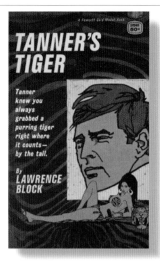 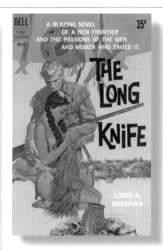 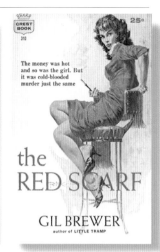

Birmingham, Stephen	**The Rest of Us**	Berkley	8074	4.50
Black, Ian Stuart	**The Passionate City**	Fawcett Crest	s 322	.35
Block, Lawrence	**Here Comes a Hero**	Fawcett Gold Medal	R 2008	.60
	Tanner's Tiger	Fawcett Gold Medal	d 1940	.50
	Tanner's Twelve Swingers	Fawcett Gold Medal	d1869	.50
	Two For Tanner	Fawcett Gold Medal	d 1896	.50
Blumberg, Gary	**Wilbur's World of Women**	Berkley	Z 2238	1.25
Bonham, Frank	**Sound of Gunfire**	Dell First Edition	A 177	.25
Bonnet, Theodore	**The Mudlark**	Popular Library	2093	.60
Borland, Barbara	**The Greater Hunger**	Popular Library	E 109	1.25
Bowden, Susan	**Homecoming**	Signet	AE 8587	4.99
Bowman, John Clarke	**Isle of Demons** (M)	Popular Library	SP 346	.50
Boyd, James	**Long Hunt**	Bantam	H3693	.60
Braine, John	**The View from Tower Hill**	Popular Library	315	.95
Bramlett, John	**Trouble – Texas Style**	Fawcett Gold Medal	k 1483	.40
Brennan, Louis A.	**The Long Knife**	Dell First Edition	B 151	.35
Brewer, Gil	**Backwoods Teaser**	Fawcett Gold Medal	950	.25
	The Red Scarf	Fawcett Crest	310	.25

Beebo Brinker 1962, gouache on board, 11¼" × 16½"

The Long Knife 1960, gouache on board, 10" × 13¾"

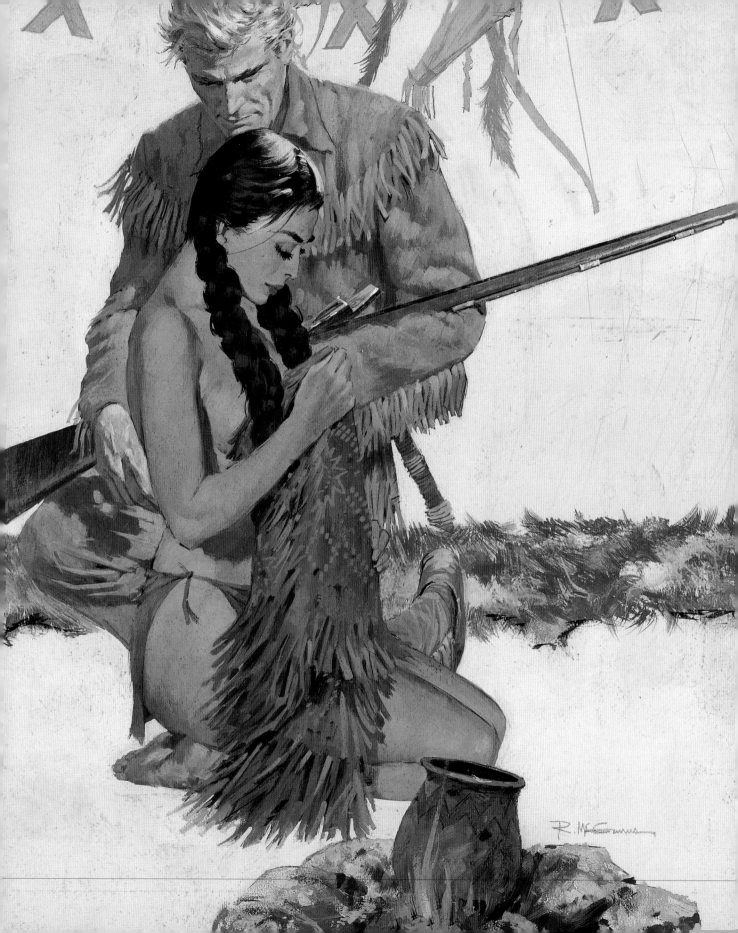

						
Brick, John	**Gettysburg**	Popular Library	G 476	.35	2365	.60
	The Raid (M)	Popular Library	249	.95		
Bright, Elizabeth	**The Virginians** (W)	Charter	86482	2.95		
Bristow, Bob	**Marked!** (BCA - pencil sketch)	Dell First Edition	B 193	.35		
Bristow, Gwen	**Celia Garth**	Popular Library	219	.95		
Brontë, Charlotte	**Shirley** (M)	Popular Library	E 37	1.25		
Brontë, Emily	**Wuthering Heights**	Bantam	21141	1.95		
Brossard, Chandler	**A Man for All Women**	Fawcett Gold Medal	d 1670	.50		
Brown, Carter	**Angel!** (M)	Signet	S 2094	.35		
	Angel!	Signet	D 3413	.50		
	The Aseptic Murders	Signet	T 4961	.75		
	The Black Lace Hangover	Signet	D 2945	.50		
	The Blonde	Signet	D 3297	.50	T 4883	.75
	Blonde on a Broomstick	Signet	D 2831	.50	T 4936	.75
	Blonde on the Rocks	Signet	G 2328	.40		
	Blonde on the Rocks	Signet	T 4682	.75		
	The Body	Signet	G 2488	.40	T 4550	.75
	The Bombshell	Signet	D 3097	.50		
	The Bombshell	Signet	T 5089	.75		
	The Brazen	Signet	P 4298	.60		
	The Bump and Grind Murders (W)	Signet	G 2541	.40		
	Burden of Guilt	Signet	P 4219	.60		
	Catch Me a Phoenix	Signet	D 2637	.50		
	(BCA same art as Blonde on the Rocks, G 2328)					
	Charlie Sent Me!	Signet	G 2394	.40	T 4775	.75
	The Coffin Bird	Signet	P 4394	.60		
	The Corpse	Signet	D 2714	.50		
	A Corpse for Christmas (W)	Signet	D 2683	.50		
	The Coven	Signet	T 4581	.75		
	The Creative Murders	Signet	T 4520	.75		
	The Dame	Signet	D 2827	.50		
	The Dance of Death	Signet	G 2425	.40		
	The Deadly Kitten	Signet	D 3345	.50		
	The Deep Cold Green	Signet	D 3623	.50		
	The Desired	Signet	D 2654	.50		
	Die Anytime, After Tuesday!	Signet	P 3903	.60	T 5175	.75
	The Dumdum Murder	Signet	S 2196	.35	D 3348	.50
	The Exotic	Signet	S 2009	.35		
	The Flagellator	Signet	D 3776	.50		
	Girl in a Shroud	Signet	G 2344	.40	P 4133	.60
	The Girl Who Was Possessed (W)	Signet	G 2291	.40	D 3472	.50
	A Good Year For Dwarfs?	Signet	P 4320	.60		
	The Guilt-Edged Cage	Signet	S 2220	.35	P 4003	.60
	Had I But Groaned	Signet	D 3380	.50		
	The Hammer of Thor	Signet	D 2794	.50		
	The Hang-Up Kid	Signet	P 4159	.60		
	The Hellcat	Signet	S 2122	.35	D 3533	.50

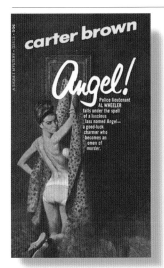
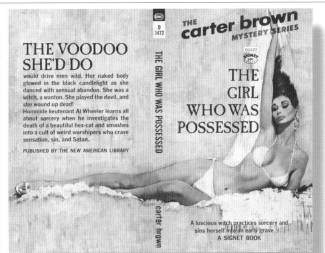
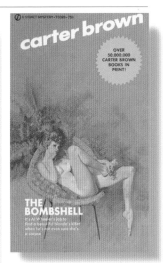

Brown, Carter (continued)						
The Hong Kong Caper	Signet	S 2180	.35	D 3151	.50	
House of Sorcery	Signet	D 3218	.50			
The Ice-Cold Nude	Signet	S 2110	.35			
The Ice-Cold Nude	Signet	P 3876	.60			
The Invisible Flamini	Signet	T 4854	.75			
The Jade-Eyed Jungle	Signet	G 2355	.40			
The Lady is Available	Signet	S 2244	.35	D 3410	.50	
The Lady is Transparent	Signet	S 2148	.35			
The Lady is Transparent	Signet	D 3251	.50	P 4344	.60	
Lament for a Lousy Lover	Signet	D 3162	.50			
Long Time No Leola	Signet	D 3190	.50			
The Lover	Signet	D 2742	.50			
Lover, Don't Come Back	Signet	S 2183	.35	P 3963	.60	
The Loving and The Dead	Signet	D 2808	.50			
The Mini-Murders	Signet	D 3585	.50			
Murder in the Family Way	Signet	T 4722	.75			
Murder in the Key Club	Signet	S 2140	.35	D 3704	.50	
Murder Is a Package Deal	Signet	G 2530	.40			
Murder Is So Nostalgic!	Signet	T 5064	.75			
Murder Is the Message	Signet	P 4105	.60			
Murder Wears a Mantilla	Signet	S 2048	.35			
A Murderer Among Us	Signet	S 2228	.35			
A Murderer Among Us	Signet	P 4081	.60			
The Never-Was Girl	Signet	G 2457	.40			
No Blonde Is an Island	Signet	D 2612	.50			
None But the Lethal Heart	Signet	D 2849	.50			
No Tears From The Widow	Signet	D 3052	.50			
Nude – With a View	Signet	D 2670	.50			
Nymph to the Slaughter	Signet	G 2312	.40			
Nymph to the Slaughter	Signet	T 4615	.75			
Only the Very Rich	Signet	P 3842	.60			
The Passionate	Signet	G 2537	.40			
The Passionate Pagan	Signet	S 2259	.35	T 4489	.75	

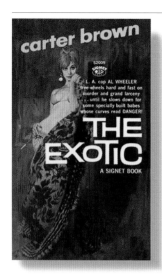

carter brown

L. A. cop AL WHEELER free-wheels hard and fast on murder and grand larceny ...until he slows down for some specially built babes whose curves read DANGER!

THE EXOTIC

A SIGNET BOOK

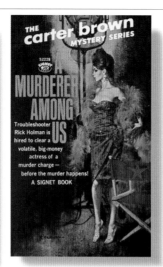

THE carter brown MYSTERY SERIES

A MURDERER AMONG US

Troubleshooter Rick Holman is hired to clear a volatile, big-money actress of a murder charge — before the murder happens!

A SIGNET BOOK

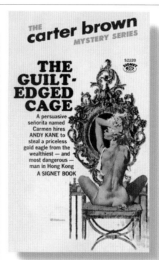

THE carter brown MYSTERY SERIES

THE GUILT-EDGED CAGE

A persuasive señorita named Carmen hires ANDY KANE to steal a priceless gold eagle from the wealthiest — and most dangerous — man in Hong Kong

A SIGNET BOOK

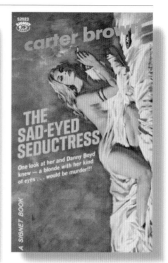

carter brown

THE SAD-EYED SEDUCTRESS

One look at her and Danny Boyd knew — a blonde with her kind of eyes . . . would be murder!!!

A SIGNET BOOK

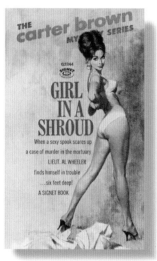

THE carter brown MYSTERY SERIES

GIRL IN A SHROUD

When a sexy spook scares up a case of murder in the mortuary LIEUT. AL WHEELER finds himself in trouble ...six feet deep!

A SIGNET BOOK

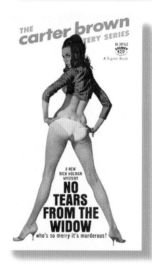

THE carter brown MYSTERY SERIES

A Signet Book

A NEW RICK HOLMAN MYSTERY

NO TEARS FROM THE WIDOW

who's so merry it's murderous!

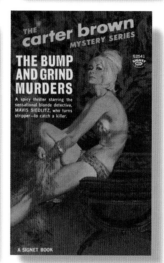

THE carter brown MYSTERY SERIES

THE BUMP AND GRIND MURDERS

A spicy thriller starring the sensational blonde detective, MAVIS SEIDLITZ, who turns stripper—to catch a killer.

A SIGNET BOOK

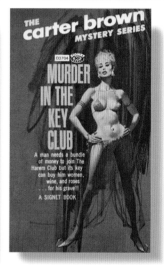

THE carter brown MYSTERY SERIES

MURDER IN THE KEY CLUB

A man needs a bundle of money to join The Harem Club but its key can buy him women, wine, and roses . . . for his grave!!

A SIGNET BOOK

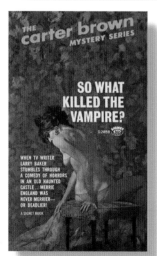

THE carter brown MYSTERY SERIES

SO WHAT KILLED THE VAMPIRE?

WHEN TV WRITER LARRY BAKER STUMBLES THROUGH A COMEDY OF HORRORS IN AN OLD HAUNTED CASTLE . . . MERRIE ENGLAND WAS NEVER MERRIER— OR DEADLIER!

A SIGNET BOOK

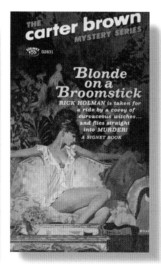

THE carter brown MYSTERY SERIES

Blonde on a Broomstick

RICK HOLMAN is taken for a ride by a covey of curvaceous witches... and flies straight into MURDER!

A SIGNET BOOK

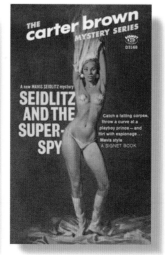

THE carter brown MYSTERY SERIES

A new MAVIS SEIDLITZ mystery

SEIDLITZ AND THE SUPER-SPY

Catch a falling corpse, throw a curve at a playboy prince — and flirt with espionage... Mavis style

A SIGNET BOOK

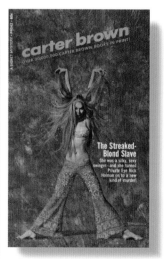

carter brown

The Streaked-Blond Slave

She was a silky, sexy swinger—and she turned Private Eye Rick Holman on to a new kind of murder!

Carter Brown, **The Unorthodox Corpse.**
The model for this stunning cover, and a great
many others, was Shere Hite. A former
Wilhelmina model, her exquisite beauty,
creativity in posing, and imaginative use of
garments and props made her a favorite
with McGinnis. Hite went on to achieve
fame as the author of *The Hite Report*
studies of American sexual mores.

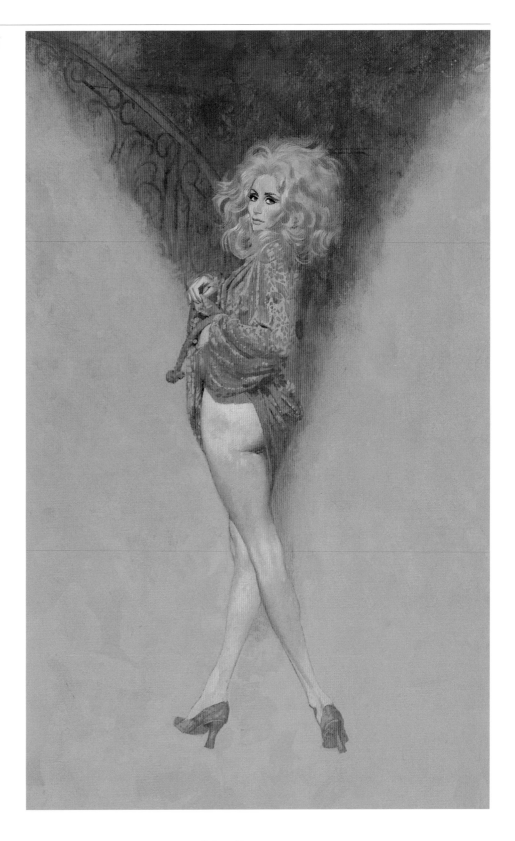

The Unorthodox Corpse 1968, gouache on board, 10³/4" × 16¹/2"

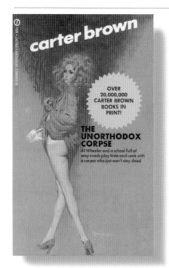

carter brown

OVER 20,000,000 CARTER BROWN BOOKS IN PRINT!

THE UNORTHODOX CORPSE
Al Wheeler and a school full of sexy coeds play hide-and-seek with a corpse who just won't stay dead!

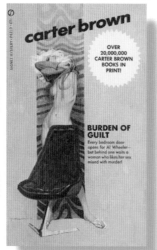

carter brown

OVER 20,000,000 CARTER BROWN BOOKS IN PRINT!

BURDEN OF GUILT
Every bedroom door opens for Al Wheeler—but behind one waits a woman who likes her sex mixed with murder!

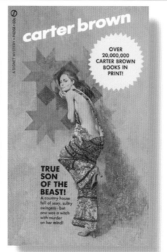

carter brown

OVER 20,000,000 CARTER BROWN BOOKS IN PRINT!

TRUE SON OF THE BEAST!
A country house full of sexy, sultry swingers - but one was a witch with murder on her mind!

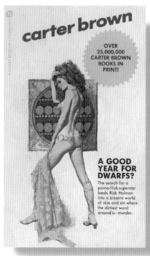

carter brown

OVER 25,000,000 CARTER BROWN BOOKS IN PRINT!

A GOOD YEAR FOR DWARFS?
The search for a porno-flick superstar leads Rick Holman into a bizarre world of skin and sin where the dirtiest word around is - murder.

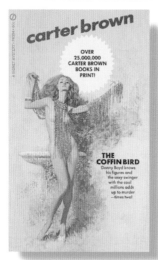

carter brown

OVER 25,000,000 CARTER BROWN BOOKS IN PRINT!

THE COFFIN BIRD
Danny Boyd knows his figures and the sexy swinger with the cool millions adds up to murder —times two!

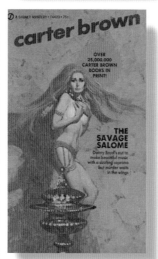

carter brown

OVER 25,000,000 CARTER BROWN BOOKS IN PRINT!

THE SAVAGE SALOME
Danny Boyd's out to make beautiful music with a sizzling soprano but murder waits in the wings.

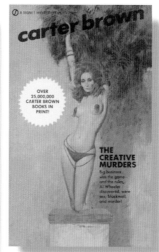

carter brown

OVER 25,000,000 CARTER BROWN BOOKS IN PRINT!

THE CREATIVE MURDERS
Big business was the game and the rules, Al Wheeler discovered, were sex, blackmail, and murder!

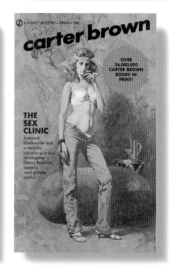

carter brown

OVER 26,000,000 CARTER BROWN BOOKS IN PRINT!

THE SEX CLINIC
A sexual blackmailer and a neurotic nympho give investigator Danny Boyd his career's most private eyeful.

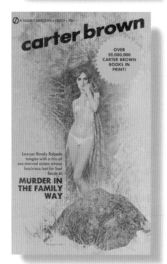

carter brown

OVER 50,000,000 CARTER BROWN BOOKS IN PRINT!

Lawyer Randy Roberts tangles with a trio of sex-starved sisters whose lascivious lust for loot leads to
MURDER IN THE FAMILY WAY

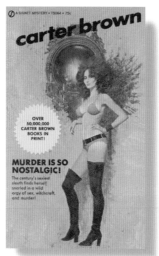

carter brown

OVER 50,000,000 CARTER BROWN BOOKS IN PRINT!

MURDER IS SO NOSTALGIC!
The century's sexiest sleuth finds herself snarled in a wild orgy of sex, witchcraft, and murder!

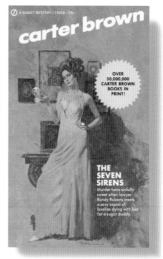

carter brown

OVER 50,000,000 CARTER BROWN BOOKS IN PRINT!

THE SEVEN SIRENS
Murder turns sinfully sweet when lawyer Randy Roberts meets a sexy septet of lovelies dying with lust for a sugar daddy.

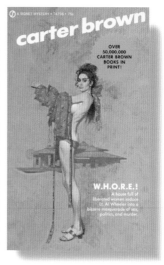

carter brown

OVER 50,000,000 CARTER BROWN BOOKS IN PRINT!

W.H.O.R.E.!
A house full of liberated women seduce Lt. Al Wheeler into a bizarre masquerade of sex, politics, and murder.

Brown, Carter (continued)	Play Now...Kill Later	Signet	D 2906	.50	T 5013	.75
	The Plush-Lined Coffin	Signet	D 3289	.50		
	The Sad-Eyed Seductress	Signet	S 2023	.35		
	(Sideways format)					
	The Sad-Eyed Seductress	Signet	P 4246	.60		
	The Savage Salome	Signet	T 4423	.75		
	The Scarlet Flush	Signet	G 2365	.40		
	Seidlitz and the Super-Spy	Signet	D 3168	.50		
	The Seven Sirens	Signet	T 4908	.75		
	The Sex Clinic	Signet	T 4658	.75		
	The Silken Nightmare	Signet	G 2400	.40		
	The Sometime Wife	Signet	D 2757	.50		
	So What Killed The Vampire?	Signet	D 2859	.50		
	The Streaked-Blond Slave	Signet	P 4042	.60		
	The Stripper	Signet	S 1981	.35		
	True Son of the Beast!	Signet	P 4268	.60		
	The Unorthodox Corpse	Signet	P 4197	.60		
	Until Temptation Do Us Part	Signet	D 3122	.50		
	The Up-Tight Blonde	Signet	P 3955	.60		
	The Velvet Vixen	Signet	G 2500	.40		
	The Victim	Signet	D 2606	.50		
	Walk Softly, Witch	Signet	G 2459	.40		
	The Wanton	Signet	D 2962	.50		
	The Wayward Wahine	Signet	D 3067	.50		
	Where Did Charity Go?	Signet	T 4455	.75		
	The White Bikini	Signet	S 2275	.35	D 3810	.50
	Who Killed Doctor Sex?	Signet	D 2581	.50		
	W.H.O.R.E.!	Signet	T 4798	.75		
	The Wind-Up Doll	Signet	G 2413	.40	T 4826	.75
	Zelda	Signet	S 2033	.35	D 3430	.50
Brown, Courtney	The Ancient Pond	Popular Library	1392	.75		
Brundy, Clyde M.	Grasslands (W)	Avon	75499	2.50		
Brunswick, James	Zubaru	Fawcett Gold Medal	R 2065	.60		
Buell, John	Four Days	Popular Library	2326	.60		
Burford, Lolah	Vice Avenged	Fawcett Crest	P 1719	1.25		
	(Issued with two different cover paintings – only one is McGinnis)					
Burgess, Alan	The Inn of the Sixth Happiness	Bantam	FP 51	.50		
Byars, Betsy	Trouble River	Puffin	4243 (D)	3.99	4243 (D)	4.99
Byrd, Elizabeth	The Famished Land (W)	Avon	39313	1.95		

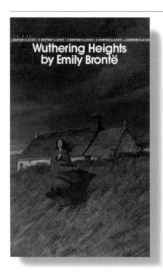

The "Milo March" series was a remarkable publishing success story. By using creative packaging – uniform design, serial numbering, and McGinnis covers – Paperback Library turned a very minor mystery series into a big seller. McGinnis had painted the actor James Coburn for movie posters and he decided to use him for the Milo March character. "Coburn was easy to draw – long and lean, ideally proportioned, with a lot of character in his face." The art director was Ed Rofhart.

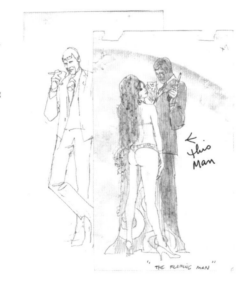

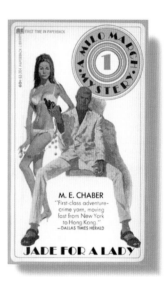

Calisher, Hortense	**The New Yorkers**	Avon	W198	1.25		
Cameron, Lou	**The Big Lonely** (M)	Popular Library	4200	1.25	4200	1.50
Capps, Benjamin	**The Brothers of Uterica** (M)	Popular Library	253	.95		
Carleton, Jetta	**The Moonflower Vine**	Bantam	24422	3.95		
Carroll, Gladys Hasty	**Christmas Without Johnny**	Popular Library	2356	.60		
	The Light Here Kindled	Popular Library	2388	.60		
Carson, Robert	**Love Affair**	Popular Library	SP 49	.50		
	My Hero	Fawcett Crest	R 509	.60		
Caspary, Vera	**Bachelor in Paradise** (MTI)	Dell First Edition	C 121	.50		
Cassill, R. V.	**Night School**	Dell First Edition	K 103	.40		
Chaber, M. E	#1 **Jade for a Lady**	Paperback Library	63-204	.60		
	#2 **A Man in the Middle**	Paperback Library	63-203	.60		
	#3 **The Day It Rained Diamonds**	Paperback Library	63-231	.60		
	#4 **The Man Inside**	Paperback Library	63-213	.60		
	#5 **Wild Midnight Falls**	Paperback Library	63-265	.60		
	#6 **Softly in the Night**	Paperback Library	63-288	.60		
	#7 **The Splintered Man**	Paperback Library	63-308	.60		
	#8 **Uneasy Lies the Dead**	Paperback Library	63-328	.60		
	#9 **The Flaming Man**	Paperback Library	63-353	.60		
	#10 **Six Who Ran**	Paperback Library	63-380	.60		
	#11 **So Dead the Rose**	Paperback Library	63-396	.60		
	#12 **A Lonely Walk**	Paperback Library	63-421	.60		
	#13 **No Grave for March**	Paperback Library	63-440	.60		
	#14 **Wanted: Dead Men**	Paperback Library	63-460	.60		
	#15 **A Hearse of Another Color**	Paperback Library	63-486	.60		
	#16 **Hangman's Harvest**	Paperback Library	63-507	.60		
	#17 **As Old as Cain**	Paperback Library	63-527	.60		
	#18 **The Gallows Garden**	Paperback Library	63-549	.60		
	#19 **Green Grow the Graves**	Paperback Library	63-568	.60		
	#20 **Abra-Cadaver**[*]	Paperback Library	64-590	.75		
	#21 **The Burned Man**[*]	Paperback Library	64-609	.75		
	#22 **Once Upon a Crime**[*]	Paperback Library	64-631	.75		
	#23 **The Lonely Graves**[*]	Paperback Library	64-654	.75		
	#24 **The Bonded Dead**	Paperback Library	64-684	.75		
	#25 **The Tortured Path**[**]	Paperback Library	64-706	.75		

[*] Written as Christopher Monig [**] Written as Kendall Foster Crossen

Chastain, Sandra	**Sweetwater**	Warner	35881	4.95		
Chopin, Kate	**The Awakening**	Avon	N 439	.95	22525	1.25
					50948	2.50
					60145	2.95
Clapp, Patricia	**Jane-Emily**	Dell Laurel Leaf	4185	.75	94185	2.25
Cleeve, Brian	**Judith**	Berkley	4168	2.25		

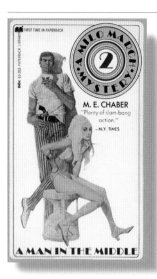

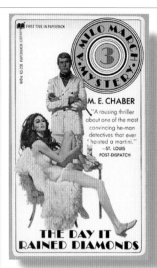

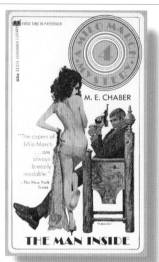

WANTED: DEAD MEN

A HEARSE OF ANOTHER COLOR

HANGMAN'S HARVEST

AS OLD AS CAIN

THE GALLOWS GARDEN

GREEN GROW THE GRAVES

ABRA-CADAVER

THE BURNED MAN

ONCE UPON A CRIME

THE LONELY GRAVES

THE BONDED DEAD

THE TORTURED PATH

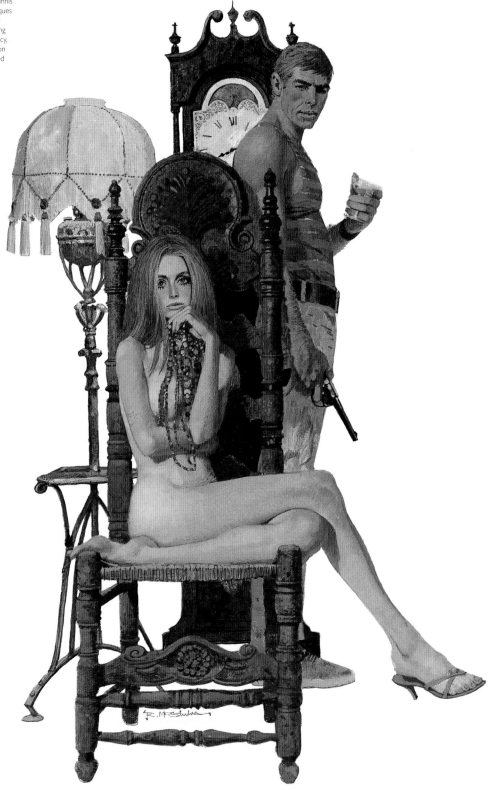

As Old As Cain 1971, gouache on board, 12¼" x 14½"

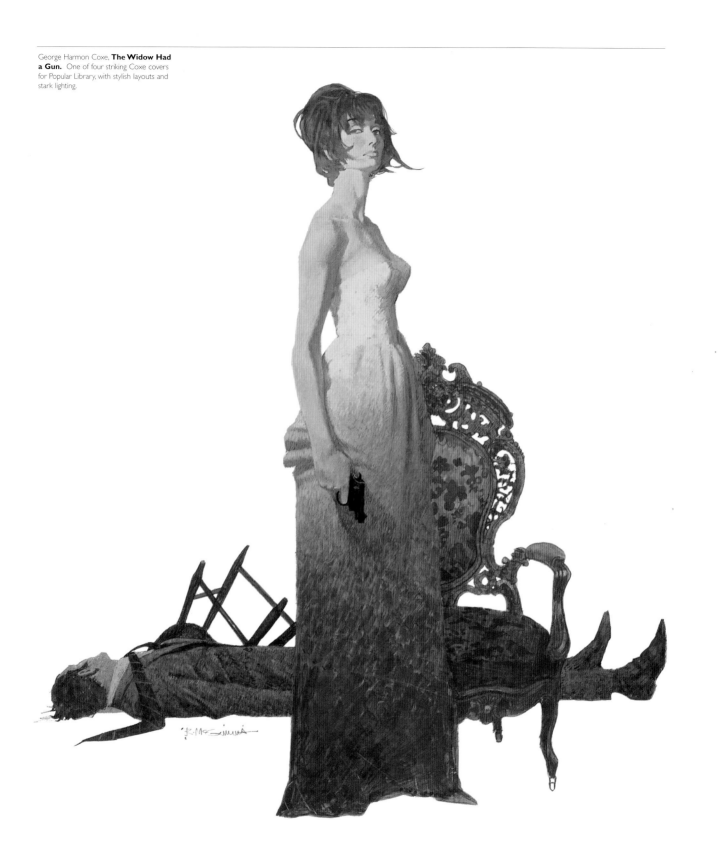

George Harmon Coxe, **The Widow Had a Gun.** One of four striking Coxe covers for Popular Library, with stylish layouts and stark lighting.

The Widow Had a Gun 1968, gouache on board, 9" x 11½"

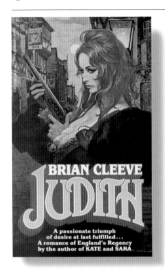
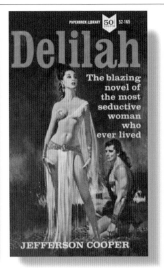
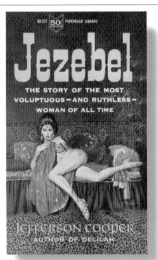
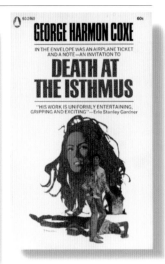

Coffman, Virginia	**The Master of Blue Mire**	Dell	5478	.75
Colby, Robert	**The Star Trap**	Fawcett Gold Medal	1043	.25
Coleman, Clayton	**Timbalier**	Dell	8908	.60
Conford, Ellen	**If This is Love, I'll Take Spaghetti**	Scholastic Point	32338	2.25
Connell, Vivian	**The Love Lush**	Pyramid	G 506	.35
Cookson, Catherine	**The Bannaman Legacy** (W)	Pocket Books	63186	4.50
	The Moth (W)	Pocket Books	64478	3.95
	The Parson's Daughter (W)	Pocket Books	64854	4.50
Cooley, Leland	**The Art Colony** (IFC - 2 pg fold-out, die-cut)	Avon	25056	1.95
Cooper, Jefferson	**Delilah**	Paperback Library	52-165	.50
	Jezebel	Paperback Library	52-237	.50
Cooper, Saul	**My Geisha** (MTI)	Dell First Edition	K 106	.40
Costello, Anthony	**Jericho**	Bantam	23291	3.95
Cotton, Ralph (W.)	**Cost of a Killing**	Pocket Books	57032	5.99
	Killers of Man	Pocket Books	57033	5.99
	Powder River	St. Martin's	95593	5.50
	Price of a Horse	St. Martin's	95793	5.99
	While Angels Dance	St. Martin's	95461	5.50
Courtier, S.H.	**Murder's Burning**	Popular Library	2512	.60
Coward, Noel	**Pomp and Circumstance** (W)	Dell	S 37	.60

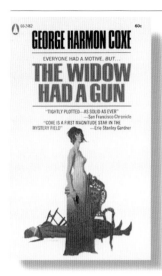

Cox, William R.	**Death Comes Early**	Dell First Edition	B 191	.35		
Coxe, George Harmon	**Death at the Isthmus**	Popular Library	2460	.60		
	Suddenly A Widow	Popular Library	2461	.60		
	Uninvited Guest	Popular Library	2459	.60		
	The Widow Had a Gun	Popular Library	2462	.60		
Craig, Jonathan	**Case of the Brazen Beauty**	Fawcett Gold Medal	d 1706	.50		
Craig, Mary Shura	**Lyon's Pride**	Jove	5295	3.50		
	Pirate's Landing	Jove	5296	3.50		
Crawford, Claudia	**Bliss**	Signet	AE 7937	5.50		
Creasey, John	**So Young, So Cold, So Fair** (First cover, one of two)	Dell	985	.25		
Crichton, Michael	**Congo** (IFC, die-cut)	Avon	56176	2.95		
Crossen, Kendall Foster (See Chaber, M.E.)						
Culp, John H.	**A Whistle in the Wind** (M)	Popular Library	1367	.75		
Cunningham, E.V.	**Sylvia**	Fawcett Crest	d 477	.50		
Cushman, Dan	**The Half-Caste**	Dell First Edition	A 202	.25		
	The Long Riders	Fawcett Gold Medal	d 1773	.50	R 2300	.60
					M 2968	.95
	Opium Flower	Bantam	J 2553	.40		

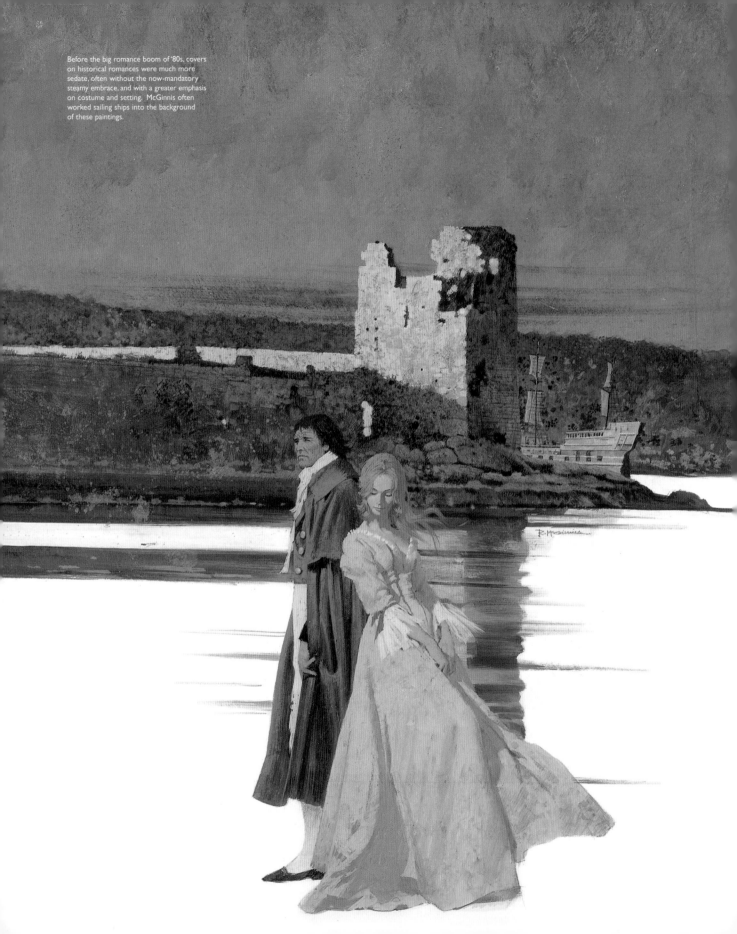

Before the big romance boom of '80s, covers on historical romances were much more sedate, often without the now-mandatory steamy embrace, and with a greater emphasis on costume and setting. McGinnis often worked sailing ships into the background of these paintings.

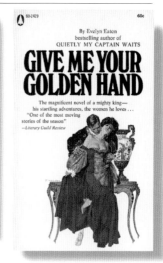

Dark, James	**Operation Octopus** (M)	Signet	P 3303	.60
Davenport, Marcia	**Of Lena Geyer** (M)	Popular Library	E 100	1.25
Davis, Gordon	**House Dick**	Fawcett Gold Medal	s 1103	.35
	Ring Around Rosy	Fawcett Gold Medal	k 1380	.40
Davis, Kathryn	**Memories and Ashes** (W)	Jove	8325	3.95
Davis, Melton S.	**The Voluptuaries**	Avon	S 219	.60
	The Voluptuaries	Avon	N 403	.95
Day, Dianne	**The Stone House**	Pocket Books	63991	3.95
De Camp, L. Sprague	**The Bronze God of Rhodes**	Bantam	H 2589	.60
Defoe, Daniel	**Roxana**	Popular Library	SP 139	.50
de Mare, George	**The Ruling Passion**	Fawcett Crest	s 343	.35
DiBenedetto, Theresa	**Wildflower**	Pageant	1004	3.95
Dietrich, Robert	**Angel Eyes**	Dell First Edition	B 203	.35
	The House on Q Street	Dell First Edition	A 175	.25
	Mistress to Murder	Dell First Edition	B 162	.35
	Murder on Her Mind	Dell First Edition	B 163	.35
Dipper, Alan	**The Wave Hangs Dark**	Popular Library	2534	.60
Dodge, David	**Angel's Ransom**	Dell	D 304	.35
Douglas, Lloyd C.	**Invitation to Live**	Popular Library	2280	.60

Pawn in Frankincense 1970, gouache on board, 16" x 17"

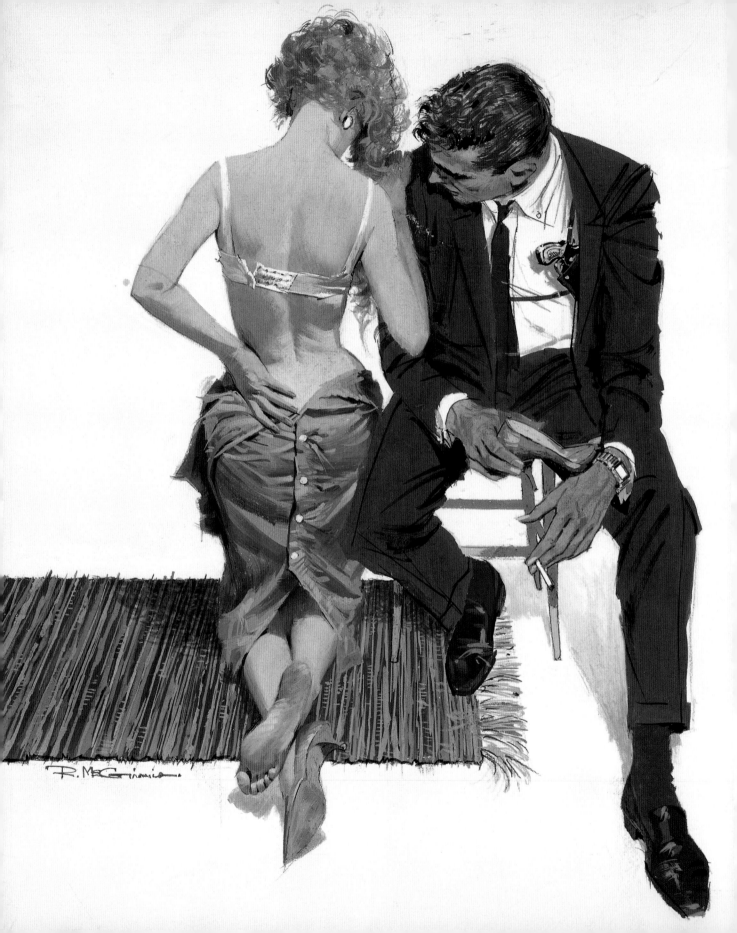

Drought, James	**A Duo**	Fawcett Crest	R 928	.60			
Dumas, Alexandre	**The Lady of the Camellias** (M)	Popular Library	SP 150	.50			
Dunnett, Dorothy	**Checkmate** (M)	Popular Library	8483	1.95			
	The Disorderly Knights	Popular Library	166	.95	8333	1.25	
	The Game of Kings	Popular Library	E 105	.95	E 84	1.25	
					8571	1.95	
					8571	2.50	
	Pawn in Frankincense	Popular Library	E 86	1.25	8472	1.95	
	Queens' Play	Popular Library	E 125	.95	8334	1.25	
					8496	1.95	
					8571	2.50	
	The Ringed Castle	Popular Library	154	1.25	8495	1.25	

East, Michael	**The Concubine**	Dell First Edition	A 169	.25	A 169	.35
Eaton, Evelyn	**Give Me Your Golden Hand** (M)	Popular Library	2429	.60		
Eckert, Allan W.	**Incident at Hawk's Hill**	Bantam Starfire	26696	2.95	26696	3.99
Eden, Dorothy	**The American Heiress** (IFC, 2 pg spread)	Fawcett Crest	4448	2.95		
	The Vines of Yarrabee	Fawcett Crest	M 1365	.95	M 1679	.95
					P 1922	1.25
					Q 2212	1.50
					3184	1.95

The Eighth Circle 1959, gouache on board, 10" x 12"

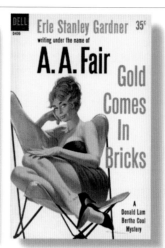

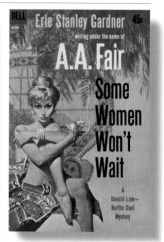

Eye contact is the key element of this striking cover, as it is in many of McGinnis's most beguiling portraits of women.

Some Women Won't Wait 1960, gouache on board, 8½" × 13"

Edwards, Jaroldeen	**Harvest of Dreams**	Onyx	JE 474	4.99		
Edwards, Samuel	**Master of Castile**	Curtis	9113	.95		
Ehrlich, Jack	**The Girl Cage**	Dell	2887	.50		
	Revenge	Dell First Edition	A168	.25		
Eidelberg, Ludwig	**Take Off Your Mask**	Pyramid	G 404	.35		
Ellin, Stanley	**The Eighth Circle**	Dell	D311	.35		
Ellis, Audrey	**Pearls Are for Tears**	Jove	8833	3.95		
Ellis, Julie	**The Jeweled Dagger**	Dell	4217	.75		
Erdman, Loula Grace	**The Years of the Locust**	Popular Library	2211	.60		
Estern, Anne Graham	**Letters from Philippa**	Bantam Skylark	15941 (D)	3.50		
Evarts, Hal G.	**The Long Rope**	Dell First Edition	A 172	.25		
	The Silver Concubine	Dell First Edition	7912	.40		
	The Turncoat	Fawcett Gold Medal	1045	.25		
Evslin, Bernard	**Merchants of Venus** (W)	Fawcett Gold Medal	d 1395	.50		

Fair, A.A.	**Bats Fly at Dusk**	Dell	D348	.35		
	Cats Prowl at Night	Dell	D 431	.35	1152	.45
	Crows Can't Count	Dell	D 373	.35	1625	.45
	Double or Quits	Dell	D 361	.35		
	Fools Die on Friday	Dell	R 105	.40	2670	.45
					6792	.45
	Gold Comes in Bricks	Dell	D 406	.35	2952	.45
	Some Women Won't Wait	Dell	D 372	.35	8104	.45
	Top of the Heap	Dell	D 309	.35		
	Top of the Heap	Dell	D 8960	.40		
Fairbairn, Douglas	**Money, Marbles and Chalk**	Berkley	G 269	.35		
Fickling, G.G.	**Girl on the Prowl**	Pyramid	G 453	.35		
Fifield, William	**The Devil's Marchioness**	Avon	W 304	1.25		
Fleischman, A.S.	**The Venetian Blonde**	Fawcett Gold Medal	k 1367	.40		
Fleming, Ian	**Diamonds Are Forever** (MTI)	Bantam	N 6997	.95		
	Live and Let Die (MTI)	Bantam	Q 5890	1.25		
	Thunderball (MTI)	Signet	P 2734	.60	T 5569	.75
Foley, Rae	**No Tears for the Dead**	Dell	6494	1.25		

A winsome blonde on an unusual cover; McGinnis rarely painted fully detailed backgrounds but he does so here. Of the varied compositions that he sketched, his favorite was the one with the jukebox (middle right), but the one in the middle left was chosen, probably to best illustrate the pun title. The model was another McGinnis favorite, Lisa Karan: "A great model – very cooperative, patient, no inhibitions."

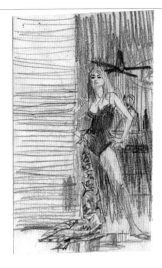
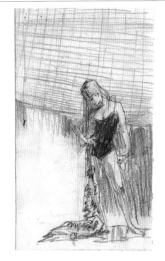

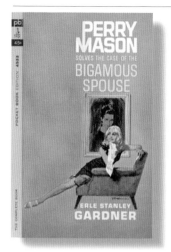
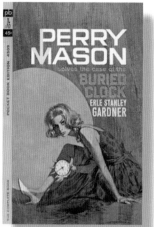
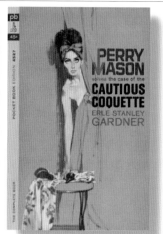
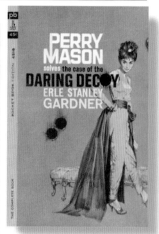

Forrest, Wilma	**Shadow Mansion**	Fawcett Gold Medal	T 2125	.75	M 2863	.95
Foster, Richard	**The Girl from Easy Street**	Popular Library	EG 479	.35		
Fox, Gardner F.	**One Wife's Ways**	Fawcett Gold Medal	s 1260	.35		
Franchere, Ruth	**Hannah Herself**	Avon	33050	1.25		
Francis, Jean	**Coming Again**	Berkley	Z 2189	1.25		
Fray, Al	**Built for Trouble** (First cover, one of two)	Dell First Edition	A 167	.25		
Frey, Ruby Frazier	**Red Morning** (M)	Popular Library	8550	1.95		
Fuller, Edmund	**The Corridor**	Bantam	H 2870	.60		

Gainham, Sarah	**Takeover Bid**	Popular Library	408	.95		
Gardner, Erle Stanley	**The Case of the...**					
	Bigamous Spouse	Pocket Books	4522	.45		
	Black-Eyed Blonde	Pocket Books	4502	.45		
	Blonde Bonanza	Pocket Books	4530	.45		
	Buried Clock	Pocket Books	4509	.45		
	Calendar Girl	Pocket Books	6040	.35	4529	.45
	Caretaker's Cat	Pocket Books	4508	.45		
	Cautious Coquette	Pocket Books	4527	.45		
	Daring Decoy	Pocket Books	6001	.35	4518	.45

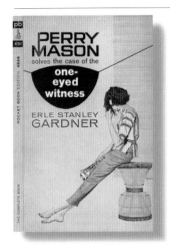 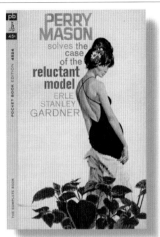 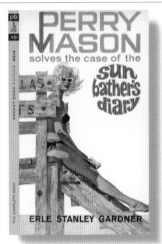 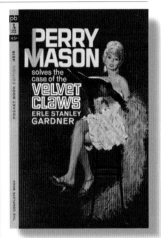

Gardner, Erle Stanley (continued)	**The Case of the...**					
	Deadly Toy	Pocket Books	4531	.45		
	Demure Defendant	Pocket Books	4520	.45		
	Duplicate Daughter	Pocket Books	4504	.45		
	Glamorous Ghost	Pocket Books	4511	.45		
	Golddigger's Purse	Pocket Books	4505	.45		
	Half-Wakened Wife	Pocket Books	6221	.35	4525	.45
	Haunted Husband	Pocket Books	4512	.45		
	Hesitant Hostess	Pocket Books	4528	.45		
	Ice-Cold Hands	Pocket Books	45008	.45		
	Long-Legged Models	Pocket Books	45005	.45		
	Lucky Loser	Pocket Books	4521	.45		
	Moth-Eaten Mink	Pocket Books	4510	.45		
	One-Eyed Witness	Pocket Books	4526	.45		
	Reluctant Model	Pocket Books	6220	.35	4524	.45
	Runaway Corpse	Pocket Books	4519	.45		
	Screaming Woman	Pocket Books	6198	.35	4523	.45
	Shapely Shadow	Pocket Books	4507	.45		
	Silent Partner	Pocket Books	4506	.45		
	Spurious Spinster	Pocket Books	4515	.45		
	Sulky Girl	Pocket Books	4513	.45		
	Sun-Bather's Diary	Pocket Books	4514	.45		
	Velvet Claws	Pocket Books	4516	.45		
Garnett, David	**The Ways of Desire** (M)	Popular Library	EG 435	.35		
Gault, Bill	**Death Out of Focus**	Dell	1012	.25		
Gebler, Ernest	**Hoffman** (M)	Popular Library	G 449	.35	1435	.75
Godden, Rumer	**China Court**	Dell	1250	.60		

Godwin, Gail	**Glass People**	Warner	92-089	2.25		
	The Odd Woman	Warner	91-215	2.50		
Goldreich, Gloria	**West to Eden**	Avon	70601	4.95		
Golightly, Bonnie	**The Wild One**	Avon	F 198	.40		
Goodman, Aubrey	**The Golden Youth of Lee Prince**	Fawcett Crest	R 530	.60		
Goodman, George	**The Wheeler Dealers** (MTI)	Bantam	F 2707	.50		
Goudge, Eileen	**Trail of Secrets**	Signet	AE 8774	6.99	18774	7.50
Goudge, Elizabeth	**Gentian Hill**	Popular Library	328	.95	191	.95
	The Middle Window	Popular Library	1257	.75	335	.95
	The White Witch	Popular Library	167	.95		
Gower, Iris	**Beloved Captive**	Charter	5321	2.95		
Graham, Alice Walworth	**The Vows of the Peacock** (M)	Popular Library	M 2033	.60		
Graham, John Alexander	**Arthur**	Popular Library	1381	.75		
Graham, Winston	**After the Act**	Fawcett Crest	R 1087	.60		
Granbeck, Marilyn	**Maura** (W)	Jove	K 4626	2.50		
Green, Edith Pinero	**Providence** (W)	Bantam	20404	2.95		
Griffin, Gwyn	**Master of This Vessel**	Avon	V 2053	.75		
Gulick, Bill	**They Came to a Valley** (M)	Popular Library	173	.95	274	1.25

The Young Lovers 1960, gouache on board, 8 3/4" x 12 1/2"

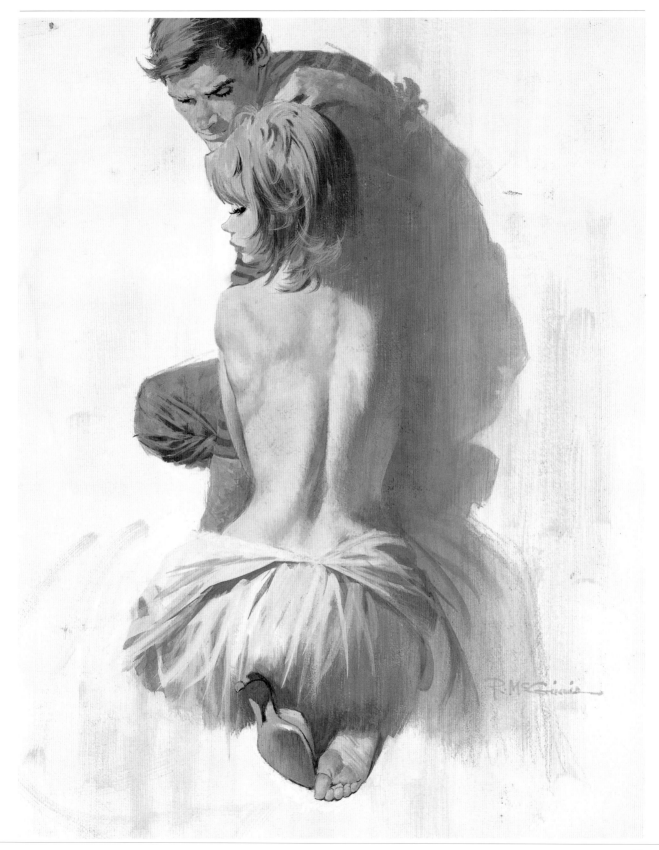

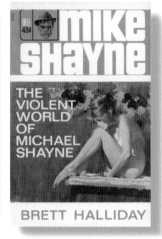

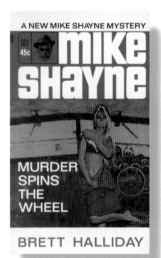
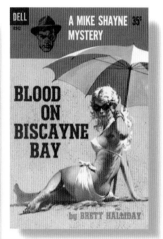
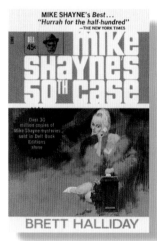
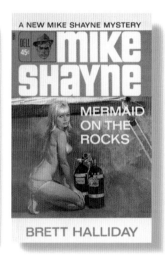

Hagan, Patricia	**Love and Dreams** (W)	Avon	75159	3.95		
	Love and Fury (W)	Avon	89614	3.95		
	Love and Glory (W)	Avon	79665	3.50	47667	3.95
	Love and Honor (W)	Avon	75557	3.95		
	Love and Splendor (W)	Avon	75158	3.95		
	Love and Triumph	Avon	75558	4.95		
	Love and War (W)	Avon	37960	2.25	47704	2.50
					80044	3.50
	Passion's Fury	Avon	77727	2.95		
	The Raging Hearts (W)	Avon	46201	2.75		
Hahn, Emily	**Purple Passage**	Curtis	7026	.75		
Hale, Katherine	**Affinity** (W)	Avon	40907	1.95		

Hale, Leon	**Bonney's Place**	Popular Library	466	.95
Halevy, Julian	**The Young Lovers**	Dell	F 114	.50

Halliday, Brett	**Armed...Dangerous...**	Dell	299	.45
(Michael Shayne Series)	**The Blonde Cried Murder**	Dell	614	.40
	Blood on Biscayne Bay	Dell	D 342	.35
	Blood on Biscayne Bay	Dell	618	.45
	Blood on the Stars	Dell	626	.40
	Blood on the Stars	Dell	626	.45
	Bodies are Where You Find Them	Dell	D 327	.35
	Bodies are Where You Find Them	Dell	668	.45
	The Body Came Back	Dell	672	.40
	Call for Michael Shayne	Dell	D 269	.35
	Call for Michael Shayne	Dell	972	.40
	The Careless Corpse	Dell	1064	.40
	The Corpse Came Calling	Dell	D 401	.35
	The Corpse Came Calling	Dell	1496	.40
	The Corpse that Never Was	Dell	1498	.40
	Counterfeit Wife	Dell	D 358	.35
	Counterfeit Wife	Dell	1528	.45
	Date With a Dead Man	Dell	D 374	.35
	Date With a Dead Man	Dell	1664	.45
	Dead Man's Diary and A Taste for Cognac	Dell	D 292	.35
	Dead Man's Diary and A Taste for Cognac	Dell	1943	.40
	Death Has Three Lives	Dell	D 423	.35
	Die Like a Dog	Dell	D 391	.35
	Die Like a Dog	Dell	1930	.45
	Dividend on Death	Dell	D 293	.35
	Dolls are Deadly	Dell	D 424	.35
	Fit to Kill	Dell	D 314	.35
	Fit to Kill	Dell	2562	.45
	Framed in Blood	Dell	2714	.40
	Framed in Blood	Dell	2714	.45
	Guilty as Hell	Dell	3291	.50
	Heads You Lose	Dell	3515	.40
	The Homicidal Virgin	Dell	D 437	.50
	The Homicidal Virgin (M)	Dell	3698	.50
	In a Deadly Vein	Dell	4016	.40
	In a Deadly Vein	Dell	4016	.50
	Killers from the Keys	Dell	4476	.40
	Marked for Murder	Dell	D 291	.35
	Marked for Murder	Dell	5386	.40
	Marked for Murder (M)	Dell	5386	.50
	Mermaid on the Rocks	Dell	5581	.45
	Michael Shayne's Long Chance	Dell	D 416	.35
	Michael Shayne's Long Chance	Dell	5602	.45
	Mike Shayne's 50th Case	Dell	5603	.45
	Murder and the Married Virgin	Dell	5932	.40
	Murder and the Wanton Bride	Dell	D 283	.35
	Murder and the Wanton Bride	Dell	5934	.45
	Murder by Proxy	Dell	5949	.40

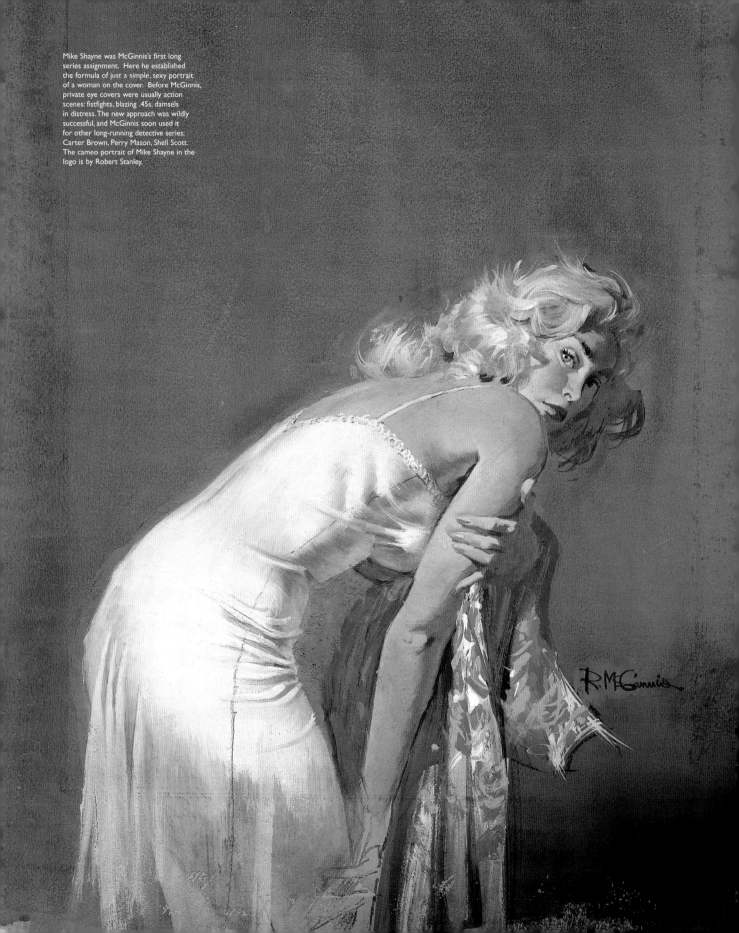

Mike Shayne was McGinnis's first long series assignment. Here he established the formula of just a simple, sexy portrait of a woman on the cover. Before McGinnis, private eye covers were usually action scenes: fistfights, blazing .45s, damsels in distress. The new approach was wildly successful, and McGinnis soon used it for other long-running detective series: Carter Brown, Perry Mason, Shell Scott. The cameo portrait of Mike Shayne in the logo is by Robert Stanley.

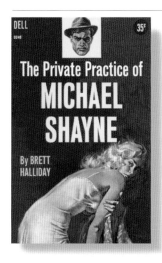

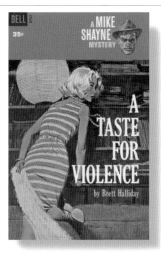

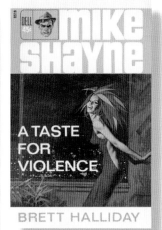

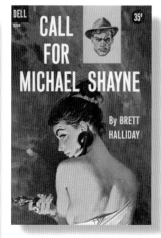

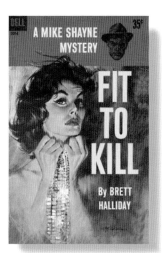

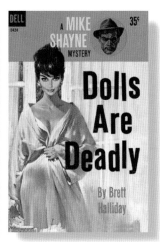

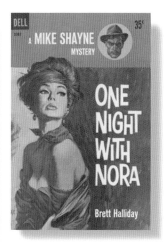

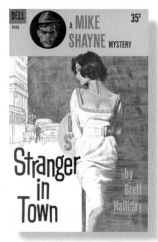

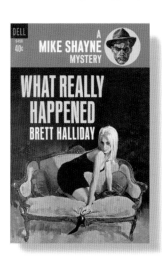

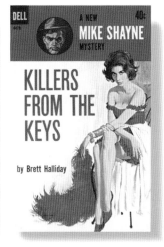

The Private Practice of Michael Shayne 1958, gouache on board, 10¾" x 17¾"

Halliday, Brett (continued) (Michael Shayne)	**Murder in Haste**	Dell	5970	.40
	Murder is My Business	Dell	6052	.40
	Murder Spins the Wheel	Dell	6123	.45
	Murder Takes No Holiday	Dell	D 379	.35
	Murder Takes No Holiday	Dell	6126	.45
	Never Kill a Client	Dell	6300	.40
	Nice Fillies Finish Last	Dell	6361	.45
	One Night With Nora	Dell	D 387	.35
	Pay-off in Blood	Dell	6858	.40
	The Private Practice of Michael Shayne	Dell	D 248	.35
	The Private Practice of Michael Shayne	Dell	7142	.45
	A Redhead for Michael Shayne	Dell	7329	.40
	She Woke to Darkness	Dell	D 446	.35
	Shoot the Works	Dell	7844	.45
	Shoot to Kill	Dell	7843	.45
	So Lush, So Deadly	Dell	8055	.50
	Stranger in Town	Dell	D 425	.35
	Target: Mike Shayne	Dell	D 355	.35
	Target: Mike Shayne	Dell	8492	.45
	A Taste for Violence	Dell	D 463	.35
	A Taste for Violence	Dell	8518	.45
	This is It, Michael Shayne	Dell	8794	.40
	This is It, Michael Shayne	Dell	8794	.50
	Tickets for Death	Dell	8884	.45
	Too Friendly, Too Dead	Dell	8949	.45
	The Uncomplaining Corpses	Dell	9216	.40
	Violence is Golden	Dell	9316	.50
	The Violent World of Michael Shayne	Dell	9334	.45
	Weep for a Blonde	Dell	9445	.40
	What Really Happened	Dell	D 381	.35
	What Really Happened	Dell	9458	.40
	When Dorinda Dances	Dell	D 359	.35
	When Dorinda Dances	Dell	9462	.40
Halliday, Bret (not Michael Shayne)	**Dangerous Dames** (Short Stories edited by "Mike Shayne")	Dell	1651	.40
	Mike Shayne's Torrid Twelve (Short Stories edited by Leo Margulies)	Dell First Edition	K 109	.40
	Mum's the Word for Murder	Dell	5918	.40
	Murder in Miami (Short Story Collection edited by "Mike Shayne")	Dell	D 331	.35
	Best Detective Stories 16th Annual	Dell	541	.50
	Best Detective Stories 17th Annual	Dell	542	.50
Ham, Jr., Roswell G.	**A Peak in Darien**	Avon	G 1082	.50
Hardwick, Michael & Mollie	**The Private Life of Sherlock Holmes** (MTI)	Bantam	S 5877	.75

Hardy, Thomas	**A Pair of Blue Eyes** (M)	Popular Library	1203	.75		
Harris, Elizabeth	**The Herb Gatherers**	Avon	76823	4.99		
Harris, Marilyn	**American Eden** (IFC, 2pg spread)	St. Martin's	91001	4.50		
Harris, Ruth	**The Fun City Girls**	Dell	2764	1.25		
Harrison, Barbara	**The Pagans**	Avon	W 228	1.25		
Hatch, Eric	**The Horse in the Gray Flannel Suit** (MTI)	Dell Laurel Leaf	3727	.50		
Heatter, Basil	**Harry and the Bikini Bandits** **Virgin Cay** (W)	Fawcett Gold Medal Fawcett Gold Medal	T 2372 k 1310	.75 .40		
Heiman, Judith	**The Young Marrieds**	Fawcett Crest	d 562	.50	d 797	.50
Hill, Pamela	**Norah**	Fawcett Crest	3482	1.95		
Hilton, James	**Goodbye, Mr. Chips**	Bantam Starfire	25613	2.75	27321 27321	2.95 3.99
Himes, Chester	**Cotton Comes to Harlem** (MTI)	Dell	1513	.75		
Hine, Al	**Signs and Portents**	Avon	14845	1.25		
Hobbs, Will	**Downriver** **River Thunder**	Bantam Starfire Laurel Leaf Laurel Leaf	29717 22673 22681	3.50 5.50 4.50	22681	4.99
Hodge, Jane Aiken	**The Master of Penrose**	Dell	5481	.75		

Hoffman, Alice	**White Horses** (W)	Berkley	6325	3.50		
Honig, Donald	**The Americans**	Popular Library	PC 1006	.35	SP 279	.50
Horton, Patricia Campbell	**Royal Mistress**	Avon	33886	1.95		
Howe, Fanny	**The Blue Hills**	Avon	78998	1.95		
Howe, Helen	**The Success**	Popular Library	1230	.75		
Huggins, Roy	**77 Sunset Strip** (BCA, 3 cameos)	Dell First Edition	A 176	.25		
Hume, Doris	**The Sin of Susan Slade**	Dell First Edition	K 104	.40		
Hunt, Kyle	**Kill My Love**	Fawcett Crest	334	.25		
Hunter, Evan	**Don't Crowd Me** (M)	Popular Library	SP 279	.50		
Hurd, Florence	**Legacy** (W)	Avon	33480	1.95		
	Shadows of the Heart (W)	Avon	76406	2.50		

I

| Innes, Hammond | **Levkas Man** | Avon | W 344 | 1.25 |
| Israel, Charles E. | **Rizpah** | Fawcett Crest | t 517 | .75 |

J

| Jackson, Alan R. | **East 57th Street** | Dell | 2220 | .50 |

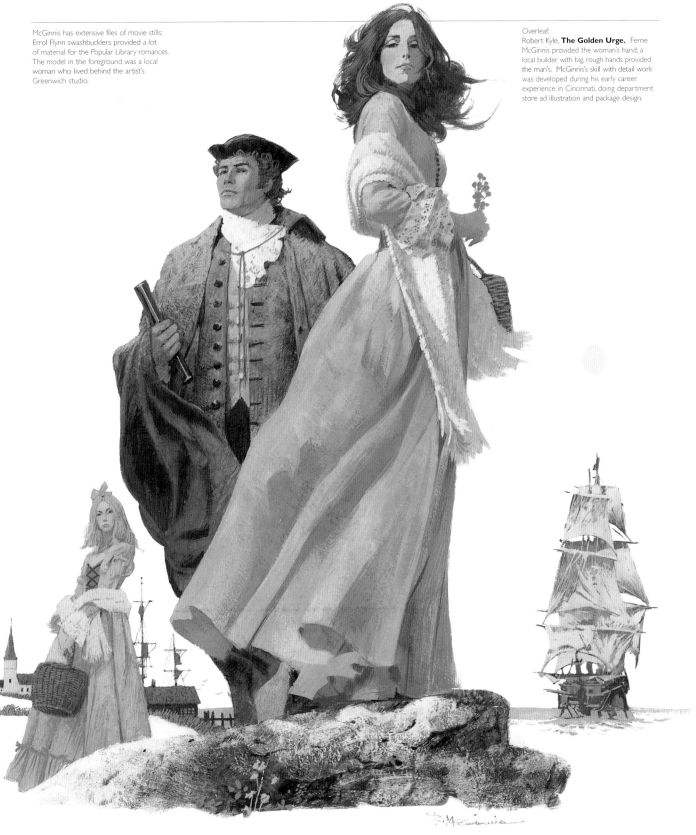

McGinnis has extensive files of movie stills;
Errol Flynn swashbucklers provided a lot
of material for the Popular Library romances.
The model in the foreground was a local
woman who lived behind the artist's
Greenwich studio.

Overleaf:
Robert Kyle, **The Golden Urge.** Ferne
McGinnis provided the woman's hand; a
local builder with big, rough hands provided
the man's. McGinnis's skill with detail work
was developed during his early career
experience in Cincinnati, doing department
store ad illustration and package design.

The Pepper Tree (detail) 1971, gouache on board, 9" x 12"

Overleaf: **The Golden Urge** (detail) 1963, gouache on board, 9" x 11¼"

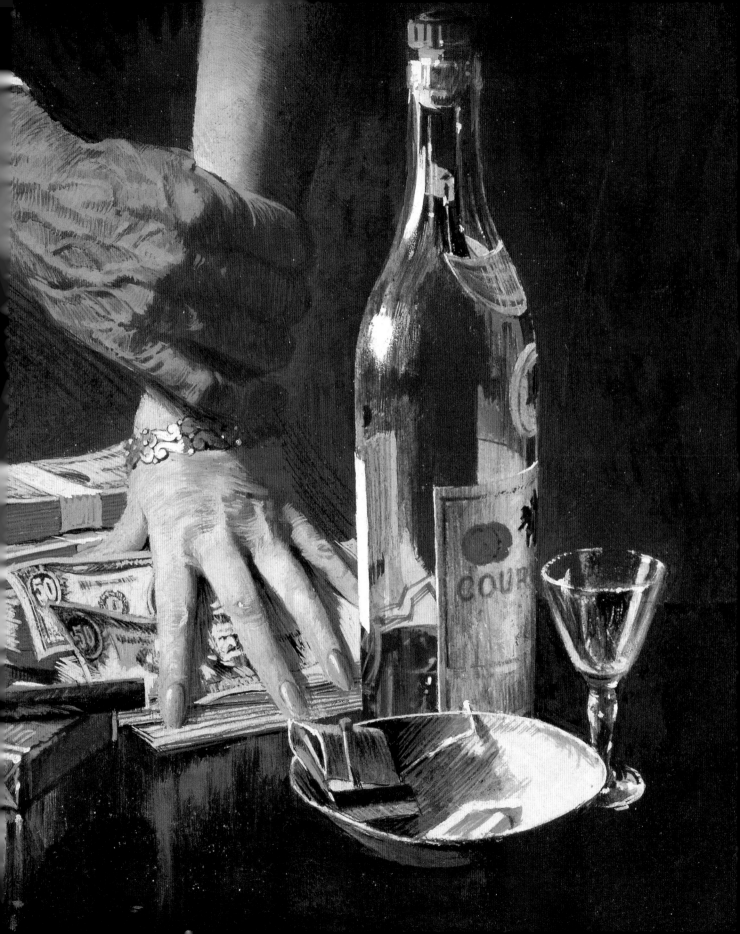

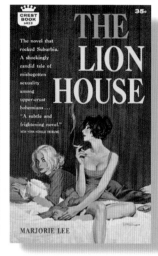

Jaffe, Rona	**Away from Home**	Fawcett Crest	R 462	.60	t 770	.75
	The Best of Everything	Avon	38174	2.25	54221	2.75
Jahoda, Gloria	**Delilah's Mountain**	Popular Library	2169	.60		
Jekel, Pamela	**Columbia** (W)	Charter	11416	4.50		
Jenkins, Dan	**Semi-Tough** (MTI)	Signet	J 8184	1.95		
Jennet, Anna	**My Lady Captor**	Jove	11858	5.99		
Jennings, Gary	**The Journeyer** (W)	Avon	69609	4.95		
Jennings, John	**The Pepper Tree**	Popular Library	150	1.25		
John, Stephen	**The Bigger the Bust**	Berkley	Z 2211	1.25		
Johnson, Barbara Ferry	**Lionors** (W)	Avon	24679	1.75		
Johnston, Joan	**Colter's Wife** (W)	Pocket Books	60472	3.50		
	Comanche Woman (W)	Pocket Books	62899	3.95		
	Frontier Woman (W)	Pocket Books	62898	3.95		
	Texas Woman (W)	Pocket Books	62900	3.95		
Johnston, Mary	**Cease Firing**	Popular Library	201	.95		
	The Fortunes of Garin (M)	Popular Library	1295	.75		
	The Long Roll	Popular Library	E 61	1.25		
Jones, Madison	**The Innocent**	Popular Library	286	.95		

Some Like it Cool 1962, gouache on board, 10 7/8" × 16 3/8"

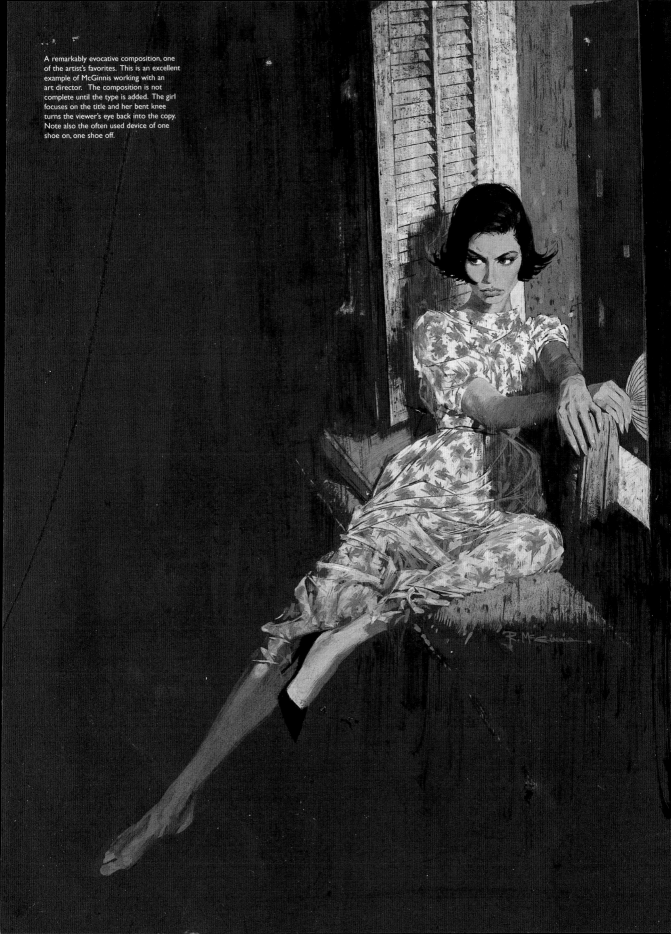

A remarkably evocative composition, one
of the artist's favorites. This is an excellent
example of McGinnis working with an
art director. The composition is not
complete until the type is added. The girl
focuses on the title and her bent knee
turns the viewer's eye back into the copy.
Note also the often used device of one
shoe on, one shoe off.

McGinnis enjoyed reading the book and put a lot of work into the painting, originally designed as a wraparound. It was his first $5,000 job, an unprecedented price for a paperback cover. For some reason, Bantam decided to go with a photo cover (they issued the book with five different photos), and used the painting as an inside front cover spread instead. The little girl under the tree is McGinnis's daughter; the model for Daisy (in the painting) was Shere Hite. In later printings of the book the McGinnis spread was dropped.

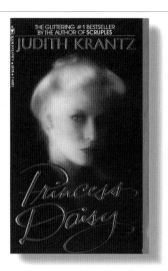

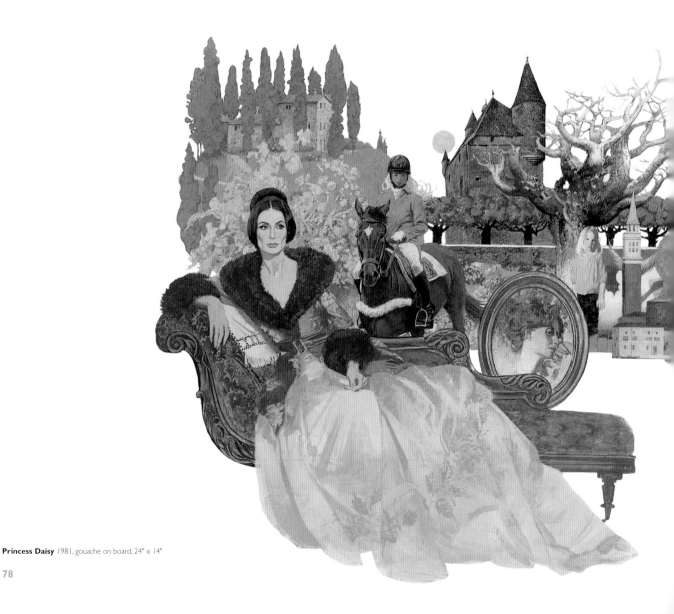

Princess Daisy 1981, gouache on board, 24" x 14"

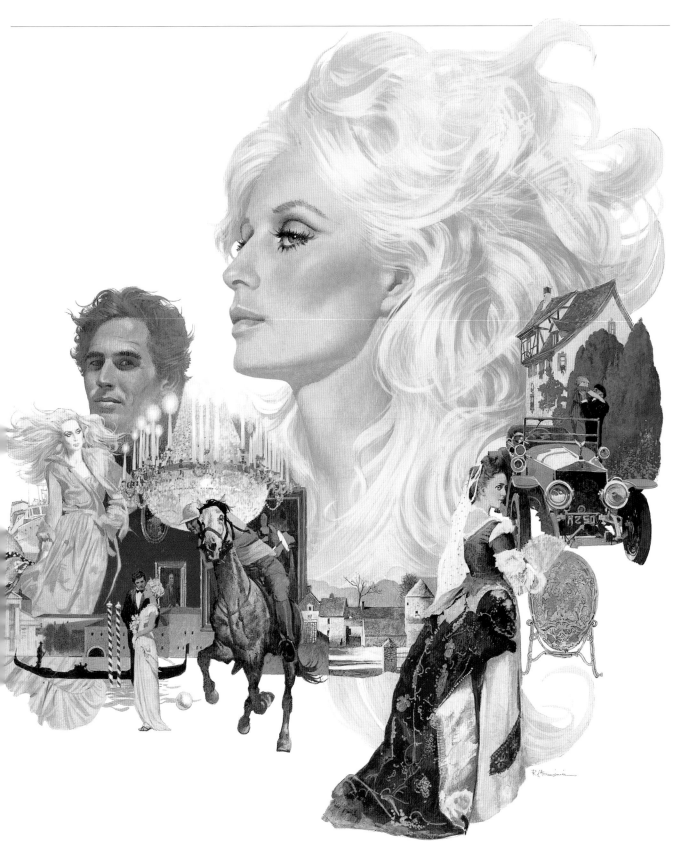

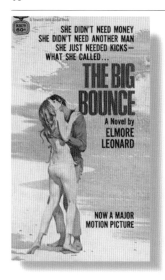
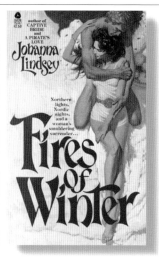

Kane, Frank	**Frank Kane's Stacked Deck**	Dell First Edition	B 197	.35
	Syndicate Girl	Dell First Edition	B 123	.35
Kane, Harnett T.	**Bride of Fortune** (M)	Popular Library	SP 90	.50
	Pathway to the Stars	Curtis	9033	.95
Karp, Marvin Allen	**Catch a Spy** (M)	Popular Library	SP 370	.50
Kastle, Herbert	**Miami Golden Boy**	Avon	W 253	1.25
Kaufelt, David A.	**Six Months with an Older Woman**	Avon	20040	1.25
Kaufmann, Myron S.	**The Love of Elspeth Baker** (W)	Bantam	23711	3.95
Kavinoky, Bernice	**So Strong a Flame**	Popular Library	G 375	.35
Keene, Day	**Too Hot to Hold**	Fawcett Gold Medal	931	.25
Keene, Day and Leonard Pruyn	**World Without Women**	Fawcett Gold Medal	s 975	.35
Keyes, Frances Parkinson	**Senator Marlowe's Daughter**	Avon	V 2043	.75
Killens, John Oliver	**The Cotillion**	Pocket Books	78136	1.25
Kingery, Don	**Good Time Girl**	Dell First Edition	B 164	.35
Kiraly, Marie	**Leanna**	Berkley	15224	5.99
	Mina	Berkley	14359	5.50
Kirkland, Elithe Hamilton	**Divine Average**	Avon	41764	2.25
	Love Is a Wild Assault	Avon	33498	2.25

Kjelgaard, Jim	**Big Red**	Bantam Skylark	15434 (D)3.99	15434 (D) 4.50	
				15434 (D) 4.99	
	Snow Dog	Bantam Skylark	15560 (D)3.99	15560 (D) 4.99	
	Stormy	Bantam Skylark	15468 (D)3.99	15468 (D) 4.50	
Knowles, John	**Spreading Fires**	Ballantine	24514	1.50	
Koningsberger, Hans	**An American Romance**	Avon	T 528	.35	
Krantz, Judith	**Princess Daisy** (IFC, 2 pg spread)	Bantam	14200	3.95	(5 versions)
Kyle, Robert	**The Golden Urge**	Fawcett Gold Medal	k 1338	.40	
	Kill Now, Pay Later	Dell First Edition	B 178	.35	
	Model for Murder	Dell First Edition	A 192	.25	
	Some Like It Cool	Dell First Edition	8100	.35	

L'Amour, Louis	**Hondo**	Bantam	24757	2.95	28090	3.99
	The Man Called Noon	Bantam	24753	3.50		
La Bern, Arthur	**Frenzy**	Paperback Library	65-713	.95		
Laker, Rosalind	**Banners of Silk** (W)	Signet	AE 1545	3.50		
Lamont, Marianne	**Dark Changeling**	Avon	17509	.95		
Lampedusa, Giuseppe Di	**The Leopard**	Avon	24281	1.75		
Lancaster, Bruce	**The Secret Road** (M)	Popular Library	1304	.75		
Laurence, Margaret	**Heart of a Stranger**	Bantam Seal (Canadian)	42038	3.50		
Le Comte, Edward	**He and She**	Avon	G 1078	.50		
Lee, Marjorie	**The Lion House**	Fawcett Crest	s 413	.35		
Leonard, Elmore	**The Big Bounce**	Fawcett Gold Medal	R 2079	.60		
Lesberg, Sandy	**Jenny**	Avon	S 166	.60		
	Jenny (M)	Avon	S 265	.60		
	Jenny Abroad (M)	Avon	G 1304	.50	S 254	.60
Leslie, Warren	**Love or Whatever It Is**	Fawcett Crest	d 435	.50		
Lewis, Hilda	**Wife to the Bastard**	Popular Library	192	.95		
Lindop, Audrey Erskine	**I Start Counting**	Dell	4075	.75		
Lindquist, Donald	**A Moment's Surrender**	Avon	31849	1.50		

L

Lindsey, Johanna	**Brave the Wild Wind** (W)	Avon	89284	3.95		
	Captive Bride (BCA)	Avon	33720	1.95	81901	3.50
	Fires of Winter	Avon	75747	2.50		
	A Gentle Feuding (W)	Avon	87155	3.95		
	Glorious Angel	Avon	79202	3.50		
	Heart of Thunder (W)	Avon	85118	3.95		
	A Heart So Wild (W)	Avon	75084	3.95		
	Love Only Once (W)	Avon	89953	3.95		
	Paradise Wild	Avon	77651	2.95		
	A Pirate's Love (BCA)	Avon	40048	2.25		
	So Speaks the Heart	Avon	81471	3.95		
	Tender is the Storm (W)	Avon	89693	3.95		
	When Love Awaits (W)	Avon	89739	3.95		
Logan, Ben	**The Land Remembers** (W)	Avon	27714	1.75		
Logan, Cait	**Tame the Fury** (W)	Charter	55773	4.50		
Lo-Johannsson, Ivar	**Bodies of Love**	Avon	J 139	1.50		
London, Jack and Robert Fish	**The Assassination Bureau, Ltd.** (MTI)	Berkley	X 1719	.60		
Longstreet, Stephen	**God and Sarah Pedlock**	Avon	31815	1.75		
	The Kingston Fortune (W)	Avon	25585	1.95		
	Nell Kimball	Berkley	4582	2.50		
	The Nylon Island	Fawcett Gold Medal	d 1415	.50		
	Pedlock and Sons	Avon	27730	1.75		
	Pedlock at Law	Avon	28993	1.75		
	The Pedlocks	Avon	27250	1.95		
	Pedlock Saint, Pedlock Sinner	Avon	29710	1.75		
	The Pedlocks in Love	Avon	36962	1.95		
	Wild Harvest	Fawcett Gold Medal	s 1068	.35		
Lotan, Yael	**The Other I**	Bantam	F 2612	.50		
Lottman, Eileen	**The Greek Tycoon** (MTI)	Warner	82-712	2.25		
Luke, Mary	**The Nonesuch Lure**	Berkley	3552	1.95		

M

Macdonald, Elisabeth	**Falling Star** (W)	Pocket Books	60290 (T)	6.95	66798	3.95
MacDonald, John D.	**All These Condemned**	Fawcett Gold Medal	T 2590	.75	M 3020	.95
					3358	1.25
					3950	1.50
					4239	1.75
	April Evil	Dell First Edition	B 146	.35		
	April Evil	Fawcett Gold Medal	3619	1.50	4128	1.75
	Area of Suspicion	Fawcett Gold Medal	T 2539	.75		

JOHN D. MACDONALD

AREA
OF
SUSPICION

Specially
revised by
the author

THIS DUE
SECOND

BOB
This
One

AREA OF SUSPICION ①

John D. MacDonald was one of McGinnis's favorite writers. He read many of the books he illustrated, though certainly not all (sometimes he got his cover ideas from 3-4 page "reader's reports" prepared by the publisher that summarized the plot, characters and setting). After Carter Brown and Brett Halliday, the MacDonald books for Fawcett constituted his longest-running assignment, and very likely the best-selling.

The pencil sketch shows the art director agreed with McGinnis on the best pose.

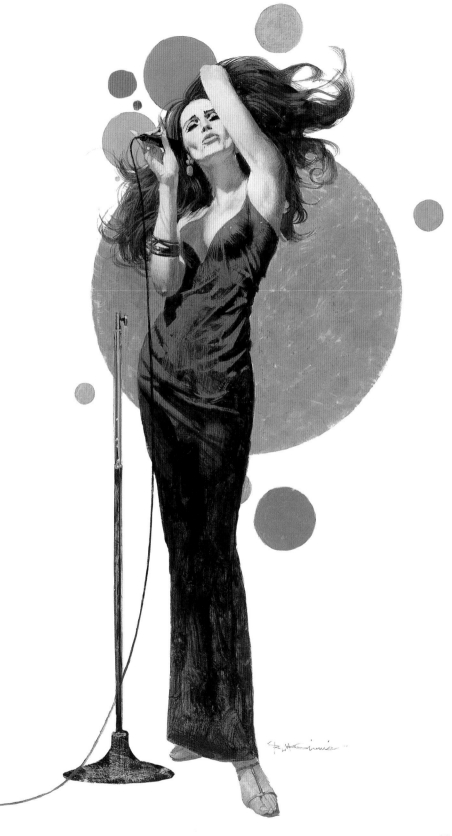

Area of Suspicion 1970,
gouache on board, 10 7/8" x 16 3/8"

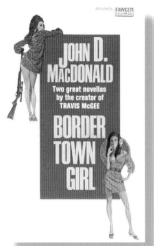

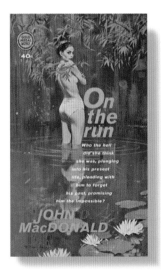

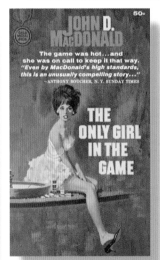

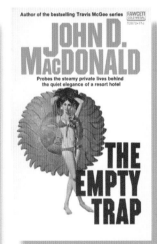

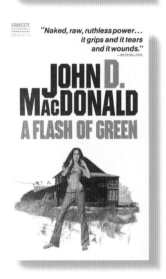

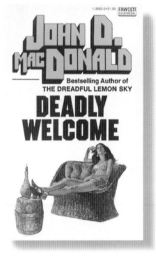

MacDonald, John D. (continued)

Title	Publisher	Code	Price	Reprint	Price
Area of Suspicion	Fawcett Gold Medal	P 3185	1.25	3706	1.50
				4008	1.75
				4008	1.95
				4008	2.50
				12618	2.50
				13099	3.50
The Beach Girls	Fawcett Gold Medal	T 2604	.75	M 3147	.95
				3584	1.50
				4081	1.75
Border Town Girl	Fawcett Gold Medal	R 2097	.60	R 2512	.60
				M 3160	.95
The Brass Cupcake	Fawcett Gold Medal	3807	1.50	4141	1.75
				4141	1.95
Bright Orange for the Shroud	Fawcett Gold Medal	3595	1.50	4100	1.75
				4243	1.95
				4243	2.25
				4243	2.50
A Bullet for Cinderella	Fawcett Gold Medal	P 3508	1.25	3849	1.50
				4106	1.75
				4106	2.25
				12946	2.95
Contrary Pleasure	Fawcett Gold Medal	4104	2.50		
The Crossroads	Fawcett Gold Medal	M 3162	.95	3663	1.50
				4033	1.75
				4033	1.95
Cry Hard, Cry Fast	Fawcett Gold Medal	M 2906	.95		
Cry Hard, Cry Fast	Fawcett Gold Medal	P 3510	1.25	3969	1.50
				3969	1.95
				12634	2.50
The Damned	Fawcett Gold Medal	M 2972	.95	3490	1.25
				3997	1.50
				3997	1.95
				3997	2.25
Darker Than Amber	Fawcett Gold Medal	Q 3563	1.50	4162	1.95
				4162	2.25
				4162	2.50
				2373	2.75
Dead Low Tide	Fawcett Gold Medal	M 2922	.95	3523	1.25
				3901	1.50
				4166	1.75
				4166	1.95
A Deadly Shade of Gold	Fawcett Gold Medal	P 3013	1.25	Q 3335	1.50
				3815	1.75
				4221	1.95
				4221	2.25
				12544	2.25
Deadly Welcome	Dell First Edition	B127	.35		
Deadly Welcome	Fawcett Gold Medal	M 2872	.95	3381	1.25
				3682	1.50
				3682	1.95
				3682	2.25
Death Trap	Fawcett Gold Medal	M 2993	.95	P 3381	1.50
				3557	1.50

A Man of Affairs 1961, gouache on board, 6" x 15"

MacDonald, John D. (continued)

						
The Deceivers	Fawcett Gold Medal	M 3146	.95	3763	1.50	
				4016	1.75	
				4016	1.95	
The Dreadful Lemon Sky	Fawcett Gold Medal	Q 3285	1.50	3965	1.75	
				4148	1.95	
				4148	2.25	
				4148	2.95	
Dress Her in Indigo	Fawcett Gold Medal	T 2127	.75	T 2494	.75	
				M 2757	.95	
Dress Her in Indigo	Fawcett Gold Medal	P 3014	1.25	3511	1.50	
				3732	1.75	
				4170	1.95	
				4170	2.25	
				4170	2.50	
The Empty Trap	Fawcett Gold Medal	T 2870	.75	3380	1.25	
				3911	1.50	
				4185	1.75	
				4185	1.95	
The End of the Night	Fawcett Gold Medal	P 3209	1.25	3731	1.50	
				4192	1.75	
				4192	2.25	
A Flash of Green	Fawcett Gold Medal	P 2816	1.25	3452	1.50	
				3938	1.75	
				4186	1.95	
				4186	2.25	
				4186	2.50	
				4186	2.95	
The Girl in the Plain Brown Wrapper	Fawcett Gold Medal	P 3010	1.25	Q 3440	1.50	
				3768	1.75	
The Girl in the Plain Brown Wrapper	Fawcett Gold Medal	4256	1.95	4256	2.25	
				4256	2.50	
				2397	2.75	
The Girl, The Gold Watch and Everything	Fawcett Gold Medal	P 3231	1.25	3745	1.50	
				4296	1.95	
Judge Me Not	Fawcett Gold Medal	3661	1.25	4057	1.75	
				4057	2.25	
The Lethal Sex (Short Story Anthology)	Dell First Edition	B 141	.35			
The Long Lavender Look	Fawcett Gold Medal	M 2325	.95	(2 versions)		
The Long Lavender Look	Fawcett Gold Medal	P 3006	1.25	3368	1.50	
				3548	1.75	
				3834	1.95	
				3834	2.25	
				3834	2.50	
				3834	2.95	
A Man of Affairs	Fawcett Gold Medal	d 1552	.50	d 1866	.50	
				R 2255	.60	
				T 2618	.75	
				2849	.95	
				3751	1.50	
				4051	1.75	

Border Town Girl 1968, gouache on board, 6" x 15"

MacDonald, John D. (continued)

Title	Publisher	Code	Price
Murder for the Bride	Fawcett Gold Medal	M 2876	.95
Murder in the Wind	Fawcett Gold Medal	d 1543	.50
Murder in the Wind	Fawcett Gold Medal	M 3158	.95
The Neon Jungle	Fawcett Gold Medal	Q 3621	1.50
Nightmare in Pink	Fawcett Gold Medal	3603	1.50
On the Run	Fawcett Gold Medal	k 1292	.40
On the Run	Fawcett Gold Medal	P 3487	1.25
One Fearful Yellow Eye	Fawcett Gold Medal	3853	1.75
One Monday We Killed Them All	Fawcett Gold Medal	P 3206	1.25
The Only Girl in the Game	Fawcett Gold Medal	d 1389	.50
The Only Girl in the Game	Fawcett Gold Medal	P 3223	1.25
Pale Gray for Guilt	Fawcett Gold Medal	P 3134	1.25
Please Write for Details	Fawcett Gold Medal	M 2688	.95
Please Write for Details	Fawcett Gold Medal	3664	1.50
The Price of Murder	Fawcett Gold Medal	M 2850	.95
The Quick Red Fox	Fawcett Gold Medal	P 3311	1.25

Reprint editions:

Code	Price
P 3509	1.25
3949	1.50
4232	1.75
4232	1.95
R 1954	.60
T 2320	.75
T 2642	.75
3602	1.50
3602	1.95
3621	1.95
4259	1.95
4259	2.50
d 1587	.50
d 1827	.50
R 2241	.60
T 2706	.75
3983	1.50
3983	1.95
3983	2.25
4146	1.95
4146	2.25
4146	2.50
4146	2.95
2565	2.95
3620	1.50
3620	1.95
3620	2.25
d 1636	.50
R 2010	.60
T 2354	.75
M 2755	.95
3787	1.50
4032	1.75
4032	1.95
2358	2.50
Q 3465	1.50
3817	1.75
4158	1.95
4158	2.25
4158	2.50
3181	1.25
4080	1.95
4080	2.25
P 3488	1.25
3936	1.50
4242	1.75
4242	1.95
3899	1.50
4098	1.75
4264	1.95
4264	2.25
4264	2.50
2555	2.95

Border Town Girl 1968, gouache on board, 8½" x 16"

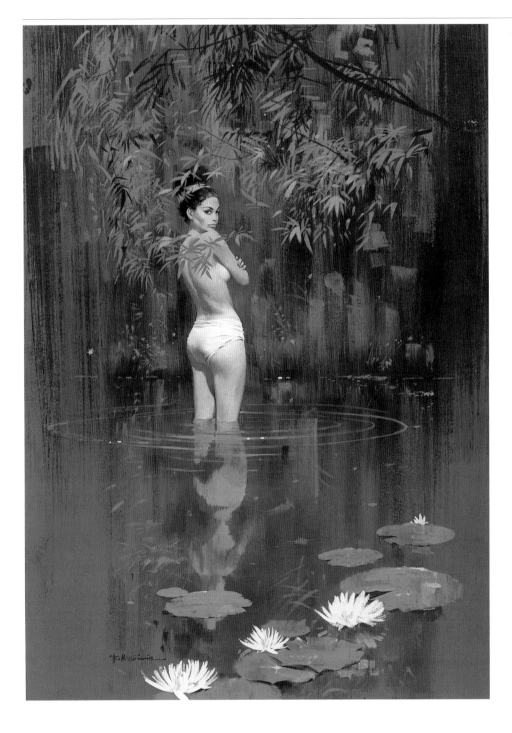

John D. MacDonald, **On the Run.**
McGinnis's take on the famous French painting by Paul Chabas, "September Morn". This one is in just about every McGinnis collector's "Top Ten".

On the Run 1963, gouache on board, 12½" x 17"

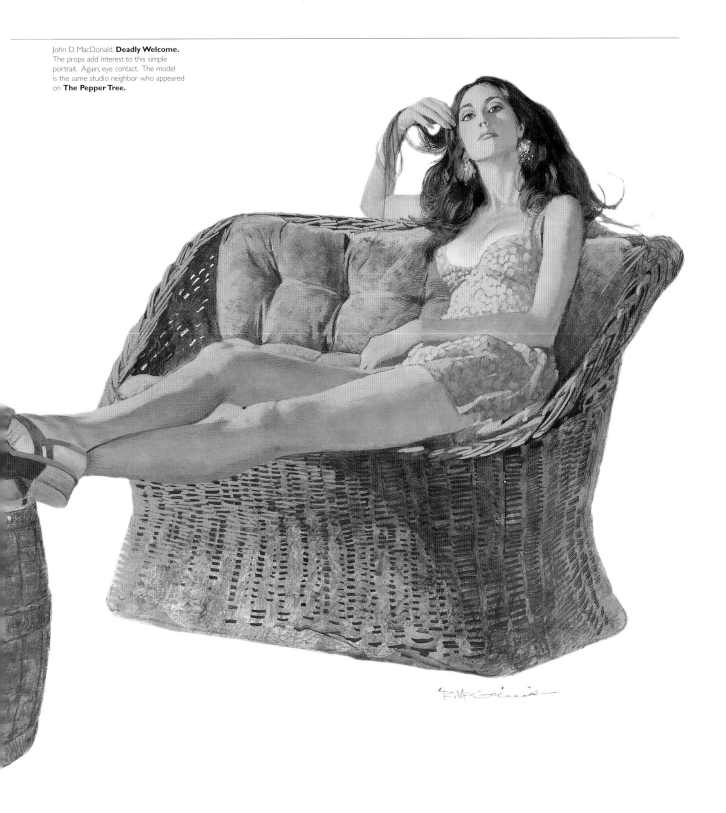

John D. MacDonald, **Deadly Welcome.**
The props add interest to this simple
portrait. Again, eye contact. The model
is the same studio neighbor who appeared
on **The Pepper Tree.**

Deadly Welcome 1972, gouache on board, 13" x 11"

Author	Title	Publisher	Number	Price	Number	Price
MacDonald, John D. (continued)	**The Scarlet Ruse**	Fawcett Gold Medal	Q 3222	1.50	3554	1.75
					3952	1.95
					3952	2.25
	The Scarlet Ruse	Fawcett Gold Medal	3952	2.50	3952	2.95
					13247	3.95
	Slam the Big Door	Fawcett Gold Medal	R 1923	.60	T 2292	.75
					T 2651	.75
					P 3186	1.25
	Slam the Big Door	Fawcett Gold Medal	3707	1.50	4295	1.95
					4295	2.25
	Soft Touch	Dell First Edition	K 116	.40		
	A Tan and Sandy Silence	Fawcett Gold Medal	M 2513	.95		
	A Tan and Sandy Silence	Fawcett Gold Medal	P 3012	1.25	3369	1.50
					3635	1.75
					4220	1.95
					4220	2.25
					4220	2.50
					2404	2.75
	The Turquoise Lament	Fawcett Gold Medal	P 2810	1.25	3340	1.50
					3806	1.75
					4200	1.95
					4200	2.25
					4200	2.50
					4200	2.95
	Where is Janice Gantry?	Fawcett Gold Medal	P 3525	1.25	3937	1.50
					4224	1.75
					4224	1.95
	You Live Once	Fawcett Gold Medal	d 1761	.50	R 2038	.60
					T 2314	.75
					2860	.95
					3345	1.25
					3799	1.50
					4050	1.75
					4050	1.95
MacDonald, Philip	**Warrant For X**	Dell	F 184	.50		
Macdonald, Ross	**The Three Roads**	Bantam	F 3665	.50		
MacIver, Sharon	**Dakota Dream**	Diamond	445	4.50		
	River Song	Diamond	592	4.99		
MacKenzie, Donald	**Moment of Danger**	Dell	D 328	.35		
Malo, Vincent Gaspard	**Murder on the Mistral**	Fawcett Crest	s 327	.35		
Maloney, Ralph	**Daily Bread**	Fawcett Crest	s 485	.35		
Mandel, Sidney	**Gigante**	Avon	W 319	1.25		
Mansfield, Elizabeth (and other authors)	**A Regency Holiday** (Short Story Anthology)	Jove	10705	4.50		

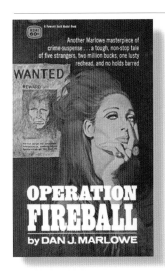
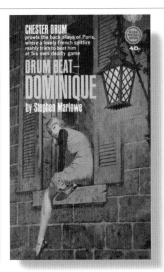
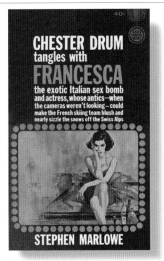
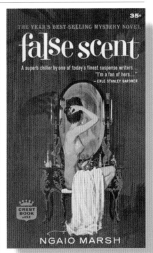

Manson, Cynthia	**Death on the Verandah** (Short Story Anthology)	Berkley	14836	5.50		
Maracotta, Lindsay	**Caribe** (W)	Jove	B 4692	2.25		
Margulies, Leo	**Mink is for a Minx** (Short Story Anthology)	Dell	5642	.45		
Markey, Gene	**That Far Paradise**	Popular Library	SP 96	.50		
Markson, David	**Epitaph For a Dead Beat**	Dell First Edition	B 189	.35		
	Epitaph For a Tramp	Dell First Edition	A193	.25	A193	.35
Marlowe, Dan J.	**Death Deep Down**	Fawcett Gold Medal	k 1524	.40		
	Flashpoint	Fawcett Gold Medal	R 2283	.60		
	Operation Flashpoint (Same art as Flashpoint, R 2283)	Fawcett Gold Medal	T 2446	.75	M 2934	.95
	Operation Fireball	Fawcett Gold Medal	R 2141	.60	R 2567	.60
	Route of the Red Gold	Fawcett Gold Medal	d 1791	.50		
Marlowe, Stephen	**Drum Beat – Dominique**	Fawcett Gold Medal	k 1508	.40		
	Drum Beat – Erica	Fawcett Gold Medal	d 1796	.50		
	Drum Beat – Madrid	Fawcett Gold Medal	d 1686	.50		
	Drum Beat – Marianne	Fawcett Gold Medal	d 1909	.50		
	Francesca	Fawcett Gold Medal	k 1285	.40		
	Peril is My Pay	Fawcett Gold Medal	1018	.25		
Marsh, Adrian	**Rocco's Niece**	Avon	N 407	.95		
Marsh, Ngaio	**False Scent**	Fawcett Crest	s 452	.35		
Marshall, Edison	**Gypsy Sixpence**	Dell	F98	.50		

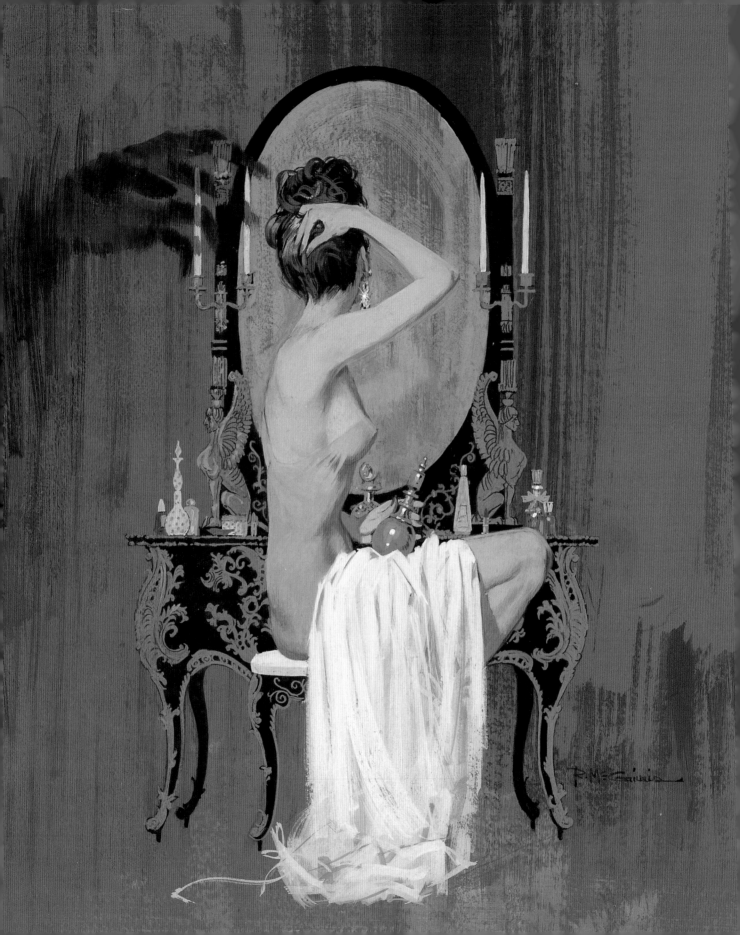

At left:
Ngaio Marsh, **False Scent.** Many people often don't see the shadow of the menacing hand – the art director's idea, not McGinnis's. Note the ornate dressing table.

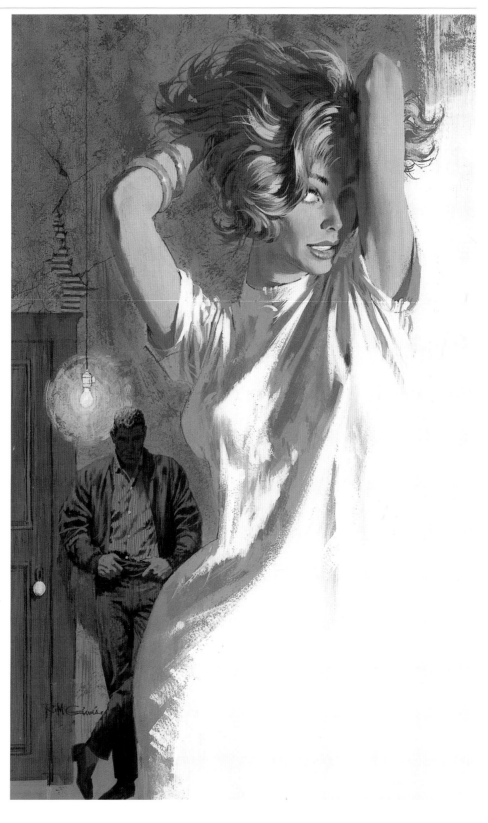

False Scent (at left, detail)
1961, gouache on board, 8 3/4" × 5 1/4"

The Wrong Ones 1961, gouache on board, 8 3/4" × 13 2"

 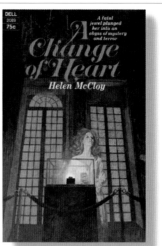

Marshall, Rosamond	**Rogue Cavalier** (M)	Popular Library	2151	.60		
Martin, Jay	**Digging the Love Goddess**	Berkley	Z 1905	1.25		
	Plugged In	Berkley	Z 2246	1.25		
Martin, Rhona	**Gallows Wedding**	Berkley	4299	2.25		
Marton, George and Tibor Meray	**Catch Me a Spy**	Popular Library	1419	.75		
Marvin, Susan	**Chateau in the Shadows**	Dell	1189	.60		
Mason, F. Van Wyck	**Rascal's Heaven**	Popular Library	E77	1.25		
Mason, Raymond	**Someone and Felicia Warwick**	Fawcett Gold Medal	s 1248	.35		
Masur, Hal (Q.)	**So Rich, So Lovely, and So Dead**	Dell	D 383	.35		
	You Can't Live Forever	Dell	D 329	.35		
Maugham, W. Somerset	**The Making of a Saint** (M)	Popular Library	1272	.75		
Maxfield, Henry S.	**Legacy of a Spy**	Fawcett Crest	s 288	.35		
Maxwell, Patricia	**The Secret of Mirror House**	Fawcett Gold Medal	R 2235	.60	R 2570	.60
Mayer, Albert	**Follow the River**	Popular Library	E 87	1.25		
Mayer, Martin	**The Bankers**	Ballantine	24750	2.25		
McBain, Ed	**The Con Man**	Permabook	M 4264	.35		
	Cop Hater	Permabook	M 4268	.35		
	The Empty Hours	Permabook	M 4271	.35		
	Killer's Choice	Permabook	M 4267	.35		
	Killer's Payoff	Permabook	M 4265	.35		
	Lady, Lady, I Did It!	Permabook	M 4253	.35		
	Like Love	Permabook	M 4289	.35		

McBain, Ed (continued)	**The Mugger**	Permabook	M 4266	.35
McCloy, Helen	**A Change of Heart**	Dell	2089	.75
McCutchan, Philip	**Bluebolt One**	Berkley	F 1069	.50
	The Dead Line	Berkley	F 1269	.50
	Gibraltar Road	Berkley	F 1050	.50
	The Man From Moscow	Berkley	F 1183	.50
	Moscow Coach	Berkley	X 1377	.60
	Redcap	Berkley	F 1051	.50
	Skyprobe	Berkley	X 1526	.60
	Warmaster	Berkley	F 1127	.50
McGerr, Patricia	**Dangerous Landing**	Dell	1911	.95
McGivern, William P.	**A Choice of Assassins**	Bantam	F 2851	.50
McKee, Jan	**By Love Divided** (W)	Pocket Books	62997	3.95
McKimmey, James	**24 Hours to Kill**	Dell First Edition	B 169	.35
	The Wrong Ones	Dell First Edition	B 192	.35
Meacham, Ellis K.	**The East Indiaman**	Popular Library	221	.95
Meade, Richard	**Summer Always Ends**	Dell	8379	.50
Mergendahl, Charles	**Call After Six**	Dell First Edition	C 112	.50
Michaels, Barbara	**Wait for What Will Come**	Fawcett Crest	4150	1.95
Miller, Warren	**Flush Times**	Fawcett Crest	R 653	.60

From about 1969 to 1974 there was a paperback boom in "gothics", which collapsed as precipitately as it arose. The cover formula was rigid: woman in white dress fleeing from dark castle with one light in the window, but McGinnis loved doing them: "You have to suggest terror and mystery. As you work you make way for your imagination to flow; keep your mind loose and more and more ideas will surface."

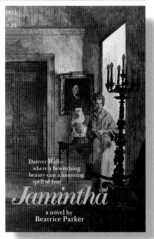

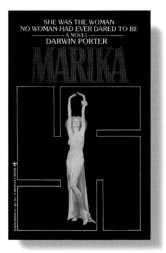

Miller, Warren (continued)	**The Way We Live Now**	Fawcett Crest	s 299	.35	d 542	.50
					d 749	.50
					T 1158	.75
Mills, Carla J.	**Three Rivers** (W)	Bantam	28442	3.95		
Mirabelli, Eugene	**The Burning Air** (M)	Popular Library	EG 425	.35		
Mitchison, Naomi	**The Barbarian**	Curtis	1030	1.25		
Mitgang, Herbert	**The Return**	Avon	15016	.95		
Moberg, Vilhelm	**Unto a Good Land** (M)	Popular Library	E 102	1.25		
Moll, Elick	**Night Without Sleep**	Paperback Library	51-148	.35		
Monig, Christopher (See also Chaber, M.E.)	**Don't Count the Corpses**	Dell	992	.25		
Monsarrat, Nicholas	**Leave Cancelled**	Dell	4718	.40		
Montgomery, L.M.	**Rainbow Valley**	Bantam Starfire	25213	2.95		
	Rilla of Ingleside	Bantam Starfire	25241	2.95		
Montherlant, Henry de	**Desert Love**	Berkley	G 277	.35		
Moore, Arthur	**The Rivals** (M)	Popular Library	3127	1.50		
Moore, Robin	**The Country Team**	Fawcett Crest	M 1069	.95	P 1780	1.25
Moray, Helga	**Dark Fury** (M)	Popular Library	SP 44	.50		
Morton, Patricia	**Province of Darkness**	Avon	S 436	.60	14324	.75
Motley, Annette	**Green Dragon, White Tiger** (IFC, 2pg spread)	Onyx	JE 61	4.95		
Munro, James	**The Innocent Bystanders** (MTI)	Bantam	S 5741	.75		
Murphy, Dennis	**The Sergeant**	Fawcett Crest	s 291	.35		
Murray, E.P.	**Firecloud**	Charter	23820	3.95		

Napier, Geoffrey	**A Very Special Agent**	Fawcett Crest	R 1185	.60	T 1489	.75
Napier, Melissa	**House of Dark Laughter**	Avon	V 2429	.75		
Nathan, Robert	**One More Spring**	Popular Library	2480	.60		
Nelson, Mark	**The Crusoe Test** (W)	Avon	34603	1.75		

A New ROSE Novel
by *Laura Parker*

Author of the bestselling
Rose of the Mists and
A Rose in Splendor

In an unconquered
land he would teach her
sweet surrender...

THE
SECRET
ROSE

WARNER BOOKS $3.95 U.S.A. 32639-9 ($4.95 CAN. 32640-2)

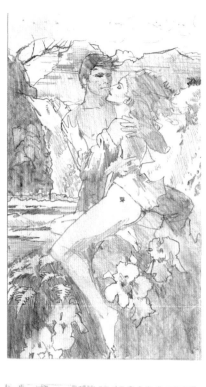
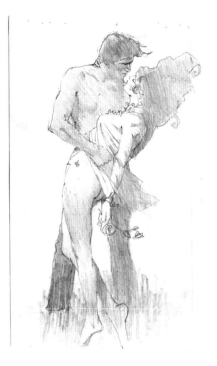
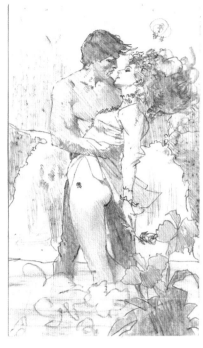
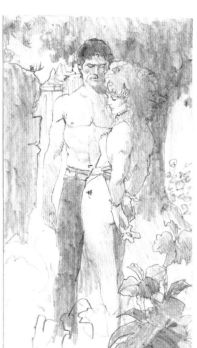

The re-invention of historical romances in the '80s was the biggest success story in publishing. By adding a stronger erotic element to the genre, writers like Kathleen Woodiwiss, Johanna Lindsey, Patricia Hagan and Laura Parker found a huge untapped market and their books became best-sellers. The cover formula – barechested man and heroine in a steamy embrace – was established by Barbara Bertoli, the art director at Avon. Here McGinnis tries out a number of variations on "the clinch". The pose of the woman was constrained by the requirement that he show the small rose tattoo on the heroine's thigh.

Overleaf:
Sylvia Pell, **The Shadow of the Sun**. A departure from the stock romance set-up, with a stronger emphasis on the "historical" aspect. Barbara Bertoli at Avon liked the ornate border, suggesting an old framed portrait; the painting was thus used without typography marring the image. The clothing came from McGinnis's costume reference files; he used the same gown seventeen years earlier on the cover of a Popular Library historical, **Blade of Honor**.

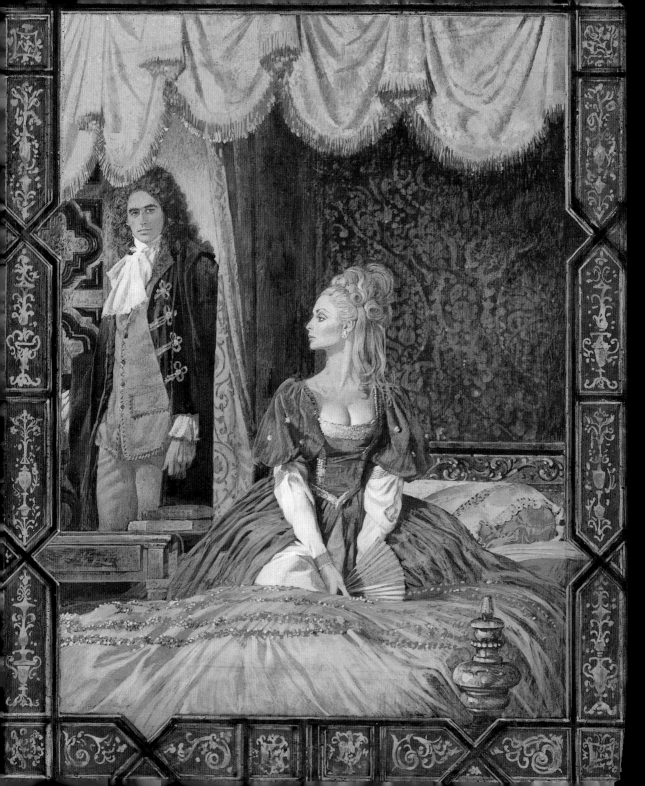

Nicolayson, Bruce	**Beekman Place** (W)	Avon	79673	3.50
	From Distant Shores (W)	Avon	75424	2.50
	Gracie Square	Avon	86058	3.95
	On Maiden Lane (W)	Avon	77800	2.95
	The Pirate of Gramercy Park (W)	Avon	83014	3.95
Norman, Elizabeth	**Castle Cloud** (W)	Avon	31583	1.95
	If the Reaper Ride (W)	Avon	37135	1.95
	Sleep, My Love (W)	Avon	48694	2.50

O'Donnell, E.P.	**Green Margins**	Popular Library	E 108	1.25
O'Donnell, Peter	**I, Lucifer**	Fawcett Crest	T 1234	.75
	Modesty Blaise	Fawcett Crest	R 899	.60
	Sabre-Tooth	Fawcett Crest	R 1065	.60
Olesker, Harry	**Exit Dying**	Dell	D 376	.35
	Now, Will You Try for Murder?	Dell	996	.25

Packer, Joy	**The Moon by Night**	Popular Library	2112	.60
Packer, Vin	**The Damnation of Adam Blessing**	Fawcett Gold Medal	s 1074	.35
	The Girl on the Best Seller List	Fawcett Gold Medal	s 976	.35

At left: **The Shadow of the Sun** (detail) 1981, gouache on board, 11" x 18¼"

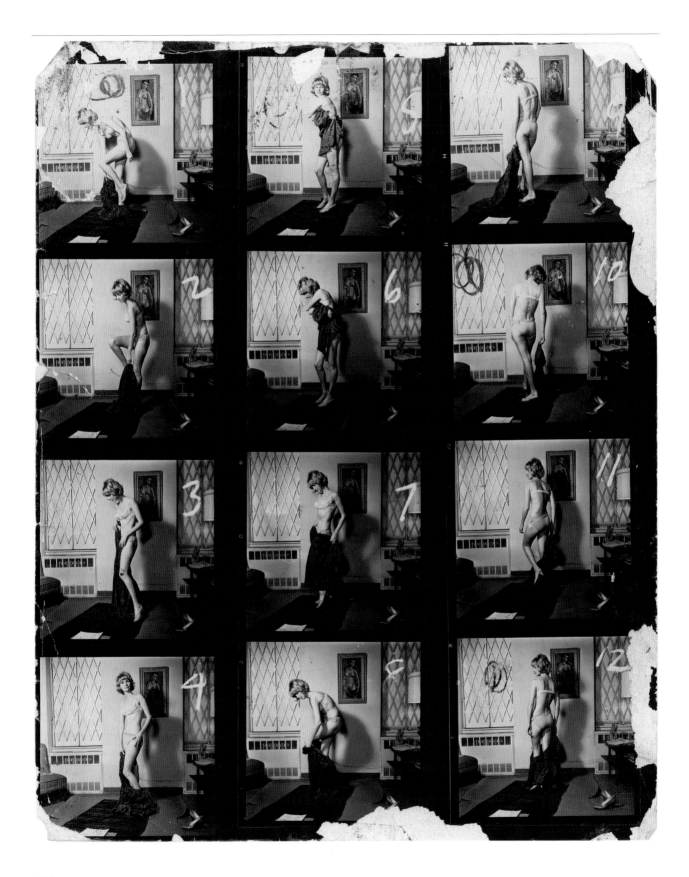

Variations on a pose. This pose of a woman stepping out of her dress was a particular favorite, and McGinnis experimented with it in a wide variety of backgrounds and situations. Whether he worked up pencil sketches or color comprehensives depended on whether he wanted to stress the color of the composition, and also on the art director. Some of them could "read" his pencils; others wanted to see the art in color. The sketch with the swastika may have been for a Modesty Blaise cover. The pose ultimately saw print on the cover of the Percivall and Burger stewardess novel, **Taking Off**.

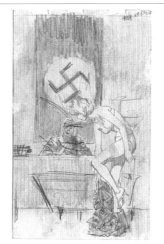
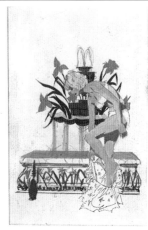
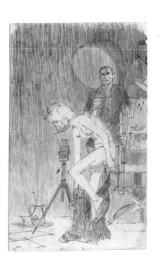

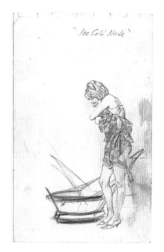
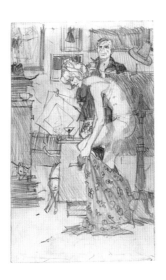
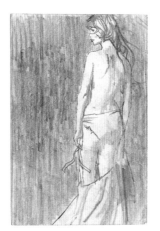
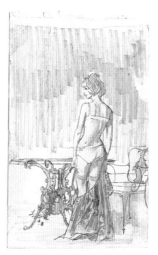

From New York to Rome,
London, and Paris
The swinging blockbuster novel
of the most talked-about
girl in the world!

AVON
14456
$1.50

Julia Percivall's
THE Stewardess

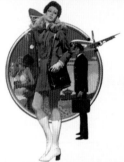

By the authors of
the blockbuster novel
THE STEWARDESS.
The exciting,
inside story
of those glamorous
girls who fly

AVON
20008
$1.25

Julia Percivall and Pixie Burger
High Flying

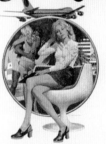

From New York to
Paris and Jamaica
The swinging
blockbuster novel
that picks up where
THE STEWARDESS
stopped!

AVON
20800
$1.25

Julia Percivall and Pixie Burger
Taking Off

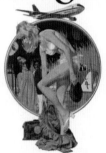

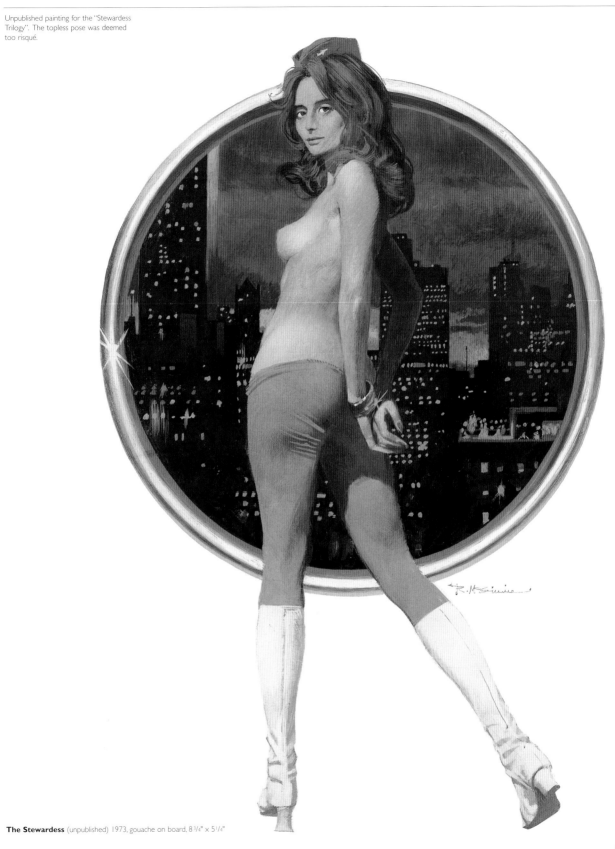

The Stewardess (unpublished) 1973, gouache on board, 8¾" x 5¼"

Parker, Beatrice	**Come to Castlemoor**	Dell	1510	.75		
	Jamintha	Dell	4371	1.25		
Parker, Laura	**Rebellious Angels** (W)	Warner	34836	4.95		
	A Rose in Splendor	Warner	34115	3.95		
	Rose of the Mists	Warner	32643	3.95		
	The Secret Rose	Warner	32639	3.95		
Paul, Charlotte	**Seattle** (W)	Signet	AE 4644	3.95		
Peale, Constance F.	**Give us Forever** (W)	Worldwide	70019	2.50		
Pell, Sylvia	**The Shadow of the Sun**	Avon	50658	2.50		
	The Sun Princess	Avon	77628	2.75		
Pelton, Sonya T.	**Forbidden Dawn** (W)	Zebra	1602	3.75		
Percivall, Julia and Pixie Burger	**High Flying**	Avon	20008	1.25		
	The Stewardess	Avon	14456	1.50	24539	1.75
	Taking Off	Avon	20800	1.25		
Pinchot, Ann	**The Man Chasers**	Avon	W 281	1.25		
Pitts, Denis	**This City is Ours**	Avon	36483	1.95		
Pollock, Robert	**Loophole, or How to Rob a Bank**	Fawcett Crest	P 2546	1.25		
Porter, Darwin	**Marika**	Berkley	4262	2.50		
Powell, Dawn	**A Cage for Lovers**	Avon	S 232	.60		
	The Wicked Pavilion	Avon	V 2108	.75		
Prather, Richard S. (Shell Scott Series)	**Always Leave 'Em Dying**	Fawcett Gold Medal	R 2261	.60		
	The Cockeyed Corpse	Fawcett Gold Medal	R 2302	.60		
	Dance With the Dead	Fawcett Gold Medal	T 2424	.75		
	Darling, It's Death	Fawcett Gold Medal	D 2501	.50		
	Dig That Crazy Grave	Fawcett Gold Medal	T 2677	.75		
	Find This Woman	Fawcett Gold Medal	T 2683	.75		
	Joker in the Deck	Fawcett Gold Medal	T 2587	.75	M 3197	.95
	Kill the Clown	Fawcett Gold Medal	T 2711	.75		
	Over Her Dear Body	Fawcett Gold Medal	T 2460	.75		
	The Scrambled Yeggs	Fawcett Gold Medal	T 2665	.75		
	Slab Happy	Fawcett Gold Medal	M 2880	.95	3713	1.25
	Strip for Murder	Fawcett Gold Medal	T 2598	.75	(The later **Slab Happy** printing has a new Shell Scott cameo protrait by McGinnis – only known instance.)	
	Take A Murder, Darling	Fawcett Gold Medal	T 2573	.75		
	Too Many Crooks	Fawcett Gold Medal	M 3246	.95		
	The Wailing Frail	Fawcett Gold Medal	T 2700	.75		
	Way of a Wanton	Fawcett Gold Medal	T 2747	.75		
(Not Shell Scott)	**Lie Down, Killer**	Fawcett Gold Medal	T 2652	.75		
	The Peddler	Fawcett Gold Medal	T 2638	.75		
Pratt, Theodore	**Tropical Disturbance**	Fawcett Gold Medal	s 1143	.35		
Priestley, J.B.	**Bright Day**	Popular Library	1263	.75		

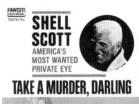

SHELL SCOTT
AMERICA'S MOST WANTED PRIVATE EYE

TAKE A MURDER, DARLING

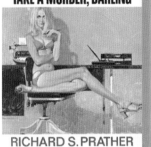

RICHARD S. PRATHER

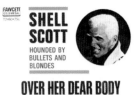

SHELL SCOTT
HOUNDED BY BULLETS AND BLONDES

OVER HER DEAR BODY

RICHARD S. PRATHER

SHELL SCOTT
TANGLES WITH A CULT OF EVIL

ALWAYS LEAVE 'EM DYING

RICHARD S. PRATHER

ONE OF THE GREAT **SHELL SCOTT** CAPERS!

DANCE WITH THE DEAD

RICHARD S. PRATHER

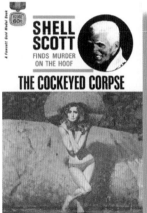

SHELL SCOTT
FINDS MURDER ON THE HOOF

THE COCKEYED CORPSE

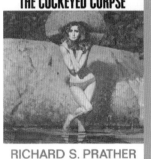

RICHARD S. PRATHER

SHELL SCOTT

DIG THAT CRAZY GRAVE

Man, she had a shape to make corpses kick open caskets — and she was dead set on giving me rigor mortis

RICHARD S. PRATHER

SHELL SCOTT
HIS WILDEST FLING

KILL THE CLOWN

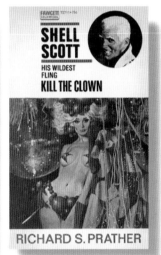

RICHARD S. PRATHER

SHELL SCOTT
WAS SHE GOING TO KISS HIM...OR KILL HIM?

WAY OF A WANTON

More than 40,000,000 Shell Scott books in print!

RICHARD S. PRATHER

MORE **SHELL SCOTT** SHENANIGANS

DARLING, IT'S DEATH

RICHARD S. PRATHER

Shell Scott
Too Many Crooks
Formerly: RIDE A HIGH HORSE

RICHARD S. PRATHER

Shell Scott was really in the soup— with both the cops and the killers

Over 40,000,000 Shell Scott books in print!

RICHARD S. PRATHER
Creator of the famous SHELL SCOTT

LIE DOWN, KILLER

The first time she double-crossed him, it broke his heart. The next time it was MURDER.

RICHARD S. PRATHER
Creator of the fabulous private eye Shell Scott

THE PEDDLER

The novel that blasts the lid off the hush-hush world of prostitution

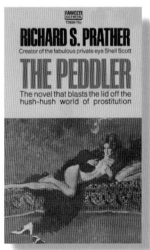

Richard S. Prather, **Dig That Crazy Grave.** The eighteen Prather covers are perhaps McGinnis's finest series of glamor portraits. He found the horizontal format, unmarred by text, liberating. Eye contact is a consistent element in these paintings. The art director at Fawcett was Dale Phillips, son of the great paperback artist Baryé Phillips, whose cameo portrait of Shell Scott is used on the covers.

Overleaf:
Peter Rabe, **Murder Me for Nickels.** The cover for this tough Gold Medal novel has a film noir feel. That almost looks like be Humphrey Bogart at the piano, but the model was McGinnis's friend and fellow artist, Jack Thurston – the reference photos were shot at his apartment.

Page 114:
The three Richter books gave McGinnis the rare opportunity to concentrate on the landscape painting he loves to do. The striking beech trees came from his reference files. McGinnis credits his amazing productivity to his extensive and well-organized reference library.

Dig That Crazy Grave 1971, gouache on board, 12½" x 10"

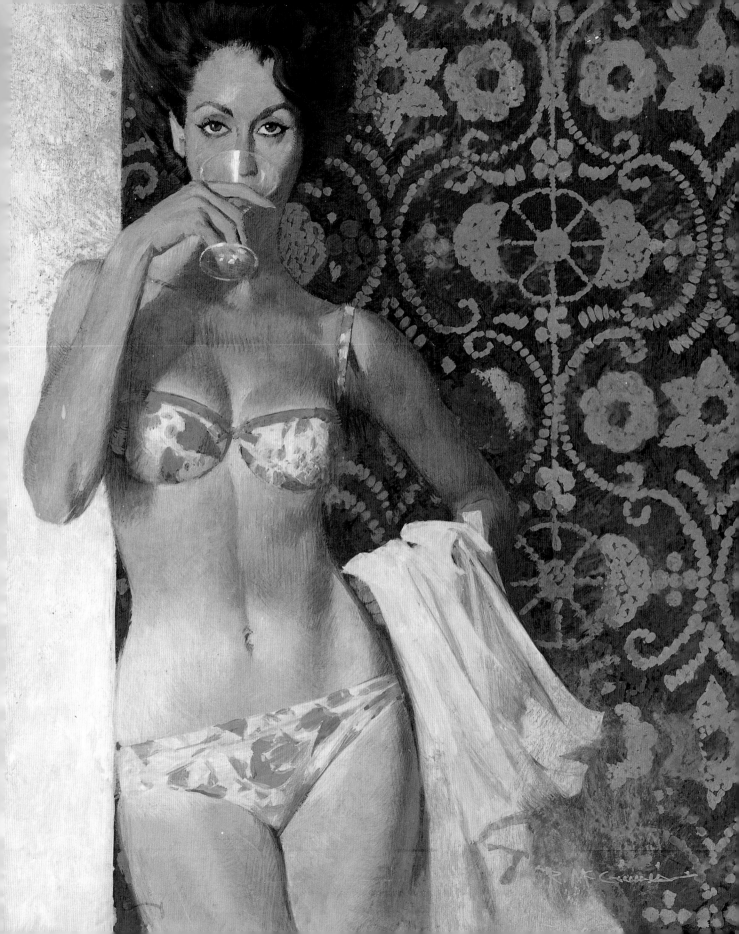

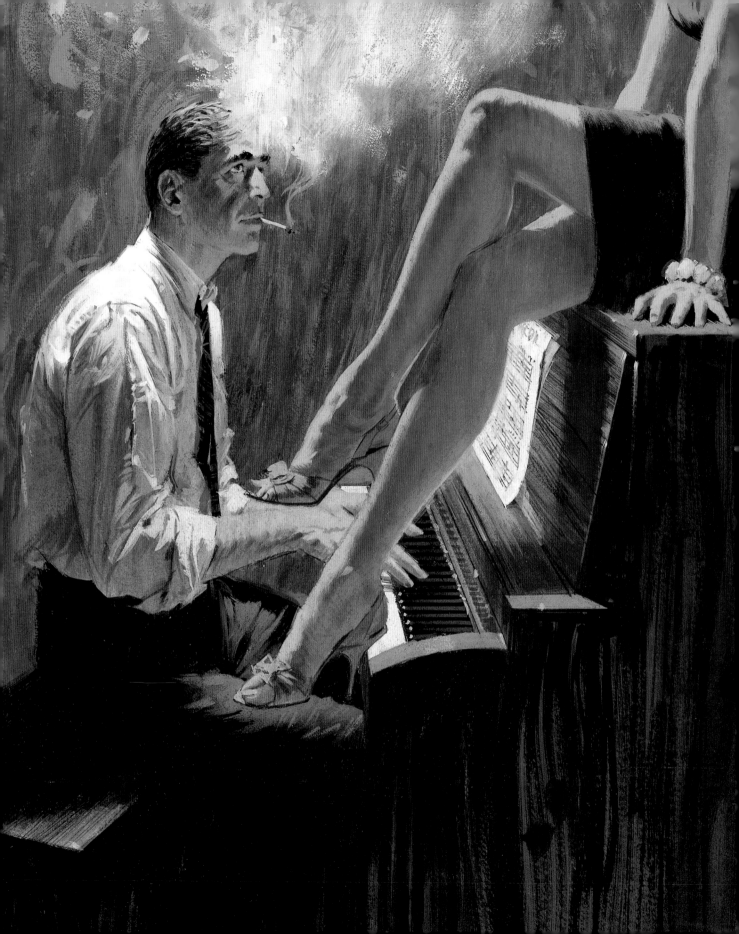

Pugh, John J.	**Blade of Honor** (M)	Popular Library	SP 252	.50		
Pyle, Howard	**The Merry Adventures of Robin Hood**	Signet	CE 2284	4.50	CE 2284	4.95

Queen, Ellery	**Kiss and Kill**	Dell	4567	.60		
Quentin, Patrick	**The Man With Two Wives**	Dell	D 322	.35		
Quinn, Colleen	**Defiant Rose** (IFC)	Diamond	672	4.99		
	Wild is the Night	Diamond	521	4.50		

Rabe, Peter	**Murder Me for Nickels**	Fawcett Gold Medal	996	.25		
Raife, Alexandra	**Drumveyn**	Signet	AE 9139	5.99	AE 9139	6.99
	Mountain Heather	Signet	AE 9140	5.99		
	Wild Highland Home (W)	Signet	AE 9469	5.99		
Rawls, Wilson	**Where the Red Fern Grows**	Bantam	27429	3.99	27429	5.99
Raynolds, Robert	**Brothers in the West** (M)	Popular Library	SP 320	.50		
Read, Piers Paul	**The Upstart** (W)	Avon	49023	2.25		
Rendell, Ruth	**No More Dying Then**	Bantam	N 7829	.95		
Renek, Morris	**Siam Miami** (BCA)	Paperback Library	68-441	1.50		
Reno, James	**Creed's Law**	Signet	AE 5664	3.50		
	Rogue River	Signet	AE 5129	2.95		
	Shadow Walker	Signet	AE 4921	2.95		
	Texas Anthem (W)	Signet	AE 4377	3.50		
	Texas Born (W)	Signet	AE 4560	3.50		
Rhys, Jean	**Wide Sargasso Sea**	Popular Library	459	.95		
Rice, Craig & Ed McBain	**The April Robin Murders**	Dell	D 306	.35		
Richter, Anne	**The Lay Analyst**	Avon	W 326	1.25		
Richter, Conrad	**The Fields**	Bantam	QP 8505	1.25	11986	1.75
	The Light in the Forest	Bantam Starfire	16679	3.50		
	The Town	Bantam	Q 8530	1.25	11985	1.75
	The Trees	Bantam	Q 8430	1.25	11987	1.75

Murder Me for Nickles 1960, gouache on board, 8 ½" x 14"

Riefe, A.R.	**Cheyenne** (W)	Signet	AE 5751	4.50		
	Salt Lake City (W)	Signet	AE 6326	4.50		
	San Francisco (W)	Signet	AE 6142	4.50		
	Tucson (W)	Signet	AE 5470	4.50		
Ripley, Alexandra	**The Time Returns** (W)	Avon	70162	4.50		
Rivoyre, Christine De	**Tangerine** (M)	Popular Library	G 449	.35		
Robbins, Harold	**Never Leave Me**	Avon	S 132	.60		
	Never Leave Me	Avon	S 228	.60		
Roberts, Ann Victoria	**Morning's Gate**	Avon	70992	5.99		
Roberts, Elizabeth Madox	**He Sent Forth a Raven**	Popular Library	2520	.60		
	Jingling In the Wind	Popular Library	2541	.60		
	The Time of Man	Popular Library	148	.95		
Roberts, Janet Louise	**The Curse of Kenton**	Avon	V 2421	.75		
	Ravenswood	Avon	V 2416	.75		
Roberts, Lee	**If the Shoe Fits**	Fawcett Crest	415	.25		
	Once A Widow	Dell	1003	.25		
Robertson, Don	**A Flag Full of Stars**	Fawcett Crest	M 838	.95	M 1316	.95
Rogers, Rosemary	**Wicked Loving Lies**	Avon	30221	1.95		
Roos, Kelley	**Requiem for a Blonde**	Dell	D 386	.35		
Ross, Clarissa	**Jade Princess** (W)	Pyramid	Y 4033	1.95		
Ross, Marilyn	**Shadow Over Denby** (W)	Popular Library	8451	1.75		

The Trees 1975, gouache on board, 10½" x 11"

Rowan, Deirdre	**Dragon's Mount**	Fawcett Gold Medal	T 2868	.75
Runyon, Charles	**Color Him Dead**	Fawcett Gold Medal	k 1320	.40
	No Place to Hide	Fawcett Gold Medal	R 2218	.60
Rushing, Jane Gilmore	**Against the Moon**	Curtis	7048	.75
	Tamzen (M)	Popular Library	8562	1.75
Ryan, J.M.	**Brooks Wilson Ltd.** (W)	Fawcett Gold Medal	R 1671	.60

Sabatini, Rafael	**Captain Blood Returns**	Popular Library	SP 207	.50
	The Hounds of God (M)	Popular Library	SP 228	.50
	Master-at-Arms (M)	Popular Library	SP 234	.50
	Mistress Wilding (M)	Popular Library	SP 222	.50
	The Sea Hawk	Popular Library	SP 109	.50
Sager, Ester	**From Moment to Moment** (W)	Jove	6221	3.50
St. Clair, Dexter	**The Lady's Not for Living**	Fawcett Gold Medal	K 1312	.40
St. John, Gail	**Dunsan House**	Dell	2182	.60
Saint-Laurent, Cecil	**The Inn of Five Lovers** (M)	Popular Library	SP 91	.50
	The Magnificent Female	Pyramid	G 446	.35
Sandburg, Carl	**The Fiery Trial**	Dell	F 77	.50

Santmeyer, Helen Hooven	**...And Ladies of the Club** (BCA)	Berkley	7704	5.95	(4 versions)
	Ohio Town	Berkely	8270	3.95	
Saroyan, William	**The Laughing Matter** (M)	Popular Library	2254	.60	
Savage, Mary	**The Coach Draws Near**	Dell	1317	.75	
Schoonover, Lawrence	**The Chancellor** (M)	Popular Library	SP 260	.50	
Scotland, Jay	**The Veils of Salome**	Avon	F 123	.40	
Selinko, Annemarie	**Desiree**	Avon	36202	2.25	
Sheldon, Walter J.	**Gold Bait**	Fawcett Gold Medal	T 2691	.75	
Shellabarger, Samuel	**Captain from Castile**	Avon	15842	1.50	
	The King's Cavalier	Avon	17442	1.50	
	Lord Vanity	Avon	16717	1.50	
	Prince of Foxes	Avon	17269	1.50	
	The Token	Popular Library	451	.50	
Shepherd, L.P.	**Cape House**	Dell	671	.95	
Sherry, Edna	**She Asked for Murder**	Dell	1004	.25	
Shiflet, Kenneth E.	**The Valiant Strain**	Dell First Edition	B 126	.35	
Short, Luke	**Brand of Empire**	Dell First Edition	D 289	.35	770 .35
	Marauders' Moon	Dell First Edition	B 130	.35	
Shulman, Irving	**Good Deeds Must Be Punished** (M)	Popular Library	434	.50	
	The Velvet Knife	Popular Library	G 436	.35	

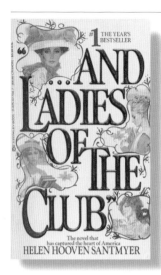
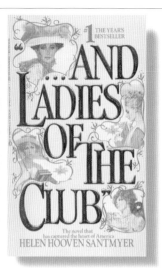
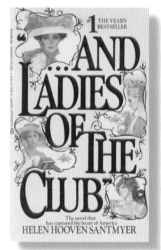

A big bestseller in more ways than one; at the time it was the thickest paperback book ever bound, 1,440 pages. McGinnis did six evocative portraits of the principal characters, each enhanced by the nineteenth century clothing and antique props. The art director, Frank Kozelek, selected four of the six portraits for the cover (all six ladies appeared in a group painting on the back cover). Bantam couldn't decide which color scheme to use, so they issued the book in four colors.

...And The Ladies of the Club 1985, gouache on board, silhouetted from the original, 29$\frac{1}{2}$" x 14"

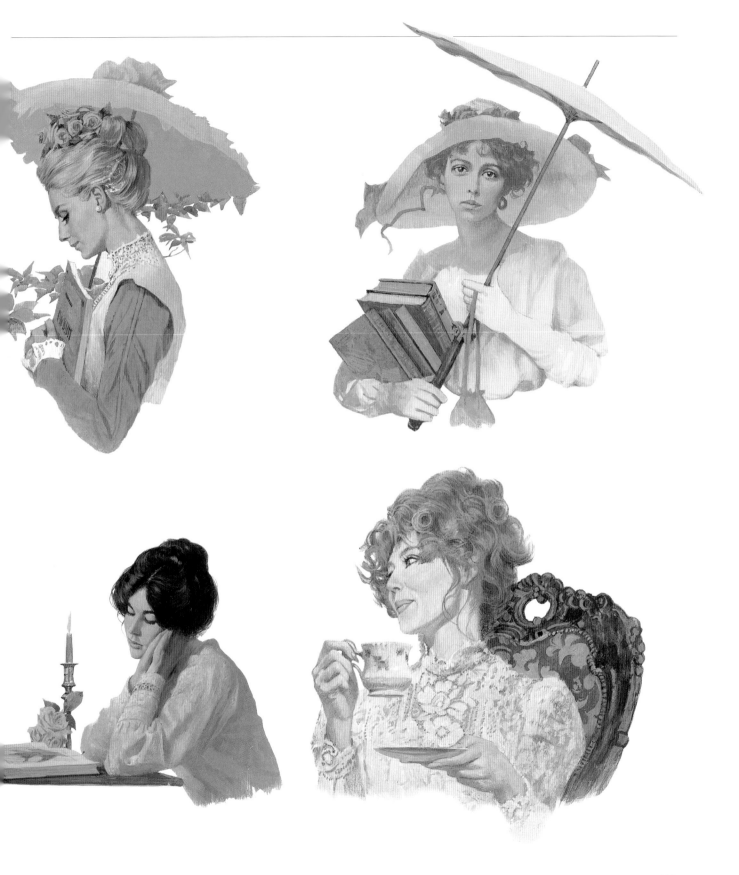

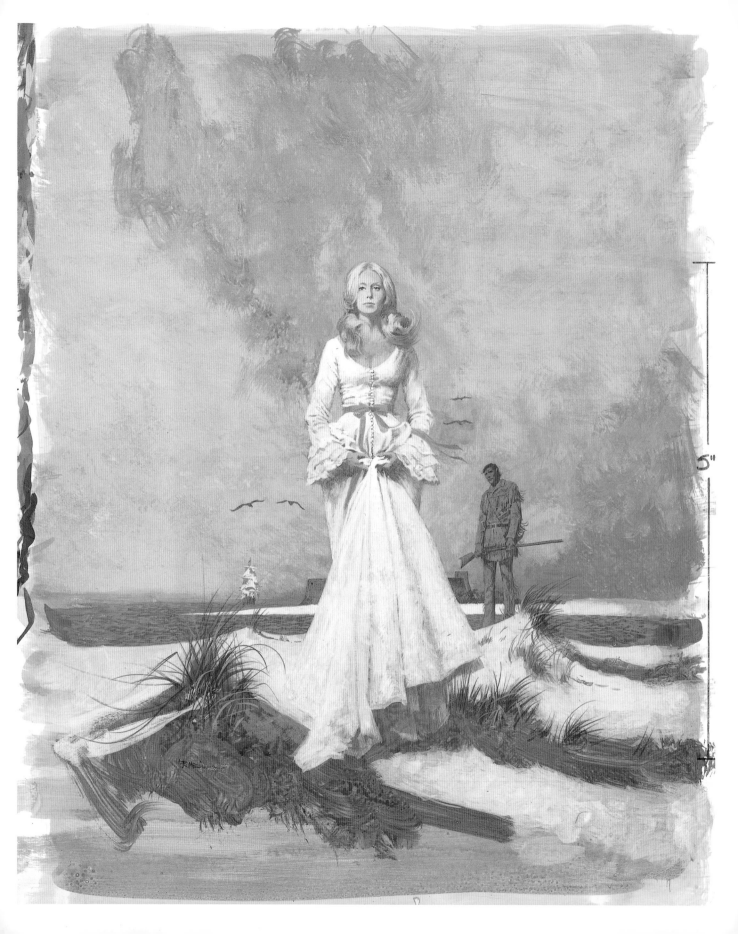

5"

Sibley, Patricia	**High Walk to Wandlemere**	Dell	3541	.95		
Simmons, Mary Kay	**The Diamonds of Alcazar**	Dell	1965	.75		
Simon, Neil	**The Odd Couple** (MTI)	Scholastic	TK 1418	.75		
Sinclair, Harold	**The Horse Soldiers** (MTI)	Dell	F76	.50		
Sinclair, James	**Warrior Queen**	Berkley	3947	2.25		
Sinclair, Michael	**How to Steal a Million** (MTI)	Signet	D 2958	.50		
Slaughter, Frank G.	**Air Surgeon**	Pocket Books	77494	.95		
	Fort Everglades	Pocket Books	77495	.95	78388	1.25
	A Savage Place	Pocket Books	77496	.95		
	The Scarlet Cord	Pocket Books	77498	.95		
	That None Should Die	Pocket Books	77497	.95		
Sleator, William	**Run**	Avon	23383	.95	45302	1.50
Small, Bertrice	**The Kadin** (W)	Avon	33746	1.95	43190	2.25
					80002	3.50
					89425	3.95
	Lost Love Found (W)	Ballantine	35275 (T)	7.95	37419	5.99
					(2 versions)	
	Love Wild And Fair (BCA)	Avon	40030	2.50	40030	3.95
Smith, Shelley	**The Shrew is Dead**	Dell	D 318	.35		
Smith, Thorne	**Did She Fall?**	Paperback Library	52-176	.50		
Solomon, Ruth Freeman	**The Candlesticks and the Cross**	Signet	Q3439	.95		

Fort Everglades 1972, gouache on board, 15" × 18"

 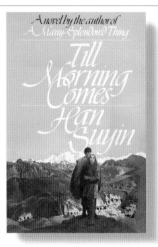 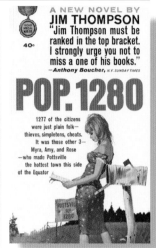

Soman, Florence Jane	**Picture of Success**	Popular Library	2187	.60		
Spencer, Scott	**Preservation Hall**	Avon	49262	1.95	52209	2.50
Spetz, Steven N.	**Rat Pack Six**	Fawcett Gold Medal	R 2182	.60		
Spillane, Mickey	**Killer Mine**	Signet	P 3483	.60		
	Me, Hood!	Signet	P 3759	.60		
Stark, Richard	**The Black Ice Score**	Fawcett Gold Medal	D 1949	.50		
	The Green Eagle Score	Fawcett Gold Medal	d 1861	.50		
	Point Blank!	Fawcett Gold Medal	d 1856	.50		
	The Rare Coin Score	Fawcett Gold Medal	d 1803	.50		
	The Sour Lemon Score	Fawcett Gold Medal	R 2037	.60		
	The Split	Fawcett Gold Medal	D 1997	.50		
Stein, Duffy	**Out of the Shadows**	Dell	16826	3.50		
Stevenson, D.E.	**Miss Buncle Married** (M)	Popular Library	1434	.75		
Steward, Davenport	**Black Spice**	Popular Library	SP 78	.50		
Stone, Hampton	**The Girl Who Kept Knocking Them Dead**	Dell	D 278	.35		
Stone, Scott C.S.	**The Dragon's Eye**	Fawcett Gold Medal	R 2157	.40	R 2554	.60
Straight, Michael	**A Very Small Remnant**	Dell	9307	.50		
Streshinsky, Shirley	**Gift of the Golden Mountain**	Berkley	12297	4.95		
	The Shores of Paradise	Berkley	13331	5.99		

Stuart, Colin	**Shoot an Arrow to Stop the Wind**	Popular Library	262	.95
Summerton, Margaret	**A Dark and Secret Place**	Avon	41301	1.75
Suyin, Han	**A Many-Splendored Thing** (W)	Bantam	22736	3.95
	Till Morning Comes	Bantam	5011 (T) (may have been issued in book club edition only)	

Tanchuck, Nathaniel	**A Certain French Girl**	Fawcett Gold Medal	k 1473	.40
Tannahill, Reay	**A Dark and Distant Shore** (W)	Dell	11696	3.95
Taylor, Beatrice	**Journey Into Danger**	Beagle	26626	.95
Taylor, Gordon	**Place of the Dawn**	Avon	34983	1.50
Telfair, Richard	**Scream Bloody Murder**	Fawcett Gold Medal	1006	.25
Terrall, Robert	**The Wow Factor**	Fawcett Gold Medal	T 2274	.75
Thane, Elswyth	**Queen's Folly** (M)	Popular Library	1316	.75
Thomas, Bob	**The Flesh Merchants**	Dell First Edition	B 133	.35
Thompson, Jim	**Pop. 1280**	Fawcett Gold Medal	k 1438	.40
Thorne, Nicola	**Cashmere** (W)	Berkley	6463	3.95

A MYSTERY BY
PHOEBE
ATWOOD
TAYLOR
WRITING AS
ALICE
TILTON

Witherall commutes to
the suburbs and death
comes along for the ride
"A favorite"—Dallas Morning News

COLD STEAL

A MYSTERY BY
PHOEBE
ATWOOD
TAYLOR
WRITING AS
ALICE
TILTON

60c

Professor Leonidas Witherall
turns sleuth and
takes a lesson in murder
"Good reading"—Time

THE CUT DIRECT

A MYSTERY BY
PHOEBE
ATWOOD
TAYLOR
WRITING AS
ALICE
TILTON

60c

Leonidas Witherall,
offbeat detective,
is haunted by neighbors,
strangers, blondes and
a most unlikely corpse
"Highly diverting"—Saturday Review

DEAD ERNEST

A MYSTERY BY
PHOEBE
ATWOOD
TAYLOR
WRITING AS
ALICE
TILTON

60c

Sleuth-of-all-trades,
Leonidas Witherall,
takes on a case of
impending murder—his own
"Fresh delight"—Houston Post

FILE FOR RECORD

A MYSTERY BY
PHOEBE
ATWOOD
TAYLOR
WRITING AS
ALICE
TILTON

60c

Leonidas Witherall,
detective extraordinary,
encounters the maddest
of all murders
"Fantastic"—New York Times

THE HOLLOW CHEST

A MYSTERY BY
PHOEBE
ATWOOD
TAYLOR
WRITING AS
ALICE
TILTON

60c

Leonidas Witherall
goes out on a limb
to find the leg of a corpse
"Highly recommended"—Boston Globe

THE LEFT LEG

McGinnis thought the Alice Tilton books
were "horrible, unreadable," but the art
director gave him "total freedom to come
up with something that would sell the
books." He had great fun with these, letting
his imagination run free, experimenting with
bright colors and a design scheme that
might be called "hallucinatory montage".

The Left Leg | 1968, gouache on board, 8½" × 7⅞"

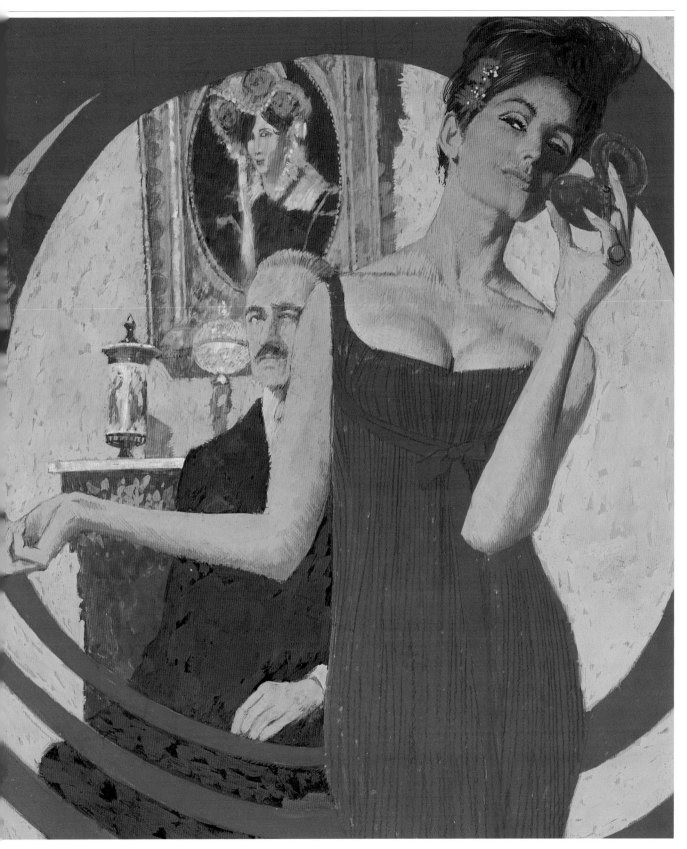

Author	Title	Publisher	No.	Price		
Thornton, Helene	**Cathay** (W)	Fawcett Gold Medal	4471	2.95		
Tilton, Alice	**Cold Steal**	Popular Library	2393	.60		
	The Cut Direct	Popular Library	2392	.60		
	Dead Ernest	Popular Library	2414	.60		
	File for Record	Popular Library	2413	.60		
	The Hollow Chest	Popular Library	2395	.60		
	The Left Leg	Popular Library	2394	.60		
Torres, Tereska	**The Dangerous Games**	Fawcett Crest	s 442	.35		
Townley, Pamela	**Rogan's Moor**	Charter	73357	3.50		
Tracy, Honor	**A Season of Mists**	Popular Library	K 11	.40		
Traver, Robert	**Anatomy of a Murder**	Dell	F75	.50	135	.75
Tree, Cornelia	**Child of the Night**	Bantam	23054	2.95		
Trevanian	**The Loo Sanction** (BCA only)	Avon	19067	1.75		
Trinian, John	**North Beach Girl**	Fawcett Gold Medal	s 1000	.35		
	Scandal on the Sand	Fawcett Gold Medal	k 1449	.40		
Troy, Katherine	**Farramonde**	Dell	2481	.60		
Truman, Margaret	**Bess W. Truman**	Jove	8973	4.50		
Twain, Mark	**The Adventures of Huckleberry Finn** (MTI)	Signet	Q 6169	.95		

Unsworth, Mair	**House of Shadows**	Avon	V 2377	.75

Van Etten, Winifred	**I Am the Fox** (M)	Popular Library	442	.50
Vaughn, Carter A.	**The Charlatan** (M)	Popular Library	SP 131	.50
	Fortress Fury (M)	Popular Library	3189	1.50
Vaughan, Robert	**Adobe Walls** (W)	St.Martin's	96737	5.99
	Blood on the Plains (W)	St.Martin's	95872	5.99
	In Honored Glory (W)	St.Martin's	97009	5.99
	Range Wars (W)	St.Martin's	96334	5.99
	Texas Glory (W)	St.Martin's	95938	5.99
	Yesterday's Reveille (W)	St.Martin's	95694	5.99
Verrette, Joyce	**Dawn of Desire** (BCA)	Avon	27375	1.95
	Desert Fires	Avon	35097	1.95
Vicary, Jean	**Castle at Glencarris**	Avon	V 2471	.75
Vichy, Bob	**All Together Now**	Berkley	Z 2259	1.25
Virga, Vincent	**Gaywyck**	Avon	75820	2.95

McGinnis submitted the painting on the left and it was approved, but he wasn't entirely satisfied with it. He thought a more sensuous approach would work better and he did a second painting, on the right, which was the one Dell ultimately used on the cover.

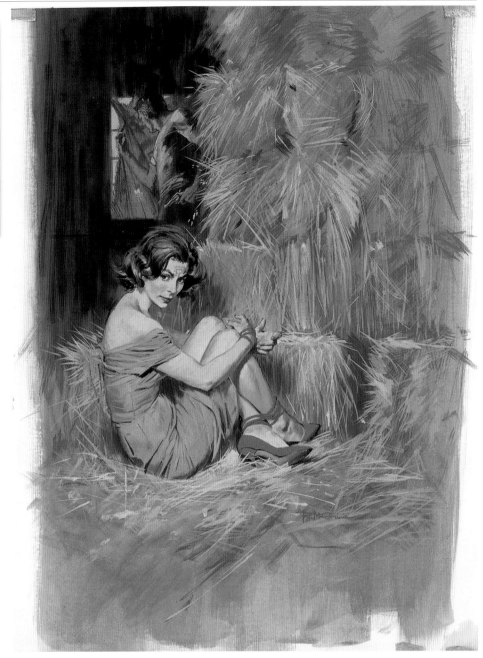

The Girl Who Cried Wolf 1960, gouache on board, 12" x 17"

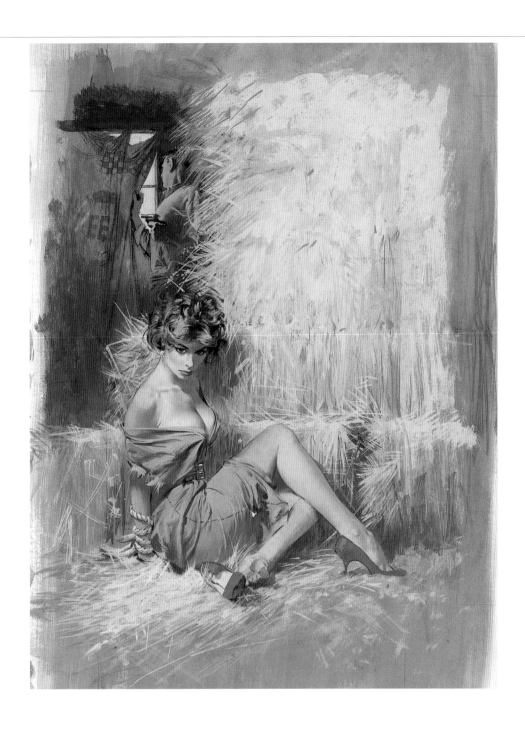

The Girl Who Cried Wolf 1960, gouache on board, 12" × 18"

Wager, Walter	**Blue Leader**	Berkley	4628	2.25		
	Blue Moon	Berkley	4929	2.50		
	Blue Murder	Berkley	5444	2.75		
Wagner, Geoffrey	**Nicchia** (M)	Popular Library	G 510	.35		
Waller, Leslie	**The American**	Fawcett Crest	P 1599	1.25		
Wallmann, Jeffrey	**Clean Sweep**	Avon	33837	1.50		
Walsh, Jill Paton	**Unleaving**	Avon	35295	1.25		
Ward, Dewey	**The House in Paris**	Dell	3789	.75		
	Reception at High Tower	Dell	7277	.60		
Warner, Sylvia Townsend	**The Barnards of Loseby**	Popular Library	181	1.25	4049	1.95
Waugh, Hillary	**The Girl Who Cried Wolf**	Dell	D 338	.35		
Webb, Jean Francis	**The Craigshaw Curse**	Dell	1548	.60		
Webb, Lucas	**Eli's Road** (M)	Popular Library	331	.95		
Weeks, Jack	**The Limbo Touch**	Fawcett Gold Medal	R 2030	.60		
Weidman, Jerome	**Other People's Money**	Fawcett Crest	m 1117	.95		
	Word of Mouth	Fawcett Crest	t 1125	.75		
Welch, James	**Winter in the Blood**	Bantam	X 2043	1.75		
Wellman, Paul I.	**The Walls of Jericho**	Curtis	9100	.95		
Werlin, Marvin & Mark	**The St. Clair Summer** (W)	Signet	AE 1201	3.50		
Weston, John	**Jolly**	Dell	4249	.60		
	The Telling	Dell	8576	.60		
White, Robin	**Be Not Afraid**	Berkley	2323	1.25		
Whittington, Harry	**Don't Speak to Strange Girls**	Fawcett Gold Medal	k1303	.40		
	Shack Road Girl	Berkley	D 2004	.35		
Widdemer, Margaret	**Buckskin Baronet** (M)	Popular Library	1363	.75		
Wilde, Jennifer	**When Love Commands** (W)	Avon	89193	3.95		
Wilder, Thornton	**The Bridge of San Luis Rey** (W)	Avon	28324	1.50		
	The Eighth Day (W)	Avon	25577	2.25		
	Theophilus North (W)	Avon	19059	1.75		
Williams, Ben Ames	**House Divided** (M)	Popular Library	EZ 27	1.25		
	The Unconquered	Popular Library	E 39	1.25	E 8181	1.50

Author	Title	Publisher	No.	Price	No.	Price
Williams, Brad and J.W. Ehrlich	**A Conflict of Interest**	Popular Library	540	.95		
	A Matter of Confidence	Popular Library	539	.95		
Williams, Charles	**Gulf Coast Girl**	Dell	D 337	.35		
	Nothing in Her Way	Fawcett Gold Medal	k 1289	.40		
Williams, Mona	**The Company Girls**	Fawcett Gold Medal	k 1503	.40		
Wilson, John Rowan	**The Side of the Angels**	Popular Library	227	.95		
Winston, Daoma	**Emerald Station** (W)	Avon	18200	1.50	38281	1.95
	The Inheritance (W)	Avon	20701	1.25		
	Moorhaven (W)	Avon	14126	1.50	29835	1.75
	The Return (W)	Avon	23341	1.50		
Wolf, Joan	**Born of the Sun**	Onyx	JE 225	5.50		
	The Edge of Light	Onyx	JE 286	5.99		
Wolfe, Winifred	**If a Man Answers** (MTI)	Dell	3966	.50		
Wood, Christopher	**James Bond and Moonraker** (MTI)	Jove	B 5344	2.25		
Woodiwiss, Kathleen E.	**The Flame and the Flower**	Avon	46276	2.50	80622	2.50
					77453	2.95
					82750	3.95
	The Wolf and the Dove	Avon	35477	2.25	77438	2.95
Woods, Sara	**The Windy Side of the Law**	Popular Library	1350	.75		

Author	Title	Publisher	No.	Price	No.	Price
York, Alison	**The Fire and the Rope**	Berkley	4045	2.50		
York, Andrew	**The Infiltrator**	Berkley	2397	.95		
Young, Stark	**So Red the Rose**	Popular Library	W 1135	.75	1227	.75

Author	Title	Publisher	No.	Price	No.	Price
Zindel, Paul	**A Begonia for Miss Applebaum**	Bantam Starfire	28765	3.50	28765	3.99
					28765	4.99
	The Pigman	Bantam Starfire	26321	2.95	26321	3.99
					26321	5.99
	The Pigman's Legacy	Bantam Starfire	26599	2.95	26599	5.50
Zolotow, Maurice	**Oh Careless Love**	Avon	T 440	.35		

Art used on Multiple Titles

AVON	Lesberg, Sandy	**Jenny**	Avon	S265	.60
	Lesberg, Sandy	**Jenny Abroad**	Avon	S254	.60

DELL	Halliday, Brett	**The Homicidal Virgin**	Dell	3698	.50
	Halliday, Brett	**Marked for Murder**	Dell	5386	.50

POPULAR LIBRARY	Andersch, Alfred	**The Redhead**	Popular Library	SP 169	.50
	Karp, Marvin Allan	**Catch a Spy**	Popular Library	SP 370	.50
	Banister, Margaret	**Burn Then, Little Lamp**	Popular Library	08546	1.95
	Stevenson, D.E.	**Miss Buncle Married**	Popular Library	1434	.75
	Barnes, Margaret Campbell	**The Tudor Rose**	Popular Library	1362	.75
	Dunnett, Dorothy	**Checkmate**	Popular Library	8483	1.95
	Basso, Hamilton	**A Touch of the Dragon**	Popular Library	SP 365	.50
	Davenport, Marcia	**Of Lena Geyer**	Popular Library	E100	.25
	Wagner, Geoffrey	**Nicchia**	Popular Library	G510	.35
	Basso, Hamilton	**The View from Pompey's Head**	Popular Library	W1149	.75
	Garnett, David	**The Ways of Desire**	Popular Library	EG435	.35
	Bowman, John Clarke	**Isle of Demons**	Popular Library	SP346	.50
	Moray, Helga	**Dark Fury**	Popular Library	SP44	.50
	Brick, John	**The Raid**	Popular Library	G476	.35
	Vaughan, Carter A.	**Fortress Fury**	Popular Library	3189	1.50
	Brontë, Charlotte	**Shirley**	Popular Library	37	1.25
	Dumas, Alexandre	**The Lady of the Camellias**	Popular Library	SP150	.50

POPULAR LIBRARY (continued)	Cameron, Lou	**The Big Lonely**	Popular Library	4200	1.50
	Capps, Benjamin	**The Brothers of Uterica**	Popular Library	253	.95
	Culp, John H.	**A Whistle in the Wind**	Popular Library	1367	.75
	Frey, Ruby Frazier	**Red Morning**	Popular Library	8550	1.95
	Eaton, Evelyn	**Give Me Your Golden Hand**	Popular Library	2429	.60
	Schoonover, Lawrence	**The Chancellor**	Popular Library	SP 260	.50
	Gebler, Ernest	**Hoffman**	Popular Library	1435	.75
	Rivoyre, Christine De	**Tangerine**	Popular Library	G449	.35
	Graham, Alice Walworth	**The Vows of the Peacock**	Popular Library	M2033	.60
	Johnston, Mary	**The Fortunes of Garin**	Popular Library	1295	.75
	Gulick, Bill	**They Came to a Valley**	Popular Library	173	.95
	Raynolds, Robert	**Brothers in the West**	Popular Library	SP320	.50
	Hardy, Thomas	**A Pair of Blue Eyes**	Popular Library	1203	.75
	Sabatini, Rafael	**Master-at-Arms**	Popular Library	SP234	.50
	Hunter, Evan	**Don't Crowd Me**	Popular Library	SP279	.50
	Saint-Laurent, Cecil	**The Inn of Five Lovers**	Popular Library	SP91	.50
	Saroyan, William	**The Laughing Matter**	Popular Library	2254	.60
	Kane, Harnett T.	**Bride of Fortune**	Popular Library	SP90	.50
	Williams, Ben Ames	**House Divided**	Popular Library	Z27	1.25
	Lancaster, Bruce	**The Secret Road**	Popular Library	1304	.75
	Vaughan, Carter A.	**The Charlatan**	Popular Library	SP131	.50
	Marshall, Rosamond	**Rogue Cavalier**	Popular Library	2151	.60
	Sabatini, Rafael	**Mistress Wilding**	Popular Library	SP222	.50
	Maugham, W. Somerset	**The Making of a Saint**	Popular Library	1271	.75
	Sabatini, Rafael	**The Hounds of God**	Popular Library	SP228	.50
	Mirabelli, Eugene	**The Burning Air**	Popular Library	EG425	.35
	Shulman, Irving	**Good Deeds Must Be Punished**	Popular Library	434	.50
	Moberg, Vilhelm	**Unto a Good Land**	Popular Library	E102	1.25
	Van Etten, Winifred	**I Am the Fox**	Popular Library	442	.50
	Moore, Arthur	**The Rivals**	Popular Library	3127	1.50
	Widdemer, Margaret	**Buckskin Baronet**	Popular Library	1363	.75
	Pugh, John J.	**Blade of Honor**	Popular Library	SP252	.50
	Thane, Elswyth	**Queen's Folly**	Popular Library	1316	.75
	Rushing, Jane Gilmore	**Tamzen**	Popular Library	8562	1.75
	Webb, Lucas	**Eli's Road**	Popular Library	331	.95
SIGNET	Brown, Carter	**Angel!**	Signet	S2094	.35
	Dark, James	**Operation Octopus**	Signet	P3303	.60

International McGinnis

Robert McGinnis's covers have appeared all over the world. This spread presents just a sampling of International McGinnis. American paperback publishers send out transparencies of cover art to overseas publishers with whom they have foreign reprint agreements. Not only is there no requirement that titles be given literal translations in foreign language editions (many titles are altered beyond recognition), there is also evidently no requirement that the artwork appear on the same book (though it's pretty much mandatory in the case of movie poster art). It's often mix and match: Stephen Marlowe covers appear on Carter Brown books; John D. MacDonald on Fleming, Prather and Gardner; Frank Kane on Brett Halliday, and so on. Often Brown and Halliday covers are switched from book to book within the series. Writers who were never so fortunate as to have McGinnis on their U.S. covers, like James Hadley Chase and Rex Stout, get lucky overseas.

Sometimes the foreign editions have better printing and less obtrusive typography than their American counterparts, but often the art is cropped, shrunk and fiddled with – just as often happens with American reprint editions. For instance here, the lovely and elaborate backgrounds in **On the Run** and **None But the Lethal Heart** have been cruelly dropped out, leaving just the figures.

Australia
Original Art: Brett Halliday
The Careless Corpse

France
Original Art: Michael & Mollie Hardwick
The Private Life of Sherlock Holmes

Germany
(Carter Brown, The Sad-Eyed Seductress)
Original Art: Stephen Marlowe
Peril is My Pay

Greece
(Richard S. Prather, Darling, It's Death)
Original Art: John D. MacDonald
All These Condemned

Norway
(Carter Brown, The Silken Nightmare)
Original Art: Carter Brown
The Silken Nightmare

Portugal
(Rex Stout, Double for Death)
Original Art: Stephen Marlowe
Drum Beat – Erica

Germany
(Ian Fleming, You Only Live Twice)
Original Art: John D. MacDonald
On the Run

Germany (Erle Stanley Gardner,
The Case of the Phantom Fortune)
Original Art: (Flipped) John D. MacDonald
Murder in the Wind

United Kingdom
Original Art: G. G. Fickling,
Girl on the Prowl

United Kingdom
Original Art: Brett Halliday
Mike Shayne's Torrid Twelve

Japan
(Ian Fleming, Diamonds Are Forever)
Original Art: Ian Fleming
Diamonds Are Forever

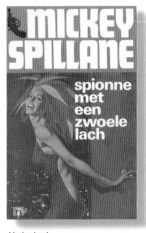

Netherlands
(Mickey Spillane, One Lonely Night)
Original Art: Brett Halliday
A Taste for Violence

United Kingdom
Original Art: William R. Cox
Death Comes Early

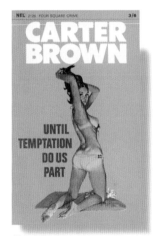

United Kingdom
Original Art: Carter Brown
None But the Lethal Heart

United Kingdom
Original Art: Brett Halliday
What Really Happened

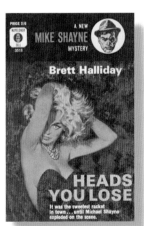

United Kingdom
Original Art: Frank Kane
Syndicate Girl

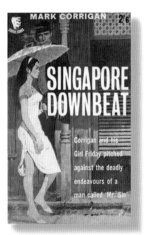

United Kingdom
Original Art: Hal G. Evarts
The Silver Concubine

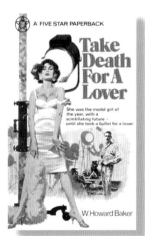

United Kingdom
Original Art: Bob Thomas
The Flesh Merchants

Index by Title

Bronze God of Rhodes, The De Camp, L. Sprague
(Bantam)

Brooks Wilson Ltd. Ryan, J. M. (Fawcett Gold Medal)

Brothers in the West Reynolds, Robert (Popular Library)

Brothers of Uterica, The Capps, Benjamin
(Popular Library)

Buckskin Baronet Widdemer, Margaret (Popular Library)

Built for Trouble Fray, Al (Dell First Edition)

Bullet for Cinderella, A MacDonald, John D.
(Fawcett Gold Medal)

Bump and Grind Murders, The Brown, Carter (Signet)

Burden of Guilt Brown, Carter (Signet)

Burn Then, Little Lamp Banister, Margaret
(Popular Library)

Burned Man, The Monig, Christopher (Paperback Library)

Burning Air, The Mirabelli, Eugene (Popular Library)

By Love Divided McKee, Jan (Pocket Books)

C

Cage for Lovers, A Powell, Dawn (Avon)

Call After Six Mergendahl, Charles (Dell First Edition)

Call for Michael Shayne [2] Halliday, Brett (Dell)

Candlesticks and the Cross, The
Solomon, Ruth Freeman (Signet)

Cape House Shepherd, L. P. (Dell)

Captain Blood Returns Sabatini, Rafael (Popular Library)

Captain from Castile Shellabarger, Samuel (Avon)

Captive Bride Lindsey, Johanna (Avon)

Careless Corpse, The Halliday, Brett (Dell)

Caribe Maracotta, Lindsay (Jove)

Case of the Bigamous Spouse, The
Gardner, Erle Stanley (Pocket Books)

Case of the Black-Eyed Blonde, The
Gardner, Erle Stanley (Pocket Books)

Case of the Blonde Bonanza, The
Gardner, Erle Stanley (Pocket Books)

Case of the Brazen Beauty Craig, Jonathan
(Fawcett Gold Medal)

Case of the Buried Clock, The Gardner, Erle Stanley
(Pocket Books)

Case of the Calendar Girl, The Gardner, Erle Stanley
(Pocket Books)

Case of the Caretaker's Cat, The
Gardner, Erle Stanley (Pocket Books)

Case of the Cautious Coquette, The
Gardner, Erle Stanley (Pocket Books)

Case of the Daring Decoy, The Gardner, Erle Stanley
(Pocket Books)

Case of the Deadly Toy, The Gardner, Erle Stanley
(Pocket Books)

Case of the Demure Defendant, The
Gardner, Erle Stanley (Pocket Books)

Case of the Duplicate Daughter, The
Gardner, Erle Stanley (Pocket Books)

Case of the Glamorous Ghost, The
Gardner, Erle Stanley (Pocket Books)

Case of the Golddigger's Purse, The
Gardner, Erle Stanley (Pocket Books)

Case of the Half-Wakened Wife, The
Gardner, Erle Stanley (Pocket Books)

Case of the Haunted Husband, The
Gardner, Erle Stanley (Pocket Books)

Case of the Hesitant Hostess, The
Gardner, Erle Stanley (Pocket Books)

Case of the Ice-Cold Hands, The
Gardner, Erle Stanley (Pocket Books)

Case of the Long-Legged Models, The
Gardner, Erle Stanley (Pocket Books)

Case of the Lucky Loser, The
Gardner, Erle Stanley (Pocket Books)

Case of the Moth-Eaten Mink, The
Gardner, Erle Stanley (Pocket Books)

Case of the One-Eyed Witness, The
Gardner, Erle Stanley (Pocket Books)

Case of the Reluctant Model, The
Gardner, Erle Stanley (Pocket Books)

Case of the Runaway Corpse, The
Gardner, Erle Stanley (Pocket Books)

Case of the Screaming Woman, The
Gardner, Erle Stanley (Pocket Books)

Case of the Shapely Shadow, The
Gardner, Erle Stanley (Pocket Books)

Case of the Silent Partner, The
Gardner, Erle Stanley (Pocket Books)

Case of the Spurious Spinster, The
Gardner, Erle Stanley (Pocket Books)

Case of the Sulky Girl, The Gardner, Erle Stanley
(Pocket Books)

Case of the Sun Bather's Diary, The
Gardner, Erle Stanley (Pocket Books)

Case of the Velvet Claws, The Gardner, Erle Stanley
(Pocket Books)

Cashmere Thorne, Nicola (Berkley)

Castle Cloud Norman, Elizabeth (Avon)

Castle at Glencarris Vicary, Jean (Avon)

Catch Me a Phoenix! Brown, Carter (Signet)

Catch Me a Spy Marton, George (Popular Library)

Catch a Spy Karp, Marvin Allen (Popular Library)

Cathay Thornton, Helene (Fawcett Gold Medal)

Cats Prowl at Night Fair, A. A. (Dell)

Cease Firing Johnston, Mary (Popular Library)

Celia Garth Bristow, Gwen (Popular Library)

Certain French Girl, A Tanchuck, Nathaniel
(Fawcett Gold Medal)

Chains of Fate, The Belle, Pamela (Berkley)

Chancellor, The Schoonover, Lawrence (Popular Library)

Change of Heart, A McCloy, Helen (Dell)

Charlatan, The Vaughan, Carter A. (Popular Library)

Charlie Sent Me! Brown, Carter (Signet)

Chateau in the Shadows Marvin, Susan (Dell)

Checkmate Dunnett, Dorothy (Popular Library)

Cheyenne Riefe, A. R. (Signet)

Child of the Night Tree, Cornelia (Bantam)

China Court Godden, Rumer (Dell)

Choice of Assassins, A McGivern, William P. (Bantam)

Christmas Without Johnny Carroll, Gladys Hasty
(Popular Library)

Clean Sweep Wallman, Jeffrey (Avon)

Climb a Dark Cliff Ashby, Kay (Dell)

Coach Draws Near, The Savage, Mary (Dell)

Cockeyed Corpse, The Prather, Richard S.
(Fawcett Gold Medal)

Coffin Bird, The Brown, Carter (Signet)

Cold Steal Tilton, Alice (Popular Library)

Color Him Dead Runyon, Charles (Fawcett Gold Medal)

Colter's Wife Johnston, Joan (Pocket Books)

Columbia Jekel, Pamela (Charter)

Comanche Woman Johnston, Joan (Pocket Books)

Come to Castlemoor Parker, Beatrice (Dell)

Coming Again Francis, Jean (Berkley)

Company Girls, The Williams, Mona (Fawcett Gold Medal)

Computer Kill, The Banks, Raymond (Popular Library)

Con Man, The McBain, Ed (Pocket Books)

Concubine, The East, Michael (Dell First Edition)

Conflict of Interest, A Williams, Brad (Popular Library)

Congo Crichton, Michael (Avon)

Contrary Pleasure MacDonald, John D.
(Fawcett Gold Medal)

Cop Hater McBain, Ed (Pocket Books)

Corpse, The Brown, Carter (Signet)

Corpse Came Calling, The [2] Halliday, Brett (Dell)

Corpse That Never Was, The Halliday, Brett (Dell)

Corpse for Christmas, A Brown, Carter (Signet)

Corridor, The Fuller, Edmund (Bantam)

Cost of a Killing Cotton, Ralph (Pocket Books)

Cotillion, The Killens, John Oliver (Pocket Books)

Cotton Comes to Harlem Himes, Chester (Dell)

Counterfeit Wife [2] Halliday, Brett (Dell)

Country Team, The Moore, Robin (Fawcett Crest)

Coven, The Brown, Carter (Signet)

Craigshaw Curse, The Webb, Jean Francis (Dell)

Creative Murders, The Brown, Carter (Signet)

Creed's Law Reno, James (Signet)

Crossroads, The MacDonald, John D.
(Fawcett Gold Medal)

Crows Can't Count Fair, A. A. (Dell)

Crusoe Test, The Nelson, Mark (Avon)

Cry Hard, Cry Fast [2] MacDonald, John D.
(Fawcett Gold Medal)

Curse of Kenton, The Roberts, Janet Louise (Avon)

Cut Direct, The Tilton, Alice (Popular Library)

D

Daily Bread Maloney, Ralph (Fawcett Crest)

Dakota Dream MacIver, Sharon (Diamond)

Dame, The Brown, Carter (Signet)

Damnation of Adam Blessing, The Packer, Vin (Fawcett Gold Medal)

Damned, The MacDonald, John D. (Fawcett Gold Medal)

Dance With the Dead Prather, Richard S. (Fawcett Gold Medal)

Dance of Death, The Brown, Carter (Signet)

Dangerous Dames Halliday, Brett (Dell)

Dangerous Games, The Torres, Tereska (Fawcett Crest)

Dangerous Landing McGerr, Patricia (Dell)

Dark Changeling Lamont, Marianne (Avon)

Dark Fury Moray, Helga (Popular Library)

Dark and Distant Shore, A Tannahill, Reay (Dell)

Dark and Secret Place, A Summerton, Margaret (Avon)

Darker Than Amber MacDonald, John D. (Fawcett Gold Medal)

Darling, It's Death Prather, Richard S. (Fawcett Gold Medal)

Date With a Dead Man [2] Halliday, Brett (Dell)

Dawn of Desire Verrette, Joyce (Avon)

Day It Rained Diamonds, The Chaber, M. E. (Paperback Library)

Dead Ernest Tilton, Alice (Popular Library)

Dead Line, The McCutchan, Philip (Berkley)

Dead Low Tide MacDonald, John D. (Fawcett Gold Medal)

Dead Man's Diary & A Taste for Cognac [2] Halliday, Brett (Dell)

Dead Wrong Bagby, George (Dell)

Deadly Kitten, The Brown, Carter (Signet)

Deadly Shade of Gold, A MacDonald, John D. (Fawcett Gold Medal)

Deadly Welcome [2] MacDonald, John D. (Dell First Edition)

Death Comes Early Cox, William R. (Dell First Edition)

Death Deep Down Marlowe, Dan J. (Fawcett Gold Medal)

Death Has Three Lives Halliday, Brett (Dell)

Death Out of Focus Gault, Bill (Dell)

Death Trap MacDonald, John D. (Fawcett Gold Medal)

Death at the Isthmus Coxe, George Harmon (Popular Library)

Death on the Verandah Manson, Cynthia (Berkley)

Deceivers, The MacDonald, John D. (Fawcett Gold Medal)

Deep Cold Green, The Brown, Carter (Signet)

Defiant Rose Quinn, Colleen (Diamond)

Delilah Cooper, Jefferson (Paperback Library)

Delilah's Mountain Jahoda, Gloria (Popular Library)

Desert Fires Verrette, Joyce (Avon)

Desert Love Montherlant, Henry de (Berkley)

Desired, The Brown, Carter (Signet)

Desiree Selinko, Annemarie (Avon)

Devil's Marchioness, The Fifield, William (Avon)

Diamonds Are Forever Fleming, Ian (Bantam)

Diamonds of Alcazar, The Simmons, Mary Kay (Dell)

Did She Fall? Smith, Thorne (Paperback Library)

Die Anytime, After Tuesday! Brown, Carter (Signet)

Die Like a Dog [2] Halliday, Brett (Dell)

Dig That Crazy Grave Prather, Richard S. (Fawcett Gold Medal)

Digging the Love Goddess Martin, Jay (Berkley)

Disorderly Knights, The Dunnett, Dorothy (Popular Library)

Dividend on Death Halliday, Brett (Dell)

Divine Average Kirkland, Elithe Hamilton (Avon)

Dolls Are Deadly Halliday, Brett (Dell)

Don't Count the Corpses Monig, Christopher (Dell)

Don't Crowd Me Hunter, Evan (Popular Library)

Don't Speak to Strange Girls Whittington, Harry (Fawcett Gold Medal)

Double or Quits Fair, A. A. (Dell)

Downriver Hobbs, Will (Bantam Starfire)

Dragon's Eye, The Stone, Scott C. S. (Fawcett Gold Medal)

Dragon's Mount Rowan, Deirdre (Fawcett Gold Medal)

Dreadful Lemon Sky, The MacDonald, John D. (Fawcett Gold Medal)

Dress Her In Indigo [2] MacDonald, John D. (Fawcett Gold Medal)

Drum Beat – Dominique Marlowe, Stephen (Fawcett Gold Medal)

Drum Beat – Erica Marlowe, Stephen (Fawcett Gold Medal)

Drum Beat – Madrid Marlowe, Stephen (Fawcett Gold Medal)

Drum Beat – Marianne Marlowe, Stephen (Fawcett Gold Medal)

Drumveyn Raife, Alexandra (Onyx)

Dumdum Murder, The Brown, Carter (Signet)

Dunsan House St. John, Gail (Dell)

Duo, A Drought, James (Fawcett Crest)

E

East 57th Street Jackson, Alan R. (Dell)

East Indiaman, The Meacham, Ellis K. (Popular Library)

Edge of Light, The Wolf, Joan (Onyx)

Eighth Circle, The Ellin, Stanley (Dell)

Eighth Day, The Wilder, Thornton (Avon)

Eli's Road Webb, Lucas (Popular Library)

Embezzler, The Auchincloss, Louis (Avon)

Emerald Station Winston, Daoma (Avon)

Empty Hours, The McBain, Ed (Pocket Books)

Empty Trap, The MacDonald, John D. (Fawcett Gold Medal)

End of the Night, The MacDonald, John D. (Fawcett Gold Medal)

Epitaph for a Dead Beat Markson, David (Dell First Edition)

Epitaph for a Tramp Markson, David (Dell First Edition)

Exit Dying Olesker, Harry (Dell)

Exotic, The Brown, Carter (Signet)

F

Falling Star Macdonald, Elisabeth (Pocket Books)

False Scent Marsh, Ngaio (Fawcett Crest)

Famished Land, The Byrd, Elizabeth (Avon)

Farramonde Troy, Katherine (Dell)

Fields, The Richter, Conrad (Bantam)

Fiery Trial, The Sandburg, Carl (Dell)

File for Record Tilton, Alice (Popular Library)

Find This Woman Prather, Richard S. (Fawcett Gold Medal)

Finding Out Baird, Thomas (Avon)

Fire and the Rope, The York, Alison (Berkley)

Firecloud Murray, E. P. (Charter)

Firefly Summer Binchy, Maeve (Dell)

Fires of Winter Lindsey, Johanna (Avon)

Fit to Kill [2] Halliday, Brett (Dell)

Flag Full of Stars, A Robertson, Don (Fawcett Crest)

Flagellator, The Brown, Carter (Signet)

Flame and the Flower, The Woodiwiss, Kathleen E. (Avon)

Flaming Man, The Chaber, M. E. (Paperback Library)

Flash of Green, A MacDonald, John D. (Fawcett Gold Medal)

Flashpoint Marlowe, Dan J. (Fawcett Gold Medal)

Flesh Merchants, The Thomas, Bob (Dell First Edition)

Flush Times Miller, Warren (Fawcett Crest)

Follow the River Mayer, Albert (Popular Library)

Fools Die on Friday Fair, A. A. (Dell)

Forbidden Dawn Pelton, Sonya T. (Zebra)

Fort Everglades Slaughter, Frank G. (Pocket Books)

Fortress Fury Vaughan, Carter A. (Popular Library)

Fortunes of Garin, The Johnston, Mary (Popular Library)

Four Days Buell, John (Popular Library)

Framed in Blood [2] Halliday, Brett (Dell)

Francesca Marlowe, Stephen (Fawcett Gold Medal)

Frank Kane's Stacked Deck Kane, Frank (Dell First Edition)

Frenzy La Bern, Arthur (Paperback Library)

From Distant Shores Nicolayson, Bruce (Avon)

From Moment to Moment Sager, Esther (Jove)

Frontier Woman Johnston, Joan (Pocket Books)

Fun City Girls, The Harris, Ruth (Dell)

G

Gallows Garden, The Chaber, M. E. (Paperback Library)

Gallows Wedding Martin, Rhona (Berkley)

Game of Kings, The Dunnett, Dorothy (Popular Library)

Gaywyck Virga, Vincent (Avon)

Gentian Hill Goudge, Elizabeth (Popular Library)

Gentle Feuding, A Lindsey, Johanna (Avon)

Gettysburg Brick, John (Popular Library)

Gibraltar Road McCutchan, Philip (Berkley)

Gift of the Golden Mountain Streshinsky, Shirley (Berkley)

Gigante Mandel, Sidney (Avon)

Girl Cage, The Ehrlich, Jack (Dell)

Girl Who Cried Wolf, The Waugh, Hillary (Dell)

Girl Who Kept Knocking Them Dead, The
 Stone, Hampton (Dell)

Girl Who Was Possessed, The Brown, Carter (Signet)

Girl from Easy Street, The Foster, Richard
 (Popular Library)

Girl in a Shroud Brown, Carter (Signet)

Girl in the Plain Brown Wrapper, The [2]
 MacDonald, John D. (Fawcett Gold Medal)

Girl on the Best Seller List, The Packer, Vin
 (Fawcett Gold Medal)

Girl on the Prowl Fickling, G. G. (Pyramid)

Girl, the Gold Watch & Everything, The
 MacDonald, John D. (Fawcett Gold Medal)

Give Me Your Golden Hand Eaton, Evelyn
 (Popular Library)

Give Us Forever Peale, Constance F.
 (Worldwide Super Romance)

Glass People Godwin, Gail (Warner)

Glorious Angel Lindsey, Johanna (Avon)

God and Sarah Pedlock Longstreet, Stephen (Avon)

Gold Bait Sheldon, Walter J. (Fawcett Gold Medal)

Gold Comes in Bricks Fair, A. A. (Dell)

Golden Urge, The Kyle, Robert (Fawcett Gold Medal)

Golden Youth of Lee Prince, The Goodman, Aubrey
 (Fawcett Crest)

Good Deeds Must Be Punished Shulman, Irving
 (Popular Library)

Good Time Girl Kingery, Don (Dell First Edition)

Good Year for Dwarfs?, A Brown, Carter (Signet)

Goodbye, Mr. Chips Hilton, James (Bantam Starfire)

Gracie Square Nicolayson, Bruce (Avon)

Grasslands Brundy, Clyde M. (Avon)

Greater Hunger, The Borland, Barbara (Popular Library)

Greek Tycoon, The Lottman, Eileen (Warner)

Green Dragon, White Tiger Motley, Annette (Onyx)

Green Eagle Score, The Stark, Richard
 (Fawcett Gold Medal)

Green Grow the Graves Chaber, M. E.
 (Paperback Library)

Green Margins O'Donnell, E. P. (Popular Library)

Guilt-Edged Cage, The Brown, Carter (Signet)

Guilty as Hell Halliday, Brett (Dell)

Gulf Coast Girl Williams, Charles (Dell)

Gypsy Sixpence Marshall, Edison (Dell)

H

Had I But Groaned Brown, Carter (Signet)

Half-Caste, The Cushman, Dan (Dell First Edition)

Hammer of Thor, The Brown, Carter (Signet)

Hang-Up Kid, The Brown, Carter (Signet)

Hangman's Harvest Chaber, M. E. (Paperback Library)

Hannah Herself Franchere, Ruth (Avon)

Harry and the Bikini Bandits Heatter, Basil
 (Fawcett Gold Medal)

Harvest of Dreams Edwards, Jaroldeen (Onyx)

He Sent Forth a Raven Roberts, Elizabeth Madox
 (Popular Library)

He and She Le Comte, Edward (Avon)

Heads You Lose Halliday, Brett (Dell)

Hearse of Another Color, A Chaber, M. E.
 (Paperback Library)

Heart of a Stranger Laurence, Margaret (Bantam Seal)

Heart of Thunder Lindsey, Johanna (Avon)

Heart So Wild, A Lindsey, Johanna (Avon)

Hellcat, The Brown, Carter (Signet)

Herb Gatherers, The Harris, Elizabeth (Avon)

Here Comes a Hero Block, Lawrence
 (Fawcett Gold Medal)

High Flying Percivall, Julia (Avon)

High Walk to Wandlemere Sibley, Patricia (Dell)

Hoffman Gebler, Ernest (Popular Library)

Hollow Chest, The Tilton, Alice (Popular Library)

Homecoming Bowden, Susan (Signet)

Homicidal Virgin, The [2] Halliday, Brett (Dell)

Hondo L'Amour, Louis (Bantam)

Hong Kong Caper, The Brown, Carter (Signet)

Horse Soldiers, The Sinclair, Harold (Dell)

Horse in the Gray Flannel Suit, The Hatch, Eric
 (Dell Laurel Leaf)

Hounds of God, The Sabatini, Rafael (Popular Library)

House Dick Davis, Gordon (Fawcett Gold Medal)

House Divided Williams, Ben Ames (Popular Library)

House in Paris, The Ward, Dewey (Dell)

House of Dark Laughter Napier, Melissa (Avon)

House of Shadows Unsworth, Mair (Avon)

House of Sorcery Brown, Carter (Signet)

House on Q Street, The Dietrich, Robert
 (Dell First Edition)

How to Steal a Million Sinclair, Michael (Signet)

I

I Am the Fox Van Etten, Winifred (Popular Library)

I Start Counting Lindop, Audrey Erskine (Dell)

I, Lucifer O'Donnell, Peter (Fawcett Crest)

Ice-Cold Nude, The [2] Brown, Carter (Signet)

If This Is Love, I'll Take Spaghetti Conford, Ellen
 (Scholastic)

If a Man Answers Wolfe, Winifred (Dell)

If the Reaper Ride Norman, Elizabeth (Avon)

If the Shoe Fits Roberts, Lee (Fawcett Crest)

In Honored Glory Vaughan, Robert (St. Martin's)

In a Deadly Vein [2] Halliday, Brett (Dell)

Incident at Hawk's Hill Eckert, Allan W. (Bantam Starfire)

Infiltrator, The York, Andrew (Berkley)

Inheritance, The Winston, Daoma (Avon)

Injustice Collectors, The Auchincloss, Louis (Avon)

Inn of Five Lovers, The Saint-Laurent, Cecil
 (Popular Library)

Inn of the Sixth Happiness, The Burgess, Alan (Bantam)

Innocent, The Jones, Madison (Popular Library)

Innocent Bystanders, The Munro, James (Bantam)

Invisible Flamini, The Brown, Carter (Signet)

Invitation to Live Douglas, Lloyd C. (Popular Library)

Is That Your Best Offer? Auerbach, Arnold M.
 (Paperback Library)

Isle of Demons Bowman, John Clarke (Popular Library)

J

Jade Princess Ross, Clarissa (Pyramid)

Jade for a Lady Chaber, M. E. (Paperback Library)

Jade-Eyed Jungle, The Brown, Carter (Signet)

James Bond and Moonraker Wood, Christopher (Jove)

Jamintha Parker, Beatrice (Dell)

Jane-Emily Clapp, Patricia (Dell)

Jenny [2] Lesberg, Sandy (Avon)

Jenny Abroad Lesberg, Sandy (Avon)

Jericho Costello, Anthony (Bantam)

Jeweled Dagger, The Ellis, Julie (Dell)

Jezebel Cooper, Jefferson (Paperback Library)

Jingling in the Wind Roberts, Elizabeth Madox
 (Popular Library)

Joker in the Deck Prather, Richard S.
 (Fawcett Gold Medal)

Jolly Weston, John (Dell)

Journey Into Danger Taylor, Beatrice (Beagle)

Journeyer, The Jennings, Gary (Avon)

Judge Me Not MacDonald, John D. (Fawcett Gold Medal)

Judith Cleeve, Brian (Berkley)

K

Kadin, The Small, Bertrice (Avon)

Kill My Love Hunt, Kyle (Fawcett Crest)

Kill Now, Pay Later Kyle, Robert (Dell First Edition)

Kill the Clown Prather, Richard S. (Fawcett Gold Medal)

Killer Mine Spillane, Mickey (Signet)

Killer's Choice McBain, Ed (Pocket Books)

Killer's Payoff McBain, Ed (Pocket Books)

Killers from the Keys Halliday, Brett (Dell)

Killers of Man Cotton, Ralph (Pocket Books)

King's Cavalier, The Shellabarger, Samuel (Avon)

Kingston Fortune, The Longstreet, Stephen (Avon)

Kiss and Kill Queen, Ellery (Dell)

L

Lady Is Available, The Brown, Carter (Signet)

Lady Is Transparent, The [2] Brown, Carter (Signet)

Lady of the Camellias, The Dumas, Alexandre (Popular Library)

Lady's Not for Living, The St. Clair, Dexter (Fawcett Gold Medal)

Lady, Lady, I Did It! McBain, Ed (Pocket Books)

Lament for a Lousy Lover Brown, Carter (Signet)

Land Remembers, The Logan, Ben (Avon)

Laughing Matter, The Saroyan, William (Popular Library)

Lay Analyst, The Richter, Anne (Avon)

Leanna Kiraly, Marie (Berkley)

Leave Cancelled Monsarrat, Nicholas (Dell)

Left Leg, The Tilton, Alice (Popular Library)

Legacy Hurd, Florence (Avon)

Legacy of a Spy Maxfield, Henry S. (Fawcett Crest)

Leopard, The Lampedusa, Giuseppe Di (Avon)

Lethal Sex, The MacDonald, John D. (Dell First Edition)

Letters from Philippa Estern, Anne Graham (Bantam Skylark)

Levkas Man Innes, Hammond (Avon)

Lie Down, Killer Prather, Richard S. (Fawcett Gold Medal)

Light Here Kindled, The Carroll, Gladys Hasty (Popular Library)

Light in the Forest, The Richter, Conrad (Bantam Starfire)

Like Love McBain, Ed (Pocket Books)

Limbo Touch, The Weeks, Jack (Fawcett Gold Medal)

Lion House, The Lee, Marjorie (Fawcett Crest)

Lionors Johnson, Barbara Ferry (Avon)

Live and Let Die Fleming, Ian (Bantam)

Lonely Graves, The Monig, Christopher (Paperback Library)

Lonely Walk, A Chaber, M. E. (Paperback Library)

Long Hunt Boyd, James (Bantam)

Long Knife, The Brennan, Louis A. (Dell First Edition)

Long Lavender Look, The [2] MacDonald, John D. (Fawcett Gold Medal)

Long Riders, The Cushman, Dan (Fawcett Gold Medal)

Long Roll, The Johnston, Mary (Popular Library)

Long Rope, The Evarts, Hal G. (Dell First Edition)

Long Time No Leola Brown, Carter (Signet)

Loo Sanction, The Trevanian, (Avon)

Loophole, or How to Rob a Bank Pollock, Robert (Fawcett Crest)

Lord Vanity Shellabarger, Samuel (Avon)

Losing People Baird, Thomas (Avon)

Lost Love Found Small, Bertrice (Ballantine)

Love Affair Carson, Robert (Popular Library)

Love Is a Wild Assault Kirkland, Elithe Hamilton (Avon)

Love Lush, The Connell, Vivian (Pyramid)

Love Only Once Lindsey, Johanna (Avon)

Love Or Whatever It Is Leslie, Warren (Fawcett Crest)

Love Wild and Fair Small, Bertrice (Avon)

Love and Dreams Hagan, Patricia (Avon)

Love and Fury Hagan, Patricia (Avon)

Love and Glory Hagan, Patricia (Avon)

Love and Honor Hagan, Patricia (Avon)

Love and Splendor Hagan, Patricia (Avon)

Love and Triumph Hagan, Patricia (Avon)

Love and War Hagan, Patricia (Avon)

Love of Elspeth Baker, The Kaufmann, Myron S. (Bantam)

Lover, The Brown, Carter (Signet)

Lover, Don't Come Back Brown, Carter (Signet)

Loving and the Dead, The Brown, Carter (Signet)

Lyon's Pride Craig, Mary Shura (Jove)

M

Magnificent Female, The Saint-Laurent, Cecil (Pyramid)

Making of a Saint, The Maugham, W. Somerset (Popular Library)

Man Called Noon, The L'Amour, Louis (Bantam)

Man Chasers, The Pinchot, Ann (Avon)

Man Inside, The Chaber, M. E. (Paperback Library)

Man With Two Wives, The Quentin, Patrick (Dell)

Man for All Women, A Brossard, Chandler (Fawcett Gold Medal)

Man from Moscow, The McCutchan, Philip (Berkley)

Man in the Middle, A Chaber, M. E. (Paperback Library)

Man of Affairs, A MacDonald, John D. (Fawcett Gold Medal)

Many-Splendored Thing, A Suyin, Han (Bantam)

Marauders' Moon Short, Luke (Dell First Edition)

Marianne and the Masked Prince Benzoni, Juliette (Berkley)

Marika Porter, Darwin (Berkley)

Marked for Murder [3] Halliday, Brett (Dell)

Marked! Bristow, Bob (Dell First Edition)

Master of Blue Mire, The Coffman, Virginia (Dell)

Master of Castile Edwards, Samuel (Curtis)

Master of Penrose, The Hodge, Jane Aiken (Dell)

Master of This Vessel Griffin, Gwyn (Avon)

Master-at-Arms Sabatini, Rafael (Popular Library)

Matter of Confidence, A Williams, Brad (Popular Library)

Maura Granbeck, Marilyn (Jove)

Me, Hood! Spillane, Mickey (Signet)

Memories and Ashes Davis, Kathryn (Jove)

Merchants of Venus Evslin, Bernard (Fawcett Gold Medal)

Mermaid on the Rocks Halliday, Brett (Dell)

Merry Adventures of Robin Hood, The Pyle, Howard (Signet)

Miami Golden Boy Kastle, Herbert (Avon)

Michael Shayne's Long Chance [2] Halliday, Brett (Dell)

Middle Window, The Goudge, Elizabeth (Popular Library)

Mike Shayne's 50th Case Halliday, Brett (Dell)

Mike Shayne's Torrid Twelve Halliday, Brett (Dell First Edition)

Mina Kiraly, Marie (Berkley)

Mini-Murders, The Brown, Carter (Signet)

Mink Is for a Minx Margulies, Leo (Dell)

Miss Buncle Married Stevenson, D. E. (Popular Library)

Mistress Wilding Sabatini, Rafael (Popular Library)

Mistress to Murder Dietrich, Robert (Dell First Edition)

Model for Murder Kyle, Robert (Dell First Edition)

Modesty Blaise O'Donnell, Peter (Fawcett Crest)

Moment of Danger MacKenzie, Donald (Dell)

Moment's Surrender, A Lindquist, Donald (Avon)

Money, Marbles and Chalk Fairbairn, Douglas (Berkley)

Moon By Night, The Packer, Joy (Popular Library)

Moon in the Water, The Belle, Pamela (Berkley)

Moonflower Vine, The Carleton, Jetta (Bantam)

Moonsong Bennett, Constance (Diamond)

Moorhaven Winston, Daoma (Avon)

Morning Sky Bennett, Constance (Diamond)

Morning's Gate Roberts, Ann Victoria (Avon)

Moscow Coach McCutchan, Philip (Berkley)

Moth, The Cookson, Catherine (Pocket Books)

Mountain Heather Raife, Alexandra (Signet)

Mudlark, The Bonnet, Theodore (Popular Library)

Mugger, The McBain, Ed (Pocket Books)

Mum's the Word for Murder Halliday, Brett (Dell)

Murder By Proxy Halliday, Brett (Dell)

Murder Is My Business Halliday, Brett (Dell)

Murder Is So Nostalgic! Brown, Carter (Signet)

Murder Is a Package Deal Brown, Carter (Signet)

Murder Is the Message Brown, Carter (Signet)

Murder Me for Nickels Rabe, Peter (Fawcett Gold Medal)

Murder Spins the Wheel Halliday, Brett (Dell)

Murder Takes No Holiday [2] Halliday, Brett (Dell)

Murder Wears a Mantilla Brown, Carter (Signet)

Murder and the Married Virgin Halliday, Brett (Dell)

Murder and the Wanton Bride [2] Halliday, Brett (Dell)

Murder for the Bride MacDonald, John D. (Fawcett Gold Medal)

Murder in Haste Halliday, Brett (Dell)

Murder in Miami Halliday, Brett (Dell)

Murder in the Family Way Brown, Carter (Signet)

Murder in the Key Club Brown, Carter (Signet)

Murder in the Wind [2] MacDonald, John D. (Fawcett Gold Medal)

Murder on Her Mind Dietrich, Robert (Dell First Edition)

Murder on the Mistral Malo, Vincent Gaspard (Fawcett Crest)

Murder's Burning Courtier, S. H. (Popular Library)

Murderer Among Us, A [2] Brown, Carter (Signet)

My Geisha Cooper, Saul (Dell First Edition)

My Hero Carson, Robert (Fawcett Crest)

My Lady Captor Jennet, Anna (Jove)

My Path Belated Ames, Norma (Avon)

Nell Kimball Longstreet, Stephen (Berkley)

N

Neon Jungle, The MacDonald, John D.
 (Fawcett Gold Medal)
Never Kill a Client Halliday, Brett (Dell)
Never Leave Me [2] Robbins, Harold (Avon)
Never-Was Girl, The Brown, Carter (Signet)
New Yorkers, The Calisher, Hortense (Avon)
Nicchia Wagner, Geoffrey (Popular Library)
Nice Fillies Finish Last Halliday, Brett (Dell)
Night School Cassill, R.V. (Dell First Edition)
Night Without Sleep Moll, Elick (Paperback Library)
Nightmare in Pink MacDonald, John D.
 (Fawcett Gold Medal)
No Blonde Is an Island Brown, Carter (Signet)
No Grave for March Chaber, M. E. (Paperback Library)
No More Dying Then Rendell, Ruth (Bantam)
No Place to Hide Runyon, Charles (Fawcett Gold Medal)
No Tears for the Dead Foley, Rae (Dell)
No Tears from the Widow Brown, Carter (Signet)
None But the Lethal Heart Brown, Carter (Signet)
Nonesuch Lure, The Luke, Mary (Berkley)
Norah Hill, Pamela (Fawcett Crest)
North Beach Girl Trinian, John (Fawcett Gold Medal)
North Dallas Forty Gent, Peter (Signet)
Not Dead Yet Banko, Daniel (Fawcett Gold Medal)
Nothing In Her Way Williams, Charles
 (Fawcett Gold Medal)
Now, Will You Try for Murder? Olesker, Harry (Dell)
Nude – With a View Brown, Carter (Signet)
Nylon Island, The Longstreet, Stephen
 (Fawcett Gold Medal)
Nymph to the Slaughter [2] Brown, Carter (Signet)

O

Odd Couple, The Simon, Neil (Scholastic)
Odd Woman, The Godwin, Gail (Warner)
Of Lena Geyer Davenport, Marcia (Popular Library)
Oh Careless Love Zolotow, Maurice (Avon)
Ohio Town Santmyer, Helen Hooven (Berkley)
Old Masters, The Baird, Thomas (Avon)
On Maiden Lane Nicolayson, Bruce (Avon)
On the Run [2] MacDonald, John D. (Fawcett Gold Medal)
Once Upon a Crime Monig, Christopher
 (Paperback Library)
Once a Widow Roberts, Lee (Dell)
One Fearful Yellow Eye MacDonald, John D.
 (Fawcett Gold Medal)
One Monday We Killed Them All MacDonald, John D.
 (Fawcett Gold Medal)
One More Spring Nathan, Robert (Popular Library)
One Night With Nora Halliday, Brett (Dell)
One Wife's Ways Fox, Gardner F. (Fawcett Gold Medal)
Only Girl in the Game, The [2] MacDonald, John D.
 (Fawcett Gold Medal)

Only the Very Rich Brown, Carter (Signet)
Operation Fireball Marlowe, Dan J.
 (Fawcett Gold Medal)
Operation Octopus Dark, James (Signet)
Opium Flower Cushman, Dan (Bantam)
Other I, The Lotan, Yael (Bantam)
Other People's Money Weidman, Jerome
 (Fawcett Crest)
Out of the Shadows Stein, Duffy (Dell)
Over Her Dear Body Prather, Richard S.
 (Fawcett Gold Medal)

P

Pagans, The Harrison, Barbara (Avon)
Pair of Blue Eyes, A Hardy, Thomas (Popular Library)
Pale Gray for Guilt MacDonald, John D.
 (Fawcett Gold Medal)
Paradise Wild Lindsey, Johanna (Avon)
Parson's Daughter, The Cookson, Catherine
 (Pocket Books)
Passage to Terror Aarons, Edward S.
 (Fawcett Gold Medal)
Passion's Fury Hagan, Patricia (Avon)
Passionate, The Brown, Carter (Signet)
Passionate City, The Black, Ian Stuart (Fawcett Crest)
Passionate Pagan, The Brown, Carter (Signet)
Pathway to the Stars Kane, Harnett T. (Curtis)
Pawn in Frankincense Dunnett, Dorothy
 (Popular Library)
Pay-Off in Blood Halliday, Brett (Dell)
Peak in Darien, A Ham, Jr., Roswell G. (Avon)
Pearls Are for Tears Ellis, Audrey (Jove)
Peddler, The Prather, Richard S. (Fawcett Gold Medal)
Pedlock Saint Pedlock Sinner Longstreet, Stephen
 (Avon)
Pedlock and Sons Longstreet, Stephen (Avon)
Pedlock at Law Longstreet, Stephen (Avon)
Pedlocks, The Longstreet, Stephen (Avon)
Pedlocks in Love, The Longstreet, Stephen (Avon)
People Who Pull You Down Baird, Thomas (Avon)
Pepper Tree, The Jennings, John (Popular Library)
Peril Is My Pay Marlowe, Stephen (Fawcett Gold Medal)
Picture of Success Soman, Florence Jane
 (Popular Library)
Pigman, The Zindel, Paul (Bantam Starfire)
Pigman's Legacy, The Zindel, Paul (Bantam Starfire)
Pink Panther, The Albert, Marvin (Bantam)
Pirate of Gramercy Park, The Nicolayson, Bruce
 (Avon)
Pirate's Landing Craig, Mary Shura (Jove)
Pirate's Love, A Lindsey, Johanna (Avon)
Place of the Dawn Taylor, Gordon (Avon)
Play Now, Kill Later Brown, Carter (Signet)
Please Write for Details [2] MacDonald, John D.

 (Fawcett Gold Medal)
Plugged In Martin, Jay (Berkley)
Plush-Lined Coffin, The Brown, Carter (Signet)
Point Blank! Stark, Richard (Fawcett Gold Medal)
Pomp and Circumstance Coward, Noel (Dell)
Poor Millie Baird, Thomas (Avon)
Pop. 1280 Thompson, Jim (Fawcett Gold Medal)
Portrait in Brownstone Auchincloss, Louis (Avon)
Powder River Cotton, Ralph (St. Martin's)
Preservation Hall Spencer, Scott (Avon)
Price of Murder, The MacDonald, John D.
 (Fawcett Gold Medal)
Price of a Horse Cotton, Ralph (St. Martin's)
Prince of Foxes Shellabarger, Samuel (Avon)
Princess Daisy Krantz, Judith (Bantam)
Prisoner of Ingecliff, The Bellamy, Jean (Dell)
Private Life of Sherlock Holmes, The
 Hardwick, Michael & Mollie (Bantam)
Private Practice of Michael Shayne, The [2]
 Halliday, Brett (Dell)
Providence Green, Edith Pinero (Bantam)
Province of Darkness Morton, Patricia (Avon)
Purple Passage Hahn, Emily (Curtis)

Q

Queen's Folly Thane, Elswyth (Popular Library)
Queens' Play Dunnett, Dorothy (Popular Library)
Quick Red Fox, The MacDonald, John D.
 (Fawcett Gold Medal)

R

Raging Hearts, The Hagan, Patricia (Avon)
Raid, The Brick, John (Popular Library)
Rainbow Valley Montgomery, L. M. (Bantam)
Range Wars Vaughan, Robert (St. Martin's)
Rare Coin Score, The Stark, Richard
 (Fawcett Gold Medal)
Rascal's Heaven Mason, F. Van Wyck (Popular Library)
Rat Pack Six Spetz, Steven N. (Fawcett Gold Medal)
Ravenswood Roberts, Janet Louise (Avon)
Rebellious Angels Parker, Laura (Warner)
Reception at High Tower Ward, Dewey (Dell)
Rector of Justin, The Auchincloss, Louis (Avon)
Red Morning Frey, Ruby Frazier (Popular Library)
Red Scarf, The Brewer, Gil (Fawcett Crest)
Redcap McCutchan, Philip (Berkley)
Redhead, The Andersch, Alfred (Popular Library)
Redhead for Michael Shayne, A Halliday, Brett (Dell)
Regency Holiday, A Mansfield, Elizabeth, others (Jove)
Requiem for a Blonde Roos, Kelley (Dell)
Rest of Us, The Birmingham, Stephen (Berkley)
Return, The Mitgang, Herbert (Avon)
Return, The Winston, Daoma (Avon)

R (continued)

Revenge Ehrlich, Jack (Dell First Edition)

Rilla of Ingleside Montgomery, L. M. (Bantam)

Ring Around Rosy Davis, Gordon (Fawcett Gold Medal)

Ringed Castle, The Dunnett, Dorothy (Popular Library)

Rivals, The Moore, Arthur (Popular Library)

River Song MacIver, Sharon (Diamond)

River Thunder, Hobbs, Will (Laurel Leaf)

Rizpah Israel, Charles E (Fawcett Crest)

Rocco's Niece Marsh, Adrian (Avon)

Rogan's Moor Townley, Pamela (Charter)

Rogue Cavalier Marshall, Rosamond (Popular Library)

Rogue River Reno, James (Signet)

Rose in Splendor, A Parker, Laura (Warner)

Rose of the Mists Parker, Laura (Warner)

Route of the Red Gold Marlowe, Dan J.
(Fawcett Gold Medal)

Roxana Defoe, Daniel (Popular Library)

Royal Mistress Horton, Patricia Campbell (Avon)

Ruling Passion, The De Mare, George (Fawcett Crest)

Run Sleator, William (Avon)

S

Sabre-Tooth O'Donnell, Peter (Fawcett Crest)

Sad-Eyed Seductress, The [2] Brown, Carter (Signet)

Salt Lake City Riefe, A. R. (Signet)

San Francisco Riefe, A. R. (Signet)

Savage Place, A Slaughter, Frank G. (Pocket Books)

Savage Salome, The Brown, Carter (Signet)

Scandal on the Sand Trinian, John (Fawcett Gold Medal)

Scarlet Cord, The Slaughter, Frank G. (Pocket Books)

Scarlet Flush, The Brown, Carter (Signet)

Scarlet Ruse, The [2] MacDonald, John D.
(Fawcett Gold Medal)

Scrambled Yeggs, The Prather, Richard S.
(Fawcett Gold Medal)

Scream Bloody Murder Telfair, Richard
(Fawcett Gold Medal)

Sea Hawk, The Sabatini, Rafael (Popular Library)

Seacliff Andrews, Felicia (Charter)

Season of Mists, A Tracy, Honor (Popular Library)

Seattle Paul, Charlotte (Signet)

Secret Road, The Lancaster, Bruce (Popular Library)

Secret Rose, The Parker, Laura (Warner)

Secret of Mirror House, The Maxwell, Patricia
(Fawcett Gold Medal)

Seidlitz and the Super-Spy Brown, Carter (Signet)

Semi-Tough Jenkins, Dan (Signet)

Senator Marlowe's Daughter Keyes, Frances Parkinson
(Avon)

Sergeant, The Murphy, Dennis (Fawcett Crest)

Seven Sirens, The Brown, Carter (Signet)

77 Sunset Strip Huggins, Roy (Dell First Edition)

Sex Clinic, The Brown, Carter (Signet)

Shack Road Girl Whittington, Harry (Berkley)

Shadow Mansion Forrest, Wilma (Fawcett Gold Medal)

Shadow Over Denby Ross, Marilyn (Popular Library)

Shadow Walker Reno, James (Signet)

Shadow of the Sun, The Pell, Sylvia (Avon)

Shadows of the Heart Hurd, Florence (Avon)

Shanghai Incident Becker, Stephen (Fawcett Gold Medal)

She Asked for Murder Sherry, Edna (Dell)

She Woke to Darkness Halliday, Brett (Dell)

Shirley Bronte, Charlotte (Popular Library)

Shoot an Arrow to Stop the Wind Stuart, Colin
(Popular Library)

Shoot the Works Halliday, Brett (Dell)

Shoot to Kill Halliday, Brett (Dell)

Shores of Paradise, The Streshinsky, Shirley (Berkley)

Shrew Is Dead, The Smith, Shelley (Dell)

Siam Miami Renek, Morris (Paperback Library)

Side of the Angels, The Wilson, John Rowan
(Popular Library)

Signs and Portents Hine, Al (Avon)

Silken Baroness, The Atlee, Philip (Fawcett Gold Medal)

Silken Nightmare, The Brown, Carter (Signet)

Silver Concubine, The Evarts, Hal G. (Dell First Edition)

Sin of Susan Slade, The Hume, Doris
(Dell First Edition)

Six Months with an Older Woman Kaufelt, David A.
(Avon)

Six Who Ran Chaber, M. E. (Paperback Library)

Skyprobe McCutchan, Philip (Berkley)

Slab Happy Prather, Richard S. (Fawcett Gold Medal)

Slam the Big Door [2] MacDonald, John D.
(Fawcett Gold Medal)

Sleep, My Love Norman, Elizabeth (Avon)

Snow Dog Kjelgaard, Jim (Bantam Skylark)

So Dead the Rose Chaber, M. E. (Paperback Library)

So Lush, So Deadly Halliday, Brett (Dell)

So Red the Rose Young, Stark (Popular Library)

So Rich, So Lovely, and So Dead Masur, Hal Q. (Dell)

So Speaks the Heart Lindsey, Johanna (Avon)

So Strong a Flame Kavinoky, Bernice (Popular Library)

So What Killed the Vampire? Brown, Carter (Signet)

So Young, So Cold, So Fair Creasey, John (Dell)

Soft Touch MacDonald, John D. (Dell First Edition)

Softly in the Night Chaber, M. E. (Paperback Library)

Some Like It Cool Kyle, Robert (Dell First Edition)

Some Women Won't Wait Fair, A. A. (Dell)

Secret of Mirror House, The Maxwell, Patricia
Someone and Felicia Warwick Mason, Raymond
(Fawcett Gold Medal)

Sometime Wife, The Brown, Carter (Signet)

Song of Years Aldrich, Bess Streeter
(Bison, University of Nebraska Press))

Sound of Gunfire Bonham, Frank (Dell First Edition)

Sour Lemon Score, The Stark, Richard
(Fawcett Gold Medal)

Splintered Man, The Chaber, M. E. (Paperback Library)

Split, The Stark, Richard (Fawcett Gold Medal)

Spreading Fires Knowles, John (Ballantine)

St. Clair Summer, The Werlin, Marvin & Mark (Signet)

Star Trap, The Colby, Robert (Fawcett Gold Medal)

State Department Murders [2] Aarons, Edward S.
(Fawcett Gold Medal)

Stewardess, The Percivall, Julia (Avon)

Stone House, The Day, Dianne (Pocket Books)

Stormy Kjelgaard, Jim (Bantam Skylark)

Stranger in Town Halliday, Brett (Dell)

Streaked-Blond Slave, The Brown, Carter (Signet)

Strip for Murder Prather, Richard S.
(Fawcett Gold Medal)

Stripper, The Brown, Carter (Signet)

Success, The Howe, Helen (Popular Library)

Suddenly a Widow Coxe, George Harmon
(Popular Library)

Summer Always Ends Meade, Richard (Dell)

Sun Princess, The Pell, Sylvia (Avon)

Sweetwater Chastain, Sandra (Warner)

Sylvia Cunningham, E.V. (Fawcett Crest)

Syndicate Girl Kane, Frank (Dell First Edition)

T

Take Off Your Mask Eidelberg, MD, Ludwig (Pyramid)

Take a Murder, Darling Prather, Richard S.
(Fawcett Gold Medal)

Takeover Bid Gainham, Sarah (Popular Library)

Taking Off Percivall, Julia (Avon)

Tame the Fury Logan, Cait (Diamond)

Tamzen Rushing, Jane Gilmore (Popular Library)

Tan and Sandy Silence, A [2] MacDonald, John D.
(Fawcett Gold Medal)

Tangerine Rivoyre, Christine De (Popular Library)

Tanner's Tiger Block, Lawrence (Fawcett Gold Medal)

Tanner's Twelve Swingers Block, Lawrence
(Fawcett Gold Medal)

Target: Mike Shayne [2] Halliday, Brett (Dell)

Taste for Violence, A [2] Halliday, Brett (Dell)

Telling, The Weston, John (Dell)

Tender Is the Storm Lindsey, Johanna (Avon)

Texas Anthem Reno, James (Signet)

Texas Born Reno, James (Signet)

Texas Glory Vaughan, Robert (St. Martin's)

Texas Woman Johnston, Joan (Pocket Books)

That Far Paradise Markey, Gene (Popular Library)

That None Should Die Slaughter, Frank G.
(Pocket Books)

Theophilus North Wilder, Thornton (Avon)

They Came to a Valley Gulick, Bill (Popular Library)

This City Is Ours Pitts, Denis (Avon)

This Is It, Michael Shayne [2] Halliday, Brett (Dell)

Three Rivers Mills, Carla J. (Bantam)

Three Roads, The Macdonald, Ross (Bantam)

Thunderball Fleming, Ian (Signet)

Tickets for Death Halliday, Brett (Dell)

Till Morning Comes Suyin, Han (Bantam)

Timbalier Coleman, Clayton (Dell)

Time Returns, The Ripley, Alexandra (Avon)

Time of Man, The Roberts, Elizabeth Madox
(Popular Library)

Token, The Shellabarger, Samuel (Popular Library)

Too Friendly, Too Dead Halliday, Brett (Dell)

Too Hot to Hold Keene, Day (Fawcett Gold Medal)

Too Many Crooks Prather, Richard S.
(Fawcett Gold Medal)

Top of the Heap [2] Fair, A. A. (Dell)

Tortured Path, The Crossen, Kendall Foster
(Paperback Library)

Touch of the Dragon, A Basso, Hamilton
(Popular Library)

Toward the Morning Allen, Hervey (Popular Library)

Town, The Richter, Conrad (Bantam)

Trail of Secrets Goudge, Eileen (Signet)

Trees, The Richter, Conrad (Bantam)

Tropical Disturbance Pratt, Theodore
(Fawcett Gold Medal)

Trouble River Byars, Betsy (Puffin)

Trouble – Texas Style Bramlett, John
(Fawcett Gold Medal)

True Son of the Beast! Brown, Carter (Signet)

Tucson Riefe, A. R. (Signet)

Tudor Rose, The Barnes, Margaret Campbell
(Popular Library)

Turncoat, The Evarts, Hal G. (Fawcett Gold Medal)

Turquoise Lament, The MacDonald, John D.
(Fawcett Gold Medal)

24 Hours to Kill McKimmey, James (Dell First Edition)

Two for Tanner Block, Lawrence (Fawcett Gold Medal)

U

Uncomplaining Corpses, The Halliday, Brett (Dell)

Unconquered, The Williams, Ben Ames (Popular Library)

Uneasy Lies the Dead Chaber, M. E. (Paperback Library)

Uninvited Guest Coxe, George Harmon
(Popular Library)

Unleaving Walsh, Jill Paton (Avon)

Unorthodox Corpse, The Brown, Carter (Signet)

Until Temptation Do Us Part Brown, Carter (Signet)

Unto a Good Land Moberg, Vilhelm (Popular Library)

Up-Tight Blonde, The Brown, Carter (Signet)

Upstart, The Read, Piers Paul (Avon)

V

Valiant Strain, The Shiflet, Kenneth E. (Dell First Edition)

Veils of Salome, The Scotland, Jay (Avon)

Velvet Knife, The Shulman, Irving (Popular Library)

Velvet Vixen, The Brown, Carter (Signet)

Venetian Blonde, The Fleischman, A. S.
(Fawcett Gold Medal)

Very Small Remnant, A Straight, Michael (Dell)

Very Special Agent, A Napier, Geoffrey (Fawcett Crest)

Vice Avenged Burford, Lolah (Fawcett Crest)

Victim, The Brown, Carter (Signet)

View from Pompey's Head, The Basso, Hamilton
(Popular Library)

View from Tower Hill, The Braine, John
(Popular Library)

Vines of Yarrabee, The Eden, Dorothy (Fawcett Crest)

Violence Is Golden Halliday, Brett (Dell)

Violent World of Michael Shayne, The
Halliday, Brett (Dell)

Virgin Cay Heatter, Basil (Fawcett Gold Medal)

Virginians, The Bright, Elizabeth (Charter)

Voluptuaries, The [2] Davis, Melton S. (Avon)

Vows of the Peacock, The Graham, Alice Walworth
(Popular Library)

W

Wailing Frail, The Prather, Richard S.
(Fawcett Gold Medal)

Wait for What Will Come Michaels, Barbara
(Fawcett Crest)

Walk Softly, Witch Brown, Carter (Signet)

Walls of Jericho, The Wellman, Paul I. (Curtis)

Wanted: Danny Fontaine Ard, William (Dell)

Wanted: Dead Men Chaber, M. E. (Paperback Library)

Wanton, The Brown, Carter (Signet)

Warmaster McCutchan, Philip (Berkley)

Warrant for X MacDonald, Philip (Dell)

Warrior Queen Sinclair, James (Berkley)

Wave Hangs Dark, The Dipper, Alan (Popular Library)

Way We Live Now, The Miller, Warren (Fawcett Crest)

Way of a Wanton Prather, Richard S.
(Fawcett Gold Medal)

Way to the Old Sailor's Home, The Baird, Thomas
(Avon)

Ways of Desire, The Garnett, David (Popular Library)

Wayward Wahine, The Brown, Carter (Signet)

Weep for a Blonde Halliday, Brett (Dell)

West to Eden Goldreich, Gloria (Avon)

What Really Happened [2] Halliday, Brett (Dell)

Wheeler Dealers, The Goodman, George (Bantam)

When Dorinda Dances [2] Halliday, Brett (Dell)

When Love Awaits Lindsey, Johanna (Avon)

When Love Commands Wilde, Jennifer (Avon)

When She Was Bad Ard, William (Dell First Edition)

Where Did Charity Go? Brown, Carter (Signet)

Where Is Janice Gantry? MacDonald, John D.
(Fawcett Gold Medal)

Where the Red Fern Grows Rawls, Wilson (Bantam)

While Angels Dance Cotton, Ralph (St. Martin's)

Whisper in the Forest Ames, Norma (Avon)

Whistle in the Wind, A Culp, John H. (Popular Library)

White Bikini, The Brown, Carter (Signet)

White Horses Hoffman, Alice (Berkley)

White Witch, The Goudge, Elizabeth (Popular Library)

Who Killed Doctor Sex? Brown, Carter (Signet)

W.H.O.R.E.! Brown, Carter (Signet)

Wicked Loving Lies Rogers, Rosemary (Avon)

Wicked Pavilion, The Powell, Dawn (Avon)

Wide Sargasso Sea Rhys, Jean (Popular Library)

Widow Had a Gun, The Coxe, George Harmon
(Popular Library)

Wife to the Bastard Lewis, Hilda (Popular Library)

Wilbur's World of Women Blumberg, Gary (Berkley)

Wild Harvest Longstreet, Stephen (Fawcett Gold Medal)

Wild Highland Home Raife, Alexandra (Signet)

Wild Is the Night Quinn, Colleen (Diamond)

Wild Midnight Falls Chaber, M. E. (Paperback Library)

Wild One, The Golightly, Bonnie (Avon)

Wildflower DiBenedetto, Theresa (Pageant)

Wind-Up Doll, The Brown, Carter (Signet)

Windy Side of the Law, The Woods, Sara
(Popular Library)

Winter in the Blood Welch, James (Bantam)

Wolf and the Dove, The Woodiwiss, Kathleen E. (Avon)

Word of Mouth Weidman, Jerome (Fawcett Crest)

World Without Women Keene, Day
(Fawcett Gold Medal)

Wow Factor, The Terrall, Robert (Fawcett Gold Medal)

Wrong Ones, The McKimmey, James (Dell First Edition)

Wuthering Heights Bronte, Emily (Bantam)

Y

Years of the Locust, The Erdman, Loula Grace
(Popular Library)

Yesterday's Reveille Vaughan, Robert (St. Martin's)

You Can't Live Forever Masur, Hal (Dell)

You Live Once MacDonald, John D.
(Fawcett Gold Medal)

Young Lovers, The Halevy, Julian (Dell)

Young Marrieds, The Heiman, Judith (Fawcett Crest)

Z

Zelda Brown, Carter (Signet)

Zubaru Brunswick, James (Fawcett Gold Medal)

Dedication

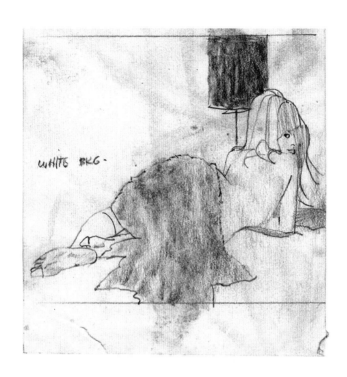